ULTIMATE
FIELD GUIDE TO
PHOTO
GRAPHY

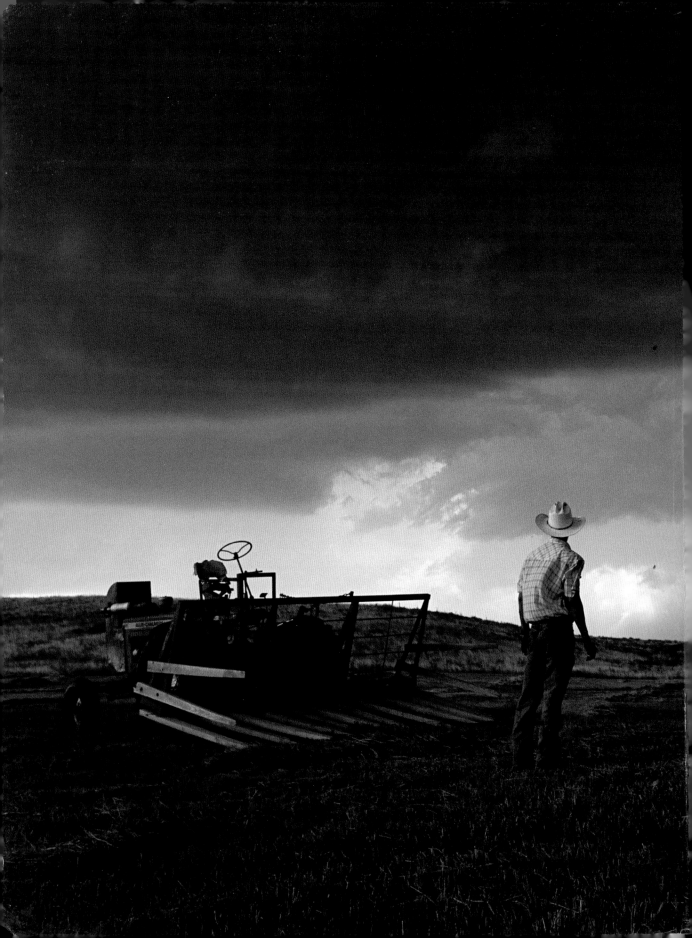

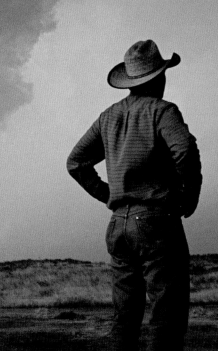

ULTIMATE
FIELD GUIDE TO
PHOTO
GRAPHY

NATIONAL GEOGRAPHIC

WASHINGTON, D.C.

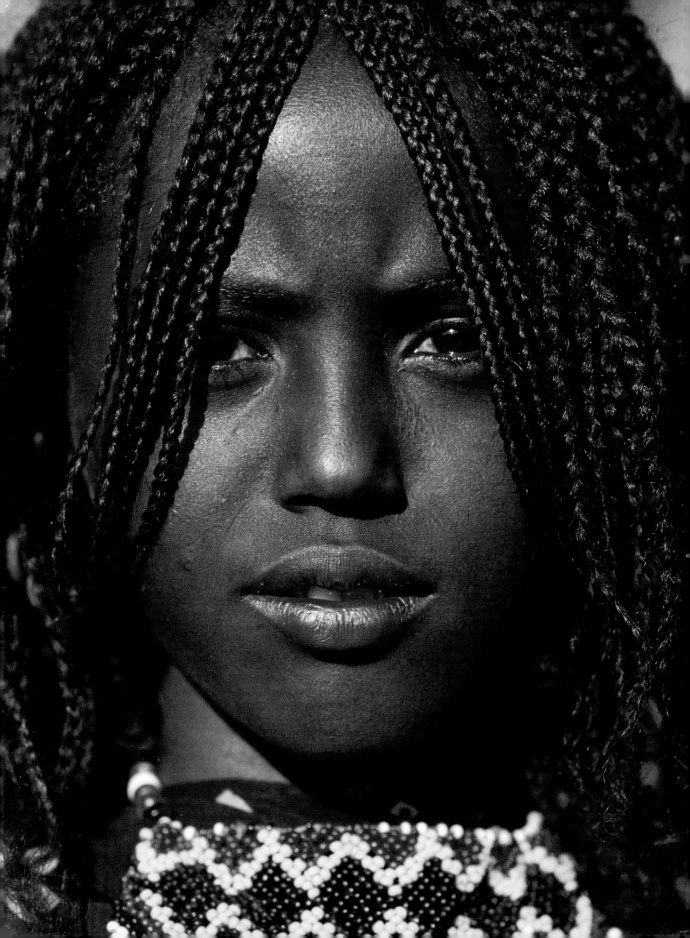

CONTENTS

*Opposite: Carsten Peter made
this portrait of a nine-year-old
Afar girl in Ethiopia.*

Introduction

Creating a revised edition of a popular book is like finessing an old family recipe. Some of the ingredients may be old-fashioned so you need to substitute with what you have available to you. Before you know it, you have a modern version of an old classic. In this book we have kept the panel of expert writers and the fun photographs but updated the technical information and deleted mention of any equipment, software, or websites rendered obsolete since we last published this book.

For those of you who are reading this guide for the first time, you will discover that each of the eight contributors emphasizes that you must photograph what interests you rather than what you think you should. Experiment. Make mistakes. Try again. Photography can be as technical as you want to make it or it can be just plain fun. I hope this book will provide you with enough information to help you with both aspects.

In the first three chapters, photographer Bob Martin maps out the basic elements of photography. Chapter One is the "Cliff Notes" chapter for people who want a few tips on how to use a point-and-shoot camera a little bit better. In Chapter Two you will find easy-to-read explanations of the basic rules for anyone using a camera. Chapter Three is for people who have mastered the basic rules and want to know a few tricks for more specialized work.

Camera phones are as common as wallets and keys in everyone's pockets these days. In Chapter Four, photographer Robert Clark takes us on his journey across America with only a camera phone and a few portable lights. Clark learned the limitations of the camera phone in comparison to his more sophisticated equipment. But he also found the camera phone gave him more freedom to work because of its smaller size. I think you will be pleasantly surprised, and informed, by his results.

In Chapter Five, photographer John Healey boils down tomes of technical information to give you the "Twelve Tips" you need to know about Adobe Photoshop or any comparable image-editing software. He uses one photograph of a Parisian street to

walk you through the different "tweaks" you can make in your computer to enhance a photograph. Photographer Richard Olsenius manages the same feat in Chapters Six and Eight by taking the mystery out of better printing and scanning techniques. With his easy-to-read, step-by-step advice, you can create a digital workflow that works.

Film photography has not disappeared entirely. As with all change, the best from the past will still have merit in times to come. In Chapter Seven archivist and picture editor Robert Stevens writes about the technical details and historic moments that brought photography through the film era and into the digital age. Sidebars throughout the chapter tell you how to make a photogram or use a pinhole camera and when to use a Holga or Polaroid film.

Photographer Debbie Grossman explains in Chapter Nine how to archive all of your work, both film and digital. She divides the chapter into sections for the different types of archivists: the minimalist; the point-and-shoot photographer, and the D-SLR photographer who needs a lot of space on the hard drive. You may never have to worry about losing a digital file again.

This book would not be complete without the expert advice of two very talented women. Writer and mother of three children, Fran Brennan offers how-to advice for nine unique projects with digital photographs in Chapter Ten. You may never have to search for a gift idea again. And picture editor Sheryl Mendez mined her notebooks from her years as a picture editor with Magnum Photos and *U.S. News & World Report* to create a useful reference in Chapter 11 at the back of this book for those photographers who never tire of finding new websites or magazines or organizations from which to learn all there is to know about photography.

Woven throughout this book, in the words and most certainly in the pictures, is the inspiration we all get from the images created by the photographers who work for the National Geographic Society. Their dedication to detail and excellence and their passion for their subjects is all the guidance we could want to kick off this new series. We hope you will feel inspired too.

Bronwen Latimer

Buying Your Digital Camera

I always dread people asking my opinion on which type of digital camera they should buy, as there are so many different factors that may influence your choice. I have therefore attempted to list the really important things to think about when you're buying a digital camera. Nowadays there are really only two types of digital camera to choose from. The first decision you need to make is whether to opt for a point-and-shoot camera or a D-SLR (Digital Single Lens Reflex).

POINT-AND-SHOOT CAMERAS

For the enthusiastic family/personal photographer, the modern semi-high-end digital point-and-shoot is hard to beat. This camera, with a non-removable lens and a built-in flash, with either a basic optical or digital viewfinder will be fine for 90 percent of your everyday shots. Even if you are a complete beginner—but with aspirations—this is the camera for you. Nearly all of these cameras have a fully automatic "idiot-proof" setting for quick social pictures. The better models on the market also have manual settings to help expand your photographic horizons as and when you dare. Some of them even allow you the option of making a 30-second film when you like. To select a point-and-shoot camera that is right for you, bear the following factors in mind:

- It should have an image sensor of at least 5 megapixels or more. This should allow you to make good prints up to 8 x 10.
- Go for an optical zoom lens; avoid a digital zoom, as this is merely cropping into a section of the sensor to zoom in.
- The camera should have a selection of manual overrides and settings to allow you to experiment, and a built-in flash with a red-eye reduction setting.

Point-and-shoot cameras are very portable.

- Make sure the camera has a large LCD screen to help you check and review your pictures. This will be one of your most important tools.
- Make sure that it has a very long battery life, the longer the better.
- Confirm that the camera can be connected directly to your computer via a USB 2.0 cable.
- Choose a camera that uses one of the more common media cards; Compact Flash (CF) and Secure Digital (SD) are the two most common types.
- Make sure your camera complies with the EXIF format to enable quick and simple printing.

Several high-capacity memory cards are a wise buy.

ANOTHER MEMORY CARD

One of the items you need to buy when you get your camera is an extra memory card. This will make your life a lot easier. If a card comes with your camera its capacity will almost certainly be limited (they range from 16MB to 32GB), and high-resolution cameras won't be able to squeeze many pictures onto them. Another advantage is that while you're getting prints done at the local photo lab, the extra card enables you to continue photographing.

I'd recommend getting at least two more cards, each with a fairly large capacity (256MB or more). Memory is getting cheaper and larger every year. As can happen with all electronic items, these cards occasionally can fail. By relying on just one huge card, you risk the loss of all of your pictures from the holiday of a lifetime.

Spreading important shoots over a number of memory cards is a safety practice adopted by many professional photographers. It's good working practice to format your memory card after every download. This can be done in the camera's software. It will destroy all the information held on your cards, so make sure they are thoroughly backed up onto your computer beforehand. This good housekeeping helps to eliminate corrupt files—one of the very few downsides of digital photography.

The most common brands of memory cards are SanDisk and Lexar. There are many other manufacturers and—be careful— several *types* of memory card. Take your camera with you when you buy an extra card to ensure it's suitable for your camera.

Opposite: Professional photographers tend to prefer D-SLR cameras.

DIGITAL SINGLE LENS REFLEX (SLR) CAMERAS

If you consider yourself a serious enthusiast, this is the camera for you. Digital SLRs are rapidly becoming the fastest-moving segment of the digital camera market, due to the increased popularity of photography with the advent of the digital era. The term SLR stands for Single Lens Reflex. This refers to a camera that uses the same lens for viewing and shooting. A mirror reflects the image from the lens to the viewfinder. When the shutter button is pressed, the mirror flips out of the way and the shutter opens, exposing the image sensor to light. These cameras come with a wealth of features and functionality and the ability to use interchangeable lenses. They are essential for photographing wildlife and sports. Many different sorts of accessories are available, such as a wide variety of flashguns, special close-up and macro equipment, remote control devices, etc. It is even possible to purchase an adapter to fix your camera onto a microscope, if you feel so inclined. In most cases you'll have the ability to shoot in RAW format, rather than JPEG, for the best quality possible. (For a better explanation of different formats, see the sidebar on page 92 for a brief introduction.) This will allow you to experiment and fully use the features in image-editing software.

When making your selection, ideally you should get a camera made by a well-known manufacturer that has the following useful features:

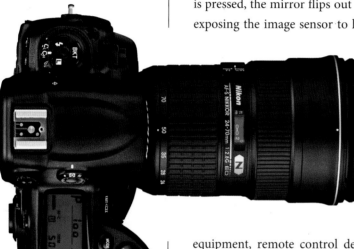

Nikon D3 SLR camera

- A full system of lenses, flashguns and accessories, so that as your interest and experience grow, the equipment available does not limit you.
- The ability to shoot JPEG and RAW format.
- A full range of automatic and manual settings and the ability to manually select shutter speed, lens aperture, color balance, and ISO sensitivity.

- A diopter adjustment on the eye-piece for a crystal clear viewfinder.
- An image sensor of at least 6 or 7 megapixels.
- A large LCD screen to help you check and review your pictures.
- A very long battery life, the longer the better.
- Ability to connect directly to your computer via a USB 2.0 cable
- Accepts the more common memory cards: Compact Flash (CF) and Secure Digital (SD), for example.
- Works with the EXIF format to enable quick and simple printing.

Once you've made your choice of camera, it's also a good idea to double-check the manufacturer's website to confirm that the features you require are in fact on the camera you're purchasing as models are continually being updated and revised.

RESEARCHING ON THE WEB

When choosing a camera today, the Web is an invaluable resource. There are many websites providing incredibly detailed reviews and reports on digital cameras. My current favorite is Digital Photography Review (*http://www.dpreview.com*). They have a very clever buyers guide search feature. You may also wish to take a look at the following:

http://www.photographyreview.com *http://www.imaging-resource.com*
http://www.camerareview.com *http://www.steves-digicams.com*
http://www.dcresource.com

Since this is a pretty big investment, do your research properly, shop around, check the Internet, and haggle to get the best price you possibly can.

Point and Shoot

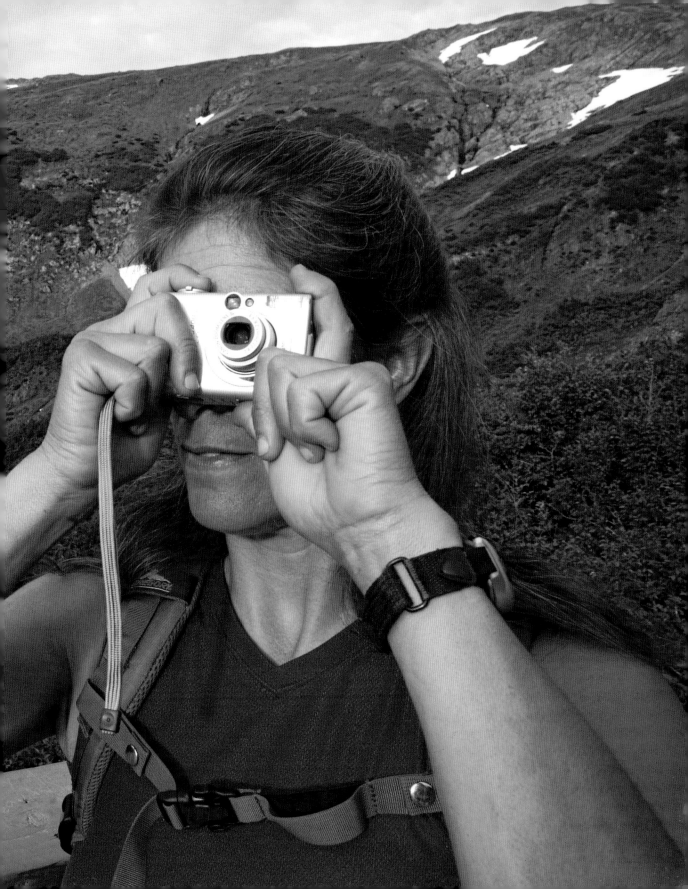

1 *Point and Shoot*

If you've decided that a point-and-shoot digital camera is the best choice for you, here are a few tips on how to use it well.

First of all, think a bit like a professional. They shoot as many pictures as they can: different angles, settings, compositions, etc. Don't be a *Camerasaurus Rex!* It's digital. It doesn't cost anything now that you have bought the camera. This really is the very best thing about digital photography. Shoot masses of pictures, delete your "mistakes," and show your relatives the crème de la crème. What a great photographer you are becoming already!

THE BASICS

Let's start off with how to hold the camera. The most common mistake people make is camera shake. When you move the camera inadvertently at the time you press the shutter, you risk the chance of blurring your image or reducing the sharpness of the image. Keep it steady! Hold the camera with both hands, making sure the horizon is straight when you look through the viewfinder or at the LCD monitor. Don't be afraid to rest your camera on something stable, be it the table at which you're sitting or the wall next to which you're standing. If you are looking through a viewfinder, tuck in your elbows and hold your breath at the instant of taking the picture. Press the shutter very, very gently. Such points might seem a bit too basic, but I'm including them because I'm always surprised by how many people hold their cameras the wrong way. I promise that more of your pictures will improve if you pay attention to this.

Here are a few tips to help you to think about how you hold the camera before you start shooting. Think about where your fingers are. A smudge on the lens is a common reason for fuzzy pictures. Make sure you don't have your fingertips over the lens. Keep them away from the front of the flash or you risk underexposed pictures. Try to keep your fingers firmly on the sides and/or underneath the camera to balance it and keep it steady.

EXPOSURE

Exposure is the amount of light necessary to register an image on your digital camera sensor. The sensor, commonly referred to

as the CCD (Charge Coupled Device) or CMOS (Complementary Metal Oxide Semiconductor), is a solid-state electronic component which, in the place of film, converts light into a pattern of electrical charges that is translated into digital data. To control

Being perfectly still is the first step to making better pictures.

this there are three settings: sensor sensitivity (ISO), shutter speed, and lens aperture (f-stop).

The exposure is controlled by a combination of shutter speed and aperture. The shutter speed is the length of time the shutter stays open to record light upon the sensor. The aperture controls how much light the lens lets in. (For a more in-depth explanation, see Chapter 2.)

Most digital point-and-shoot cameras have many useful automatic exposure (AE) settings. The most common examples are:

- Aperture priority (AE)—You set your f-stop and the camera works out what shutter speed is needed, depending on the available light.
- Shutter-speed priority (AE)—You set your shutter speed and the camera determines the correct f-stop.
- Program or fully automatic—The camera decides on both settings and sometimes even sets your sensor sensitivity.
- Combinations or more advanced versions of the above are found in many different guises, depending on manufacturer, model, etc. These modes take into account shooting styles, subject matter, etc., and will give you acceptable results with which to start. Some examples of these from different manufacturers are: Night Scene, Portrait, Twilight, Child, Sports, etc.

Most of the time these automatic settings will be fine. Sometimes, though, you will need to be more clever than your camera. Your camera can sometimes be fooled in its constant quest to produce the correct exposure. For instance, if you're photographing the classic black cat in a coal cellar, your digital point-and-shoot camera will try to expose your black cat as a gray cat, because it thinks all subjects are made up of a cross-section of the tonal range. Equally, if you were photographing a huge white polar bear at the North Pole, you'd end up with a gray bear and gray snow if relying on automatic exposure (the camera would assume that the subject could never be entirely white and would correct for this).

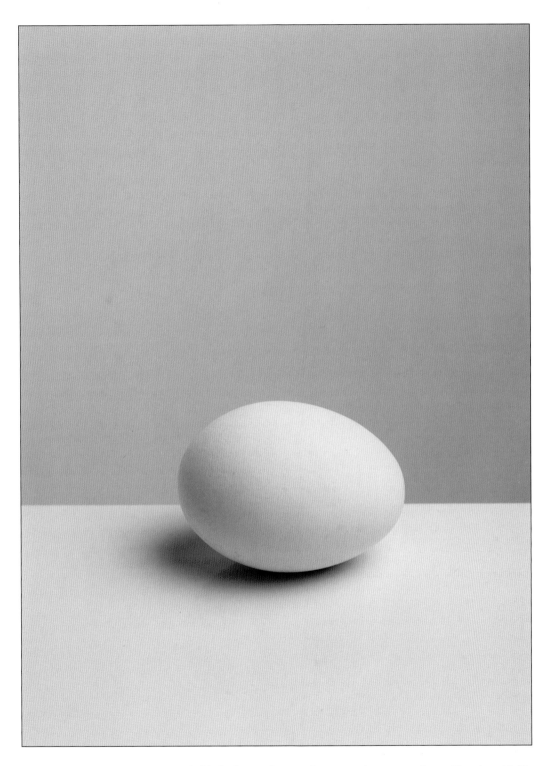

Aaron Graubart chose this egg and this background to see the range of exposures he could make with his Mamiya RB 6x7 camera, Fuji Provia 100F film, and this lighting. You can experiment in the same way with your point-and-shoot camera.

Most point-and-shoot cameras have an exposure override facility (known as exposure compensation), allowing you to change the exposure of your picture. If your subject is dark, your camera may try to lighten (or increase) its exposure. By manually reducing the exposure you can maintain the look of the subject. Likewise, if you are photographing a bright scene, you can manually increase the exposure.

Take a test picture, look at it on the camera, check the histogram, and adjust your exposure compensation. Don't be afraid to shoot four or five versions, as the LCD screen is not always accurate. You can delete the bad pictures later.

COMPOSITION

A very basic rule of composition is known as the rule of thirds, or the tic-tac-toe rule. Imagine your viewfinder or LCD monitor divided into nine equal-size squares, like a tic-tac-toe grid. Compose your picture with your subject center-positioned at one of the four intersecting points. This should help you compose more aesthetic portraits.

John Burcham used the rule of thirds when he photographed a fellow hiker in Antelope Canyon, Arizona.

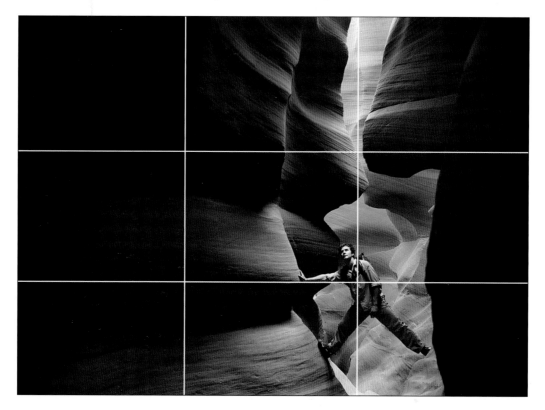

ZOOM

Your point-and-shoot camera will probably have an autofocus zoom lens. You will discover that the ability to zoom in on your subject is fantastic. Get bold. Use your zoom lens and compose your picture with the subject filling your frame. To start with, I'd be surprised if you don't get a lot of pictures that are small in the frame. When you look through the viewfinder, look at the whole picture frame and how big the subject is in your picture, not just into the eyes of the person you're photographing.

Your zoom lens is not only for zooming in for a closer shot but also zooming out to get everything in for a wide-angle shot. Completely different pictures can be made of the same subject using the optical characteristics of your zoom.

To help you understand this, try taking a series of photographs of the same subject. For example, take a friend to the park. Zoom the lens to its most powerful setting. Shoot a close-up portrait of your friend's face. Then slowly zoom out, shooting a similarly framed picture of your friend at each setting, making sure your friend's head is the same size in each picture. You must move closer to your friend each time to make this work. You will then have a set of images that shows you how the same picture changes as you change your focal length. Do the same exercise with full-length shots of your friend as well.

This exercise will teach you a great deal about how a picture can change according to how the relationship is altered between the background, the subject, and the focal length of the lens. Make sure you use a fairly busy background so you can see the results clearly. This should help you realize when a picture can be improved by zooming in, thereby losing the background and concentrating completely on the subject.

Equally, you should experiment with zooming out to the widest-angle setting to include the background in your picture, especially if this helps your shot by giving it a sense of place.

Note that zooming your lens will often change the aperture setting as you shoot. This is because as the lens zooms in (and its focal length lengthens), less light is able to reach the sensor.

TIP:
Most point-and-shoot cameras have a limited-range optical zoom with the ability to further zoom in electronically. This merely crops your picture and uses only a small section of your sensor. I recommend switching off this facility and using only the optical zoom if this is possible on your camera, since you can always crop the picture at a later stage.

When Mark Thiessen used a wide-angle lens (bottom), he included more of the environment in his picture. When he zoomed in (top), he kept Becky Hale's face the same size in the frame. As a result, the narrower angle of view and loss of focus on the background made her face more prominent. See page 19 for a full explanation.

FOCUS LOCK FACILITY

Another instance when you may wish to override the automatic settings on your camera, as we mentioned in the exposure section, is when your subject is not in the center of your frame, which may often be the case if you are following our tic-tac-toe rule. The standard setting on your camera will automatically focus on the center of the frame. The focus lock facility will enable you to lock the focus on the subject you want and then recompose the picture.

For example, say you want to photograph your nephew sitting in front of Buckingham Palace. Compose your picture with your nephew sitting on the left side of the frame. Point the camera at him and press the shutter *halfway*, locking the focal point on him. Now recompose the picture as you began and press the shutter button the rest of the way down. Your nephew should be sharp in the picture even though you have moved your camera to include his surroundings.

CHANGING THE POINT OF VIEW

Another thing to consider when taking your picture is your point of view. A picture can be more interesting when taken from an unusual angle. Don't be afraid to lie down and look up at your subject, a particularly dynamic approach when photographing pets or children and also less threatening to your subject. You could try climbing up to a higher viewpoint and looking down on your subject. Better yet, try both and then delete the one you like less.

USING FLASH

Nearly all point-and-shoot cameras have a built-in flash for use at night, indoors, etc. Be aware that the built-in flashes are not very powerful. Unless you frame the picture very tightly, a group of ten people, for example, may be underexposed in the picture. The camera will underexpose this situation—causing a dark or gray washed-out or murky quality—as the flash will not be powerful enough.

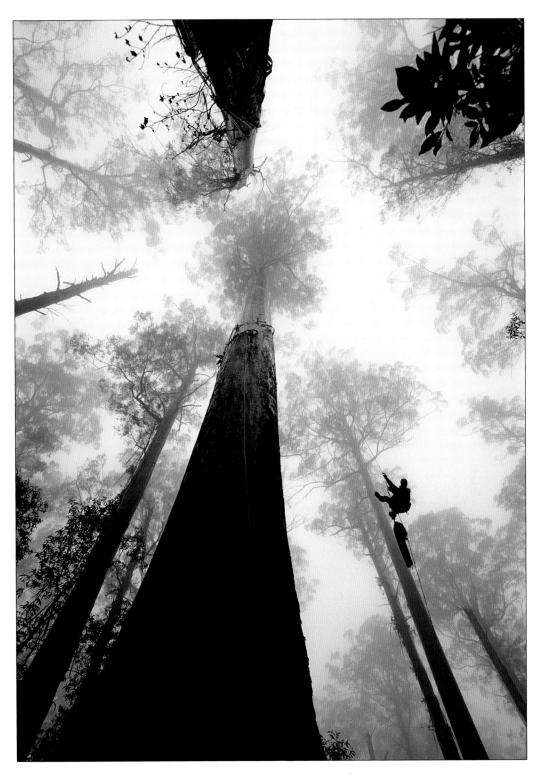

A new perspective gave photographer Bill Hatcher the chance to show how challenging an ecological survey of Mount Eucalyptus, the tallest hardwood forest in Eastern Australia, can be for surveyors.

Professionals photographing social events (weddings, parties, etc.) set their flash only slightly brighter than the available light. This produces pictures with plenty of detail in the background. The amateur's picture is normally "over-flashed," making the background completely black, with no detail, because the flash is a lot brighter than the available light. Some cameras have a setting that adjusts the flash output, so you can make your subject brighter or darker; however not all cameras do.

Your camera has a manual override, you can emulate the professional photographer's solution for this with your point-and-shoot camera by selecting the shutter speed-priority mode and a slow shutter speed (around 1/30). With this setting indoors, you should be able to see what's in the background of your pictures. Some point-and-shoot cameras have a special setting that fully automates this, sometimes called "slow-sync," for a similar effect.

The biggest enemy of the flash photographer is the mirror or window. If in doubt, flash off a frame while looking over the top of the camera to check for those pesky reflections.

Fill Flash

Many popular digital point-and-shoot cameras have a setting (sometimes called fill flash or "any-time flash") for using the flash at all times. On a dull, dreary day or even in very harsh, bright sunlight when shooting a portrait or a close-up, consider toggling to this facility with your flash-mode button. Fill flash fills in the shadows, or balances the foreground and the background if shooting backlit (into the sun). For my kids' holiday snapshots, I suggested they leave the flash on all the time. The automatic exposure feature of the camera takes into account the added light the flash gives.

The Dreaded
Red-Eye Effect

The vampire look is caused by the flash reflecting on the blood vessels at the back of the eye, visible through the pupil when it is dilated in dim lighting conditions. The red-eye reduction mode, found on most point-and-shoots, helps to reduce this, either by firing a number of small flashes, or by using a built-in incandescent beam before taking the picture with the normal powered flash, thus making the pupil less dilated. This helps, but does not eliminate the problem entirely. In the Jurassic days of film, the easiest way to deal with this dreadful effect on family snaps was to use a low-tech photographic accessory—a black permanent marker—to carefully retouch the glowing pupils on your prints. However, returning to the 21st century, red eye can be eliminated in seconds with image-editing software and your computer before the prints are made.

You must always think about all aspects of your photography: composition, background, your point of view, the light, whether the colors in your pictures are dynamic and interesting, whether the colors complement each other. A red fire truck photographed

Fill flash fixes harsh shadows created by a midday sun.

against green trees will appear far more vividly red than if photographed against a gray building. As you continue to read this book, all of this and more will become much, much clearer (and sharper)—I promise!

Practice, experimentation and making lots of mistakes is how you get better. The key to growing as a photographer is to take one step at a time and learn the techniques such as composition, adjusting your exposure and using flash. As you learn each one, you can start mixing them together. Professional photographers know these techniques inside and out and can fluidly meld all of them quickly and decisively to create the photograph they have in mind.

NEW OPTIONS IN THE DIGITAL DARKROOM

Now that you've bought your first digital camera, you're halfway there. You've taken your first set of pictures, and what on Earth are you going to do next? In the film world, it is merely a matter of dropping your film off at the local drugstore or photo lab and waiting a couple of days for your prints to return. You can still do

this with your memory cards, but you now have other options. To name a few, you can:

- print the pictures yourself on a home printer
- e-mail pictures
- create a slide show
- publish a website on your computer
- order prints online or at a local store
- write pictures to a CD-R or DVD-R

PHOTO LABS AND KIOSKS

If you decide to take your memory card to a photo lab, look for a company with the latest digital printing equipment that will enable you to do basic crops on a screen in the shop and receive your prints while you wait. In some cases, this technology can be found in malls and big stores such as photo-printing kiosks, in which the whole process is controlled by you on an easy-to-follow, on-screen menu.

EDITING YOUR WORK

Obviously there are a number of different computer operating systems. Windows is dominant, however, with about 90 percent of the home computer market. The latest version called Vista was launched in 2007, however the most common household version in use at the moment is Windows XP. I am therefore basing most of this chapter on practices within Windows XP.

For those using Apple Macintosh computers— to my mind the best operating system for photography at the moment—we'll address this system in other parts of the book. For now, it's good to know that all of the Wizards mentioned within Microsoft XP are available to you under a different guise within the program called iPhoto, which is free with nearly all new machines. If you store your pictures within iPhoto, and you've remembered to set the date and time accurately on your camera, your pictures will automatically be filed by date

TIP:
The self-serve photo kiosk is one of the fastest growing segments of the digital photo-printing business. The kiosks are appearing in airports, on cruise ships, and in retail food stores. Here are a few U.S. locations where you can compare prices and services, which can vary, to find the best option for you:

Wal-Mart
Target
Costco
Kinko's
Rite Aid
CVS
Walgreens
Ritz Camera

and time. Using the advanced editing dashboard, you can adjust exposure and crop your pictures. You can produce both simple and advanced slide shows and even add music or a soundtrack. When you've decided which are your best pictures, printing both small and large prints is easily automated; you can do it on your own printer or at an online lab over the Internet. It's very simple to produce websites and share and e-mail pictures online. There's also a terrific, unique facility to produce photo books, which are fully bound, printed books of your very own pictures, created from a variety of templates within this program.

A good place to start, if you're using Microsoft Windows XP, is to store your pictures, as suggested by the operating system, in the "My Pictures" folder of your computer. Organize your pictures carefully. Subdivide them into various folders, perhaps by date or subject, remembering that it will be difficult to find particular pictures again unless you are organized. To simplify the search process, I suggest filing your pictures by date. Whenever you get any really good pictures, make copies and put them into folders filed by subject. *It's better to have five copies of your best pictures than one picture you can't seem to find.*

Within the My Pictures folder, you can access a selection of menus/shortcuts to start you off on the right track. Any pictures stored in the folders within My Pictures, as opposed to elsewhere, can access special Windows facilities for photographers. The photos can be reviewed full screen in the Filmstrip mode found within the View menu. You can also view the pictures as a slide show, e-mail your photos, publish them on the Web, order prints online, print the pictures on your own printer, and copy the pictures onto a CD to pass on to friends. You can even set your latest snapshot as the background to your desktop, if you feel so inclined.

SLIDE SHOWS

In the top left-hand corner of the My Pictures folder, you will see a menu called Picture Tasks. The first option is "View as a slide show." Select the pictures you like, press View as a slide show,

TIP:

There are other image-editing programs out there that are worth researching for what you need.

 Photo Mechanic

 Corel's Paint Shop

 Google's Picasa

 Adobe's Photoshop Express

and your pictures will appear one after the other on your screen, changing automatically. Your very first "professional" slide show has just taken place! Providing you've been concentrating, having seen your pictures full screen, you are now in a position to decide which pictures to print. It's really, really important to look at all your pictures carefully. One of the joys of digital photography is that you do not have to print or use your mistakes. Now is the time to carefully examine every picture, disposing of all of those that could damage your reputation and have the potential to provide a source of ridicule for your newfound status as a budding Ansel Adams. (In the unlikely event that you have never heard of this icon of modern photography, rectify this immediately by visiting *www.anseladams.com*. Or leaf through one of his many books.)

A good image program will help you keep your photos organized by date, subject, keywords and category.

PRINTING PICTURES YOURSELF

Now that you've honed your first set of pictures down to a select few, you should try printing. At this point, you may decide to either write a CD of your edited-down pictures or copy them

Old shoeboxes full of photos can be scanned into a digital archive.

back onto a memory card to take to the photo lab. Equally, if you have a photo-quality printer, you may choose to print your own photos.

The first option is a stand-alone photo printer. With this you can produce standard prints without a computer by taking your memory card from your digital camera and plugging it directly into the printer. Many different manufacturers produce these, such as Epson, Hewlett Packard, Olympus, and Canon. With some models you can plug the camera directly into the printer, and the very latest cameras from Nikon and Canon can even print wirelessly via Bluetooth, providing of course that you also have the latest Bluetooth-compatible printer.

If you have an inkjet printer, be aware that many do not use permanent inks, so your priceless memories could fade after a few years. Check the specification of the inks your printer uses on the manufacturer's website or look it up in your instruction book. *Do not economize on your paper choice!* If you compare color prints produced on ordinary letter paper with those printed on photo-grade paper, you would never think that they had come from the same printer. So it's well worth spending your hard-earned pennies on good paper.

A big hurdle often encountered by those starting out in digital photography is printing on letter-size paper with a normal printer. So how do you do small prints, without wasting paper? Use the Photo Printing Wizard within your XP operating system. This gives you a variety of layout options: to print each picture full page, two per page, four per page, etc, down to a contact sheet (a series of very small images, up to 35 on one sheet) or multiple copies of each picture if necessary.

A desktop printer

INTERNET ACCESS

Alternatively, providing you have a fast Internet connection, you can order prints online via the Order Prints Online Wizard. This couldn't be simpler. Follow the instructions, and within a few moments your prints will be uploading to the online printer company, which will in turn mail the prints to you.

Another important Wizard is the "E-mail this file" facility, which automatically attaches the picture selected to an e-mail. If you and the recipient both have high-speed Internet access, try not to use the resize option. Sending the full resolution file will enable the recipient to print the picture in all its glory. However, without high-speed Internet access, this would take far too long. It's possible to downsize the picture within the Wizard by using the resize option that is available.

A good tip: If you click on "Show more options" within this menu, use the "Small" setting if the picture is purely for reference, the "Medium" setting to enable your recipient to see the picture enlarged, and the "Large" setting if the picture may be for website use. In all other cases, send the full-resolution picture.

BACKING UP YOUR PHOTOS

The final important Wizard is the "Copy to CD" facility, which enables you to write a CD (providing your computer has a CD writer) to pass on to a colleague, or to back up your picture collection. As I'm sure you are aware, all computers have a tendency

A waterproof case for your memory cards can help save your files from being corrupted by water or dust like the (film) photo below.

to crash at some point. You *must*, therefore, back up your photos in some way, and burning a CD is one of the easiest methods.

Various other options are possible from this menu, including "Publish this file to the Web," which (providing you have an MSN account/homepage) enables you to upload a picture simply to a website. All these Wizard facilities are very basic, functional tools to get you started in digital photography. One particularly annoying feature to be aware of is that the print options occasionally crop bits of your pictures off to fit the images into their standard templates.

If you're getting really technical, you can publish them on the Web for a select few, or for the whole world to see, with a facility for them to order prints directly from an online photo lab. (See sidebar) This will make your life much simpler, because you won't have the hassle and expense of distributing your photography.

CONCLUSION

Now that you've read this chapter, you should have an overall idea of the basic elements to bear in mind when starting out with your new digital point-and-shoot camera. Familiarize yourself with the features on your camera and experiment as much as possible with the different settings. Take lots and lots of pictures, and don't be afraid to play around with different backgrounds, viewpoints, etc. Don't feel you must immediately press the shutter button when you put the camera to your eye. Slow down and think when you're taking your pictures. It is admittedly a lot of information to digest at first!

It's amazing what all you can do with photographs now, but keep in mind that a simple, beautifully printed photograph in a carefully chosen frame or mount is classic in its simplicity and beauty. Such a trophy will inspire you to get out there and make more, and you can look forward to delving deeper into this wonderful art as you work through the chapters ahead.

TIP:

If you intend to store, print, and edit your pictures on a computer, a really good accessory is a card reader. Depending on the connections available on your computer, this will plug into either your FireWire or your USB port, providing an easily accessible way in which to insert the memory card for downloading to the computer (rather than connecting your whole camera to the computer with a cable). If you choose a USB card reader, make sure it's a USB 2.0 card reader, since USB 1.0 is very slow. Also bear in mind that while it's tempting and possibly prudent to go for a universal card reader that takes many types of card, each slot on the card reader will appear on computers running Windows XP as different disks/hard drives. This can be very confusing. If, however, you opt for a dedicated single-card reader, only one extra disk/hard drive will appear.

Most point and shoots have a small delay that can make shots like this tough. Try to anticipate the action and press the shutter button halfway down moments before it happens to ready the camera and reduce the delay which can cause out-of-focus pictures as seen here.

Magnum is the name of an exemplary photo agency featuring documentary work by some of history's most illustrious photographers such as Elliott Erwitt, Robert Capa, and Henri Cartier-Bresson. It is also the home of some of today's promising successors to these legendary figures. And some of them are using point-and-shoot digital cameras to make their images.

"I have been using it exclusively for the last two years," said Christopher Anderson while he was on assignment in Paris covering the fashion shows.

"There are two reasons," he continued. "The size of the digital SLR cameras was so big, I didn't want to work with them. The other reason is that I like the color the Olympus camera gives me. Choosing a digital camera is almost like choosing a roll of film: each sensor has a different color scheme," he says. (He has worked with the C-5050, the C-5060, and the C-7070 models, to name a few.)

Alex Majoli, a photographer based in New York and Milan, won the 2004 Magazine Photographer of the Year award given by the National Press Photographers Association (NPPA) with a portfolio that was almost exclusively made with his digital point-and-shoot cameras. The stories were shot in China, the Congo, and Iraq, mostly for *Newsweek* magazine.

Majoli discovered the versatility of the cameras when he was on assignment for the book project *A Day in the Life of Africa*, in 2002. A representative from Olympus, a sponsor of the project, gave each of the photographers a 4-megapixel C-4040 digital point-and-shoot camera and a bigger E-20 digital SLR camera with which to work. Majoli, having worked mostly with 35mm film Leica rangefinders and the 28mm and 35mm Leica M-system lenses since he started working at age 19, gravitated toward the smaller camera.

"I found the C-4040 amazing," Majoli told Eamon Hickey, writing for *www.robgalbraith.com*, "and it made a great file." The C-5050 to which Majoli later graduated is a 5-megapixel camera with a 35-105mm lens.

Paolo Pellegrin, who established himself in 1995 with a story on AIDS in Uganda that earned him a World Press Photo Award

Christopher Anderson portrayed victims of Hurricane Katrina in 2005 using a point-and-shoot camera.

and the Kodak Young Photographer Award (known as the Visa D'Or) during the 1996 Visa Pour L'Image photo festival in Perpignan, France, also uses digital point-and-shoot cameras in his work. Most recently he has completed stories on the citizens of China and the aftermath of the tsunami in Indonesia. Pellegrin is known for his work in places like Kosovo, Rwanda, Cambodia, and the Sudan.

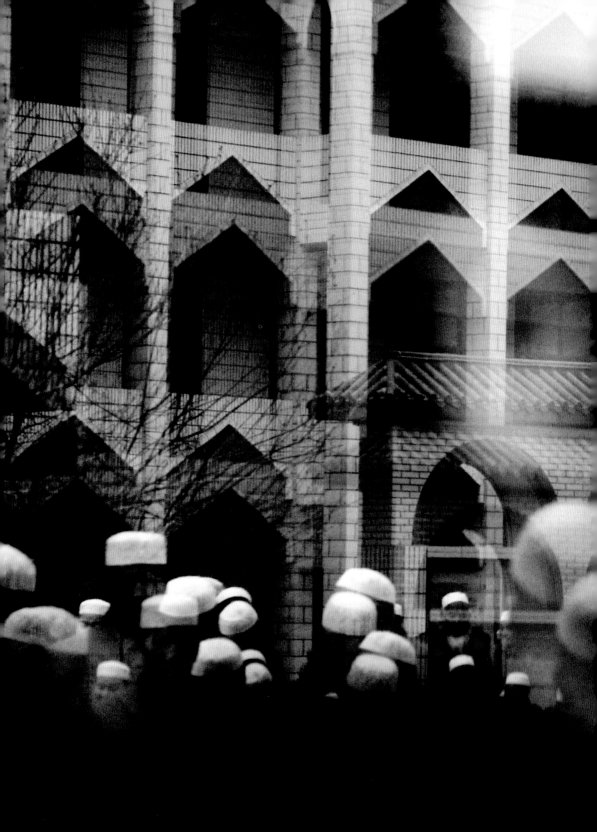

Paolo Pellegrin photographed Friday prayers at the Great Mosque in China's Qinghai Province in 2005.

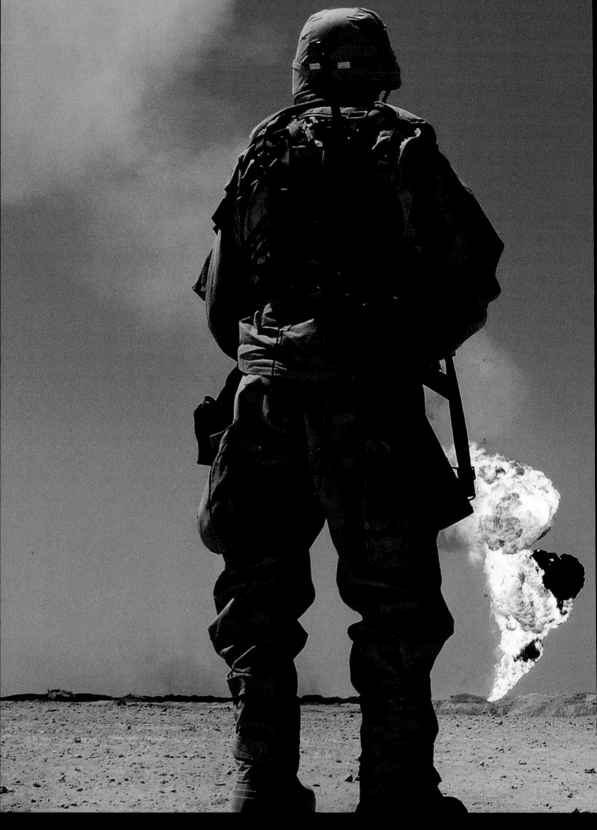

In April 2003, Alex Majoli photographed U.S. soldiers surveying burning oil fields in Iraq.

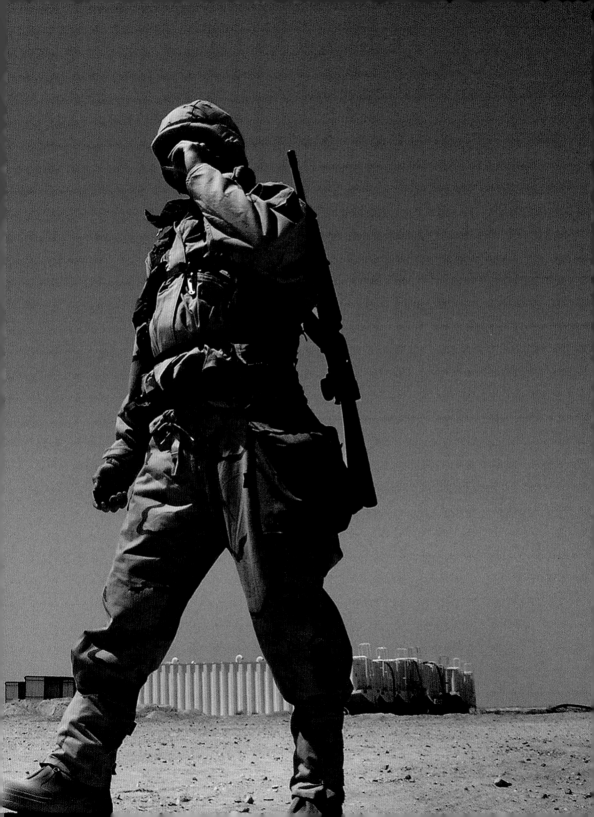

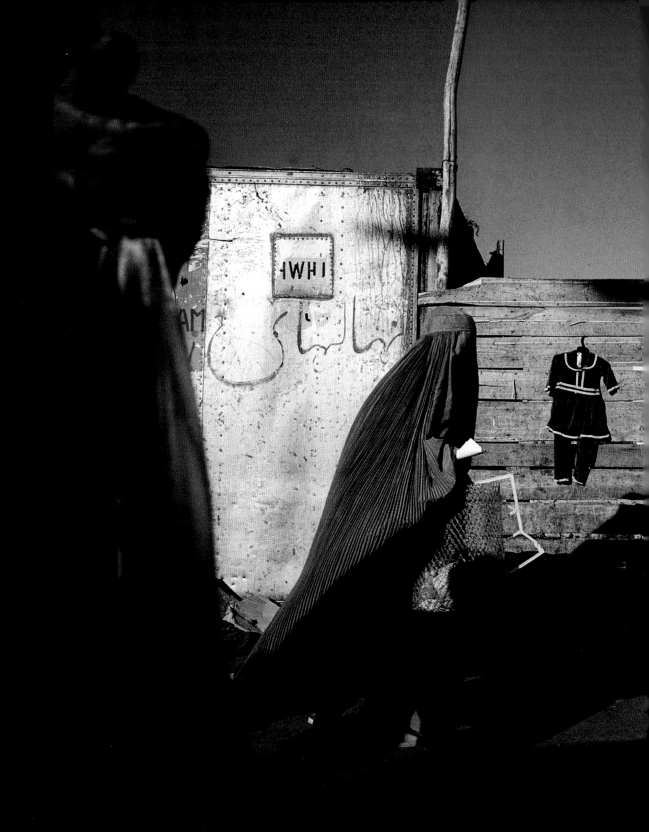

Christopher Anderson photographed a market in Kabul, Afghanistan, in 2004.

The Yellow River in Chongquing, China, was photographed by Alex Majoli in 2003.

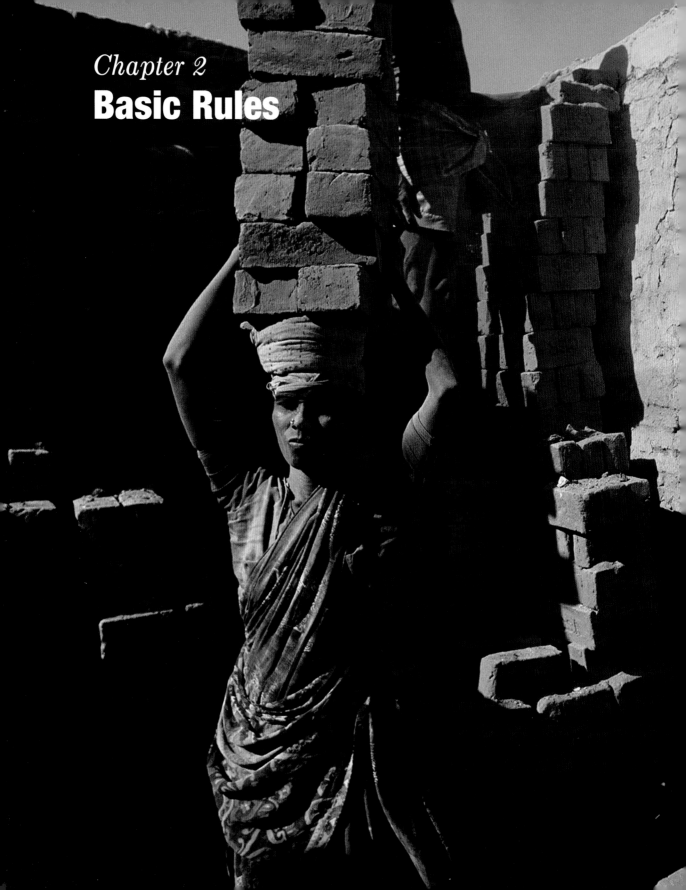

Chapter 2
Basic Rules

2 Basic Rules

Digital photography has surpassed film photography in popularity in recent years, a fact that has relegated some amateur and professional film cameras to the unlikely task of becoming a paperweight. In the art world, however, film cameras are coveted. The lesson is simple: choose the tools that you need to get the results you want.

Just a couple of years ago a professional would have chosen from a vast array of film camera types—single lens reflexes, twin lens reflexes, rangefinders, and view cameras to name a few—when selecting the tools of his or her trade. Now, with the advent of digital technology and digital software, the serious photographer can, for the most part, rely on a digital single-lens reflex camera, or D-SLR.

A D-SLR is an incredibly advanced and refined tool that still offers the all-important ability, as in film version cameras, to view your subject through the same lens that records the image onto your sensor. This is achieved via a mirror and a pentaprism so that what you see is what you get (often referred to as WYSIWYG). It is hard to imagine that every time you press the shutter to take a picture, a mirror between the rear of the lens and the image sensor flips out of the way, the camera shutter opens, and the sensor is exposed for the required time. Meanwhile, the camera's microprocessor is writing the multitude of information the image sensor has recorded to the camera's memory card. This is incredible in itself. Now consider how incredible are the cameras used by sport and press photographers, which manage this at eight frames a second!

For all intents and purposes, there are two types of D-SLR cameras. The first is a traditional-looking camera roughly based on the 35mm film camera bodies that preceded it. Photographers who would normally use both medium- and large-format professional cameras are discovering that in some instances the modern high-end D-SLR provides superior image quality when compared to the scan that was possible from their film. (The "format" of a camera refers to the size of the negative of film cameras and the size of the image sensor in digital cameras. Large format refers

to cameras with a 4 inch by 5 inch negative and larger, whereas medium refers to cameras between 35mm and large format.) Previous users of high-end film compacts and rangefinder cameras are also gravitating toward the more advanced functionality and image quality provided by the D-SLR. At the time of this writing, manufacturers such as Leica and Epson are close to producing a digital replacement for the rangefinder, but high-end digital compacts and D-SLRs are currently filling this void.

The second type of D-SLR is based on the medium-format SLR. Some models consist merely of a digital back on a medium-format film system camera, whereas a few manufacturers are producing large D-SLRs using the largest CCDs. These cameras tend to be used for pictures that require the highest image resolution, such as landscape and still life.

Once you have your new camera, you should keep in mind that the camera essentially houses a miniature computer. Keep

Large LCD displays allow you to see your pictures quickly so you can recompose your picture if necessary.

Digital backs for medium-format cameras are an option.

your camera software/firmware up to date. The camera manufacturers continuously tune and fine-tune the firmware that runs your camera. Updates can be downloaded from the support section of the manufacturer's website and the instructions to install them into your camera will be found in your instruction manual. Copying the firmware file to a memory card normally does this. Once the memory card is in your camera, use the camera's menu to upload the firmware to your camera. As soon as you buy your camera, check to make sure that you have the latest firmware.

Bear in mind that this is new technology that is continuously evolving and improving. Just as it is with computers, as soon as you buy a new model and are familiar with using it, a newer one will be on the market.

SENSORS

The image sensor in a digital camera replaces the film. There are two main types of sensors used in D-SLR cameras. They are the CMOS (Complementary Metal Oxide Semiconductor) and the CCD (Charge Coupled Device).

Both sensors have their particular idiosyncrasies, and they have various characteristics that should be taken into account when purchasing. So it's important to look at some example files and research the characteristics of the system you intend to purchase.

When professional photographers are choosing and purchasing a camera system, they like to shoot some comparison test shots with the cameras they're considering. Where possible, emulate this practice. Check the files in the image-editing software on your computer. Make sure both cameras are tested with all in-camera sharpening turned off to allow for a fair comparison. A camera technician at your local store can show you how to do this.

TIP:

There are a few other factors to take into account when choosing your camera.

- Can the camera shoot in RAW format? RAW is a protocol in which the settings are stored separately from the raw data, allowing for far more adjustment and fine-tuning than the traditional JPEG format once your picture is in your computer.

- How big is the memory buffer? The memory buffer allows you to shoot a specific number of frames in rapid succession.

- How many pictures can you take before you run out of memory? Make sure you have the right size memory card for the number of pictures you wish to take.

- How long will your battery last? Most digital cameras come with a rechargeable battery. In the early days you will review almost every picture on the LCD on the back of your camera. This is the most power-hungry operation you will undertake with your camera, so look for a camera with a long battery life and check the specification before you buy.

Some sensor/camera combinations are particularly good for low light when using a sensor sensitivity of 400 ISO or higher, while others are fantastic in full natural light and terrible when used with a high ISO sensor sensitivity. Check the amount of "noise" or "grain" at a higher ISO. Do your research well and choose a suitable sensor for the type of photography you're most interested in.

Whereas in the era of film you would have bought your camera and decided on the type of film required at a later stage, now you have to make this important decision at the outset. It's not just about the file size your intended camera is capable of. For instance, if the sensor is less sharp than the alternative camera, or the color characteristics less favorable, you could be unhappy with your choice. Some D-SLRs have in-camera sharpening to compensate for anti-aliasing filters, the main source of "unsharpness."

Initially you wouldn't think that the physical size of the image sensor would be a factor to consider, since the quality of the file would seem to be the governing factor. However, the smallest sensors on a D-SLR are 18mm x 13.5mm, compared to the format of a traditional 35mm film camera, which is 24mm x 36mm. In this case, a 50mm lens, which on a film camera would constitute a standard lens, becomes a 100mm short telephoto.

This initially may seem to be an advantage, since you won't need long telephotos. But there is an issue with wide angles. A 15mm is an extreme wide angle with a 35mm film camera. With a small sensor, this is only a slightly wide angle, equivalent to a 30mm lens on a 35mm film camera in some digital cameras. Some manufacturers are addressing this and are beginning to produce special lenses specifically for digital bodies, such as the extraordinary Olympus Zuiko Digital ED 7-14mm f/4.0.

Different sensors have different attributes. Speak with other photographers about the quality of the images their cameras make and decide which you prefer.

TIP:

Here are a few places where you can visit many different camera manufacturers to learn about their cameras and equipment when you are researching sensors:

- Your local camera shop
- Photo Plus Expo, NYC, in October
- B & H Photo, NYC
- Photo Marketing Association Sneak Peek, in Florida in February
- www.dpreview.com

THE EFFECT OF SENSOR SIZE ON FOCAL LENGTH		
SENSOR SIZE		
24 x 36mm sensor Canon DS cameras 35mm film cameras	23.7 x 15.7mm sensor Nikon digital cameras	18 x 13.5mm sensor Olympus digital cameras
Actual Focal Length of Lens	35mm Equivalent Focal Length	35mm Equivalent Focal Length
14mm	21mm	28mm
24mm	36mm	48mm
35mm	52.5mm	70mm
50mm	75mm	100mm
100mm	150mm	200mm
300mm	450mm	600mm

Think about how you want to use lenses before you buy them.

WHAT TYPE OF LENS DO I NEED?

Now that you've bought your new D-SLR camera and are starting to come to terms with its operation, you might well be thinking about buying another lens.

When you purchased the camera it more than likely came with a zoom lens; something like a 28-80mm is the usual offering with new cameras, and this is a good lens with which to start.

But if you feel like you need something different, what do you look for? There are many types of lenses available, and to know which lens you should buy you need to know what you want to photograph with it. Lenses come in all shapes and sizes—a bit like a family—and they all have specific characteristics. Here is a breakdown of the different lens types and some of their applications.

There are three basic types of lenses:
- wide-angle
- standard
- telephoto

A lens belongs in a particular category based on its focal length.
- 50mm is the traditional focal length for a standard lens.
- Less than 50mm is considered a wide-angle lens.
- Greater than 50mm is considered to be a telephoto lens.
- Lenses beyond about 300mm are known as super telephoto

Standard Lenses

The standard lens (50mm) gives an angle of view of between 45 and 55 degrees, which is approximately the same as that of the human eye. Because of this it produces an image with a natural look; it photographs things in a manner that is as near as possible to the way we would see the same subject.

Because these lenses photograph subjects in the same way as we see things, they produce pictures that tend to look "normal" and, thus, have a wide application as a general-purpose lens.

Wide-Angle Lenses

With so many wide-angle lenses available ranging in focal lengths from 8mm to 35mm, the choice is huge and can be quite confusing. Basically, the wider the lens, the more specialized its use.

Super-wide lenses can distort the image and have a limited, if valuable, use. I would suggest that either a 24mm or a 28mm lens—the more common types of wide-angle—would be a good choice to purchase as a starter lens.

The 35mm wide-angle lens is often used as a standard lens because although the focal length is slightly less than the 50mm

Photographer Carsten Peter moved in close to this camel in the Sahara Desert with a fisheye wide-angle lens on his camera.

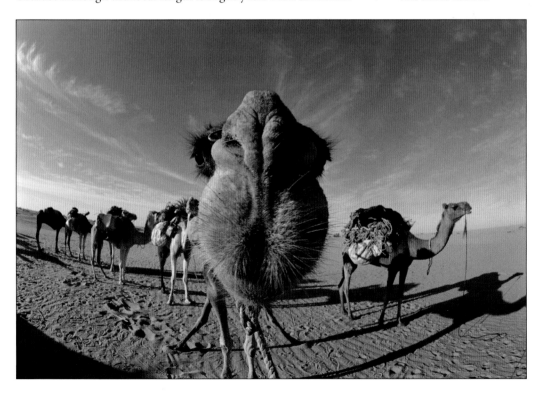

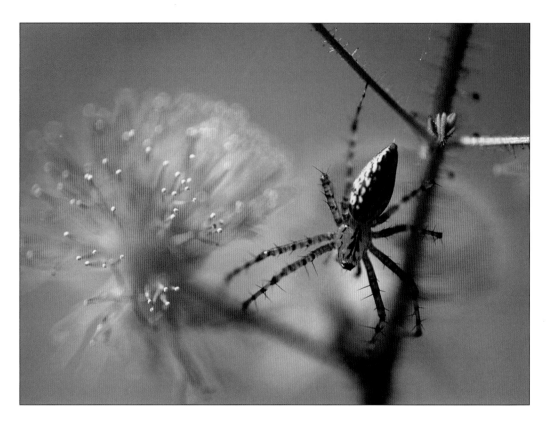

Joel Sartore used a long lens to capture this spider hanging onto a mimosa stalk in the Pantanal, in South America.

of the standard lens, the difference is not huge. It can give the photographer the advantage of extra depth of field, a real benefit for news photographers, who shoot where space is often limited and for whom the more of the picture in focus, the better.

Because the angle of view of the wide-angle lens is much greater than that of the telephoto or standard lens, it's obviously the lens to use where there's limited space or the subject is large. Taking the family picture at Christmas when 30 of your relatives have arrived at your place would be impossible unless you lived in a very large house—or you had a wide-angle lens to take the shot.

Landscape photography is another area where wide-angle lenses are very useful. Using a wide-angle offers the ability to get close to your main subject to make it more prominent in the frame while keeping as much of the background in focus as you want.

Telephoto Lenses

We all know that a long telephoto lens can bring the subject right into the heart of the picture; objects that appear to be miles away when shot with a standard lens appear to be only feet in front of the photographer when shot with a telephoto lens. This

is why all the photographers at a football match or soccer game use telephoto lenses to capture the action.

Telephoto lenses have many more uses than just sports photography. The narrow angle of acceptance and the extra magnification allow the photographer to foreshorten the distance between himself and the point of interest of the picture. The lens allows you to capture a smaller portion of the scene so that your subject is not lost. This effect makes telephoto lenses particularly suited to landscape photography when you are trying to isolate details in a rather large area.

The longer focal length of a telephoto lens means that it has much less depth of field than a wide-angle or even a standard lens. This effect can be used to "drop out" or blur backgrounds to create a sharp, clear subject without the confusion of a busy background.

You must take this factor into account when using a telephoto to shoot landscape pictures, where it's often best to have as much of the picture in focus as possible. This often requires long shutter speeds and small apertures to create greater depth of field. A tripod will be necessary to hold the camera perfectly still.

A common diuca finch perched on Joel Sartore's lens while he was working in Chile.

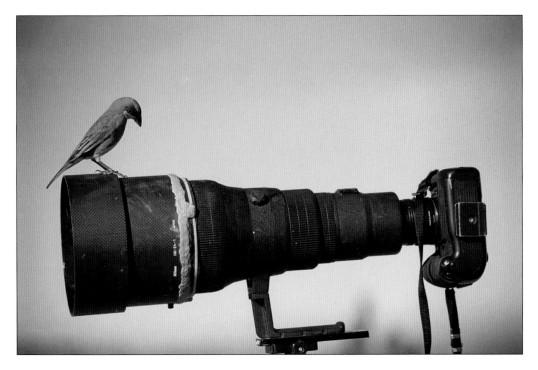

Preceding pages: A fisheye lens can offer a chance to make unusual images.

A short telephoto lens—90mm, 110mm, or 135mm- is ideal for portraiture. It allows the photographer to maintain a comfortable distance from the subject while still allowing use of the limited depth of field to avoid confusing backgrounds.

Zoom Lens or Fixed Focal Length

As zoom lenses have become better, their popularity has grown. A few years ago a zoom lens could not match the quality of a fixed focal-length lens and was seen as a cheaper alternative to buying a number of fixed focal-length lenses.

This situation has rapidly changed, and some of the sharpest and fastest lenses now available are zoom lenses. The zoom lens allows the photographer to carry less equipment, since a single zoom lens will often replace two or even three normal lenses. A top-quality zoom lens is expensive and will often cost the equivalent of the two or three fixed-focal-length lenses it replaces.

If you have a choice between a constant-aperture zoom lens versus a variable-aperture zoom lens, choose the constant one. The reason is simple: Your aperture remains the same as you zoom, so your exposure can remain the same. With a variable zoom lens, the aperture can close down as much as one f-stop. For example, if you zoom from 28mm to 135mm and you started with f/3.5, you may end up with f/5.6. The way to combat this is to stop down anyway so you are not affected. Or better yet, spend more money for a constant-aperture zoom lens.

Macro Lenses

If you have a desire to photograph insects, close-ups of flowers, or any other small objects, then the macro lens might be what you need.

Usually available in 35mm, 50 or 60mm, or 100 or 105mm focal lengths, these lenses are similar to normal lenses in that they can focus to infinity, but they are designed to focus at extremely short distances. They are used for extreme close-up photography.

Coins, stamps, or any other small objects are ideal subjects for a macro lens. And because it can focus at a distance as well, the macro lens can also be used as a standard lens. The addition of extension rings that fit between the lens and the camera can make this lens capable of even more extreme close-up photography.

Finally, there are macro zoom lenses in this category that can produce an image of an object at a 1:3 ratio. Sometimes these lenses can even give life-size reproductions on the film or on the sensor.

Fisheye Lenses

Called a fisheye lens because it produces images that look like a fish's eye, this lens is extremely wide angle. It can produce an angle of view of 180 degrees and either a circular or a full-frame image that is very distorted at the edges. Because this is the only type of image it can produce, it is obviously limited in use.

Shift Lenses

Shift lenses are expensive, but if you like photographing tall buildings, you'll find a use for this type of lens.

Using a standard lens, the camera has to be tilted backward to fit the top of the building into the frame. This produces an image in which the building appears to be falling backward, and all the

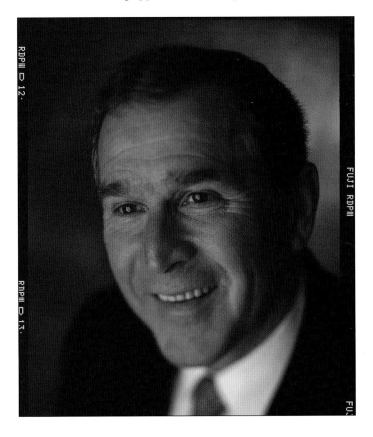

Photographer Charlie Archambault made this portrait of President George Bush with a Mamiya RZ67 with a 110mm f/2.8 mounted on a tilt-shift adapter. He used Fujichrome Provia film rated at ISO 100. Indoors, he set the exposure at f/5.6 and 40 seconds handheld. The lighting was a large soft box mounted on a Dynalite strobe.

TIP:

When researching equipment, visit your local camera store first. Read reviews in photography magazines and on specialized websites. Ask your local newspaper's photographer for guidance. Try the camera your friend likes. Each source can bring you closer to an informed, solid choice that's appropriate for you.

vertical lines converge at the top of the picture, a consequence of the film or image-sensor plane not being kept parallel to the subject.

A shift lens allows the camera to remain straight and parallel to the building and uses moving front lens elements to enable the entire building to be in the frame. You do this by sliding up the front portion of the lens to include the top of the building so you don't have to point the camera up. The use of a shift lens will stop the vertical lines from coming together while still giving the impression of looking up at the building.

The tilt-shift lens has been used by tabletop photographers and portraitists alike lately to create interesting images. The tilt feature allows photographers to control sharpness and blur in unexpected ways.

Split Field Lens

This lens consists of a semicircular close-up lens in a rotating mount that attaches to the front of a lens and allows it to produce images in which the close-up foreground image and distant objects in the background are both in sharp focus.

Teleconverters

Teleconverters are clever optical devices that fit between the camera body and the lens and increase the effective focal length of the lens. Most teleconverters come in either a 1.4x or a 2x version. A 2x converter will turn a 200mm lens into a 400mm lens, although it will also reduce maximum aperture, and thus the light reaching the film, by two stops. A 1.4x converter will reduce maximum aperture by one stop, necessitating slower shutter speeds or a higher ISO setting. This is a good option for expanding your range of telephoto lenses, but be sure to buy the best teleconverter that you can afford.

PERSPECTIVE

The control of perspective is the ability to use your camera and lenses to control the relationship between the background and foreground of your pictures.

CHECKLIST FOR D-SLR PHOTOGRAPHY

The following is a checklist to help you remember all the technical aspects of your photography that need to be kept in mind. Your new camera is a highly sophisticated piece of equipment; this list should help you avoid simple mistakes while you become familiar with it.

- Have you charged your batteries? Before every outing, charge your battery. Most digital cameras have rechargeable batteries. In the early days you will be checking almost every image on the LCD screen on the back of your camera, and this is what runs the camera battery down more than anything else. In fact, to start with, buy a spare battery.

- Have you formatted your memory card? Before every shoot, and after you download or print your pictures, always, always format your memory card. As with all technical equipment, failure is always possible. You can lose pictures. However, you can minimize this risk with good housekeeping. Format your card in the camera's menu before every use and after you confirm you have downloaded your pictures.

- Do you have enough memory in your cards? One of the plus points of the pre-digital era was the ability to pick up a new roll of film in almost every corner shop. The cards included with most digital cameras today have a very small capacity for pictures. You will inevitably need to purchase additional, more spacious cards. Make sure you buy enough for that trip to the Caribbean or some other exotic location like Alaska where you may not be able to find suitable cards while you're traveling.

- Have you cleaned your image sensor? If you like to change lenses often, there is a chance that dust attracted to your image sensor will result in black specks or hairs appearing on your image files. This is especially likely if you forget to turn off your camera before changing the lens. If the sensor is not cleaned carefully, it can be damaged. Check the manufacturer's website to see what they recommend. One way to avoid having to clean the sensor all the time is to keep the lens mount facing down when changing lenses. This way, any airborne debris is less likely to settle on the sensor.

- Have you set your sensor sensitivity (ISO)? It's best to use as low an ISO as possible because higher ISO settings produce more "noise" (undesirable visible grain). The general rule is: The lower the ISO, the better the quality (ifthe shooting circumstances permit it).

- Have you set your color/white balance? We will be going into this later in more depth, but at this stage make sure that your camera is set on auto-white balance, as in most cases this will produce an acceptable result.

- Have you set the right file type—JPEG, RAW, or TIFF? We'll be addressing this subject later on. For now, make sure your camera is set to produce the largest/highest quality JPEG possible. It is absolutely pointless to shoot on smaller JPEG settings, since doing so defeats the purpose of using a high-quality camera.

Using Color Negative, Digital, and Video to Achieve his Goals

Amotorbike barely visible in the early morning mist in Vietnam. A monk wrapped languorously in saffron cloth walking down an empty stone column-lined corridor. A young Taiwanese girl gazing toward a pagoda in a distant lake. Feet. Pajamas. Shanghai.

These are the images you find in Justin Guariglia's portfolio before he shows you his four-minute video installation of a man practicing the ancient art of Shaolin kung fu, all set in a velvet-black horizonless plane that forces you to fall into the scene.

Guariglia found photography after an argument. He was studying the Chinese language at the Capital Normal University in Beijing, and his tutor insisted he must learn the language through the tedium of writing Chinese characters. Guariglia just wanted to learn to speak. He went into the streets with a camera and introduced himself to passersby so they would speak to him and he could speak back.

Soon he was hooked on photography. He studied the work of his mentors: Greg Girard, John Stanmeyer, and James Nachtwey. His first published picture was of the 1999 elections in Jakarta, Indonesia, purchased by the *Boston Globe.* "Later someone opened fire on the crowd and I realized, *I'm done with this,*" he says.

He was not done with photography, but with war. Guariglia began by showing his work to the editors at Contact Press Images and as many magazine editors in New York as he could reach.

"For a while my entire portfolio was pictures made with Kodak SW (slightly warm) film stock," says Guariglia, who describes the incredible lengths of experimentation over six years he practiced with film, light, and exposure to create a personal style with which he felt comfortable. "Then I switched to Fuji. I guess I outgrew the colors of the SW. I had learned the boundaries of the film. I used it in very low light with just enough exposure."

While some magazines still work with stories shot entirely on large-format color negative film, Guariglia is experimenting now with digital as well. "You can go in so many different directions with digital," says Guariglia. "Tint. Temperature. There are a million

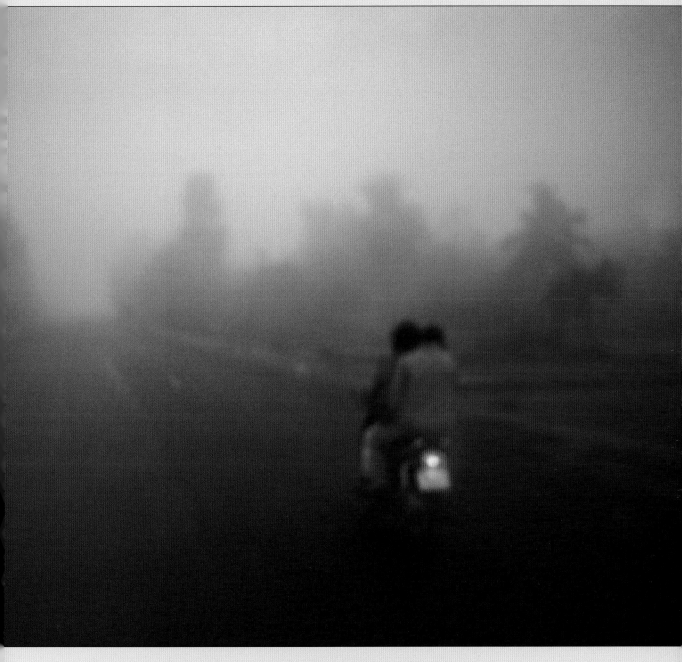

Justin Guariglia made many photographs of this couple early one foggy morning in Vietnam as he sat in the front of a bus moving alongside them.

different variables to think about. It can be very confusing."

"With film," he continues," you have the tint. It's fixed. But now you have RAW files and you can make the pictures look pretty. Now I need to make a decision: How is this whole body of work going to look?"

To see more of his work, go to *www.guariglia.com.*

When you're using a wide-angle lens, the background appears much farther away from your subject than it actually is. With a standard lens, the background appears the same distance away as it does with the naked eye. When using a telephoto lens, the background appears closer. It should also be mentioned that on a wide-angle lens your angle of acceptance is much greater than on a standard or telephoto lens where your angle of acceptance is much less. This means that with a wide-angle lens, you can sometimes surprise yourself with how much you've included in your picture. On the other hand, using a telephoto lens, your subject is more prominent and less of the background is included within your frame.

So, by varying your lenses, and therefore your perspective, you can use the background to complement your pictures or isolate your subject as you require. As I mentioned in an earlier chapter, experiment by shooting a variety of pictures of the same subject with different focal length lenses to help you understand how different focal lengths affect perspective. Remember to move backward and forward in relation to your subject to keep it the same size in all the frames and at all the different focal lengths.

EXPOSING YOUR PICTURES

First, I will define the three basic photographic terms you will need to know. Then we can learn in greater detail about each one.

Exposure

Exposure is the amount of light, controlled by aperture and shutter speed, that reaches the image sensor.

F-stops

F-stops are the measure of the size of the opening, or aperture, in the lens. Remember, the larger the f-stop number, the smaller the aperture. The smaller the f-stop number, the larger the aperture and the more light the lens will let through to the image sensor.

Shutter Speeds

Shutter speed is the measure of the duration or length of time that the shutter stays open. The longer the shutter stays open, the more light will be allowed to reach the image sensor. Faster shutter speeds "freeze" the action and often require more light and a

A perfect exposure looks like a mountain range in the histogram.

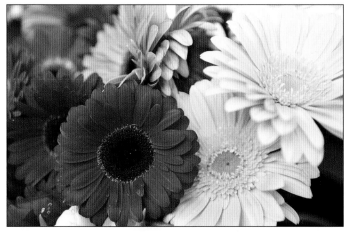

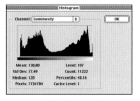

An overexposed image appears as a valley in the histogram.

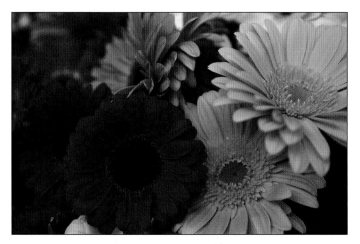

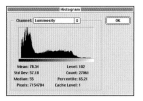

An underexposed image has extreme peaks on one side of the histogram.

larger aperture (smaller f-stop number). Slower shutter speeds enable pictures to be taken in lower light with a smaller aperture (larger f-stop number).

Before we can achieve the correct exposure it is important to know what a correctly exposed image looks like. A correctly exposed digital picture is a file that shows a full range of tones, from deep shadows to bright highlights, with detail across the entire image. You should see some detail in the dark shadow areas while at the same time retaining detail in the brighter highlight areas. Providing you get this, you can decide afterwards whether you actually need the full tonal range to appear when you print the image. If you don't ensure that you have the full tonal range from the start, there is little you can do about it later.

This last point is more crucial when shooting in JPEG format. When shooting in RAW mode, getting the right exposure is a more forgiving process than it is when you shoot color negative film because you can correct the color in your computer later.

CONTROLLING LIGHT

To register a fully-toned image on your digital camera sensor, you must allow the correct amount of light to reach the digital sensor. The three factors that control the path of light are sensor sensitivity (ISO), shutter speed, and aperture.

In the diagram below, each combination of lens aperture and shutter speed produces the same exposure, or lets the same amount of light into the camera.

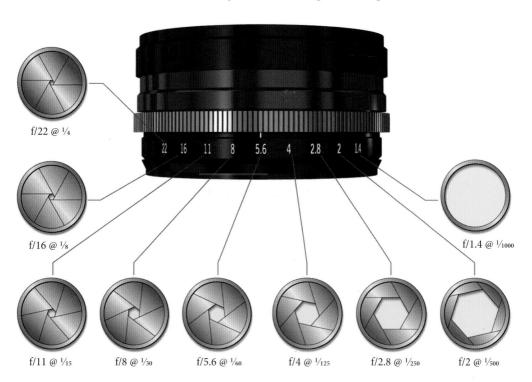

f/22 @ ¼

f/16 @ ⅛

f/1.4 @ 1/1000

f/11 @ 1/15 f/8 @ 1/30 f/5.6 @ 1/60 f/4 @ 1/125 f/2.8 @ 1/250 f/2 @ 1/500

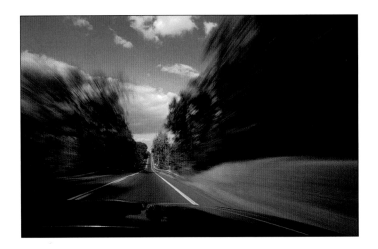

On Route 1 in Massachusetts, Bruce Dale captured the movement of the car in his photograph by setting a fairly slow shutter speed, which caused the trees to blur.

Sensor Sensitivity

When film was dominant, exposure was an incredibly important subject. The digital era has brought us light-years forward because we can now see the result of our settings instantly. Just as with film cameras, the D-SLR takes into account the brightness of the subject, the contrast, the color of the picture, and the area focused. When set for automatic exposure, the camera calculates all this and much more instantly.

I guess you'll have realized by now that I'm a fan of automatic exposure, providing that you review your pictures on the LCD screen on the back of your digital camera as you shoot. If you are a newcomer to photography, there are many other different aspects that have to be considered before you take each picture. How do I frame the picture? Is it in focus? What is the background like? Until all these elements start to become second nature, it's wise to leave your camera on auto-exposure. This will give you one less thing to worry about while you concentrate on all the others. Then slowly, as you become more technically proficient and have learned to hold the camera the right way, you'll start to appreciate the small adjustments that are possible on your camera to perfect exposure.

On most D-SLRs and high-end compact digital cameras, you have the option of overriding your automatic exposure and setting the exposure manually. This is where we begin to play with the camera's settings. We will learn not only to expose correctly but to overexpose and underexpose deliberately.

Film photography requires you to change films if you want

to change the ISO setting. Digital photography, on the other hand, allows you to shoot a group of pictures, or even a single picture, at one ISO setting, then change the ISO setting on the same memory card and keep shooting. You can change the ISO as often as you like.

Shutter speeds

Here are some basic tips about shutter speeds to begin:

- To stop a racing car, or someone riding a bicycle, start with 1/1000 second.
- For everyday pictures such as portraits and views, use speeds of 1/60 second to 1/250 second.
- If the light is really bad, try not to go below 1/60 second. If you must, hold your camera very still and don't expect to freeze any action.

Aperture (f-stop)

Here are some basic tips about f-stops:

- As a general rule, f/5.6 gives a little bit of depth of field, provided the lens focal length isn't too long, and is still wide enough to enable high shutter speeds.
- If it gets really dark, don't be afraid to open your aperture to its maximum aperture, for example, f/2.
- If you need loads of depth of field, or you want a slow shutter speed, stop down to f/11 (when using a short lens) or f/16.

If your picture looks a little bit lighter or darker than it should, take another, having adjusted the exposure. You can make your image lighter by increasing your exposure, or darker by decreasing it.

EXPOSURE COMPENSATION SETTING

If you find that your images consistently look better by underexposing by one stop, or by overexposing by half a stop, then use the exposure compensation setting to build this factor into the camera's light metering. This facility enables you to under- or overexpose by up to three f-stops or full shutter speeds. This is normally indicated on your camera by a scale from +3 to -3 with either half or third stop increments. Once you set it, the

TIP:

CAUTION!

Because the smaller f-stop lets in less light to achieve the correct exposure, you will need to set a slower shutter speed. Camera movement is something you have to watch out for here.

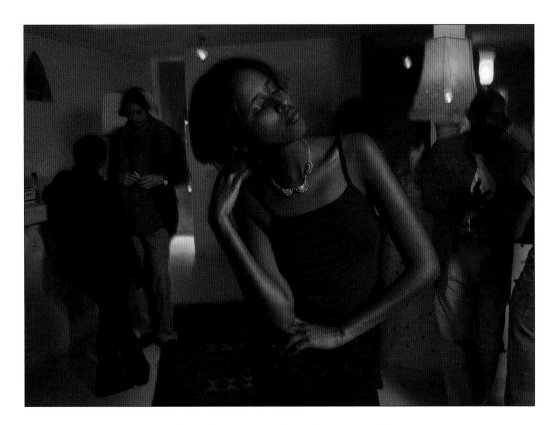

camera will usually maintain the adjustment until you change it. Most professional photographers I know use the exposure compensation feature to fine-tune the meter of their camera.

Take lots of different versions of each picture. When you have time and the subject permits, vary your exposures so you don't miss an important shot. Check the images on your computer screen and delete all the bad ones before you show anyone your work.

Low lighting and slight movement are assets in David Alan Harvey's portrait of Khadija Hassan Kanyare shot in Nairobi in 2004.

Automatic Exposure (AE) Modes

On most digital cameras you'll find a variety of exposure modes, typically referred to as:

- aperture priority AE(Av)
- shutter priority AE(Tv)
- program AE (P)
- manual (M)

Aperture Priority

The aperture priority mode enables you to set the f-stop (aperture) and the camera will then adjust the shutter speed to give the correct exposure. This mode is particularly useful in low-light

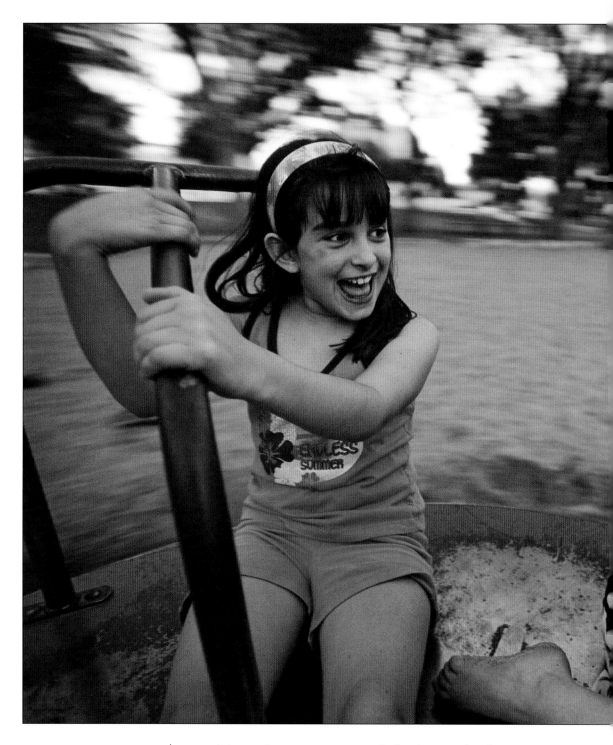

conditions, where you want to set the brightest, widest f-stop in order to get the highest shutter speed and the minimum amount of movement. If more depth of field is needed, you can use a small f-stop to get as much of your picture in focus as possible.

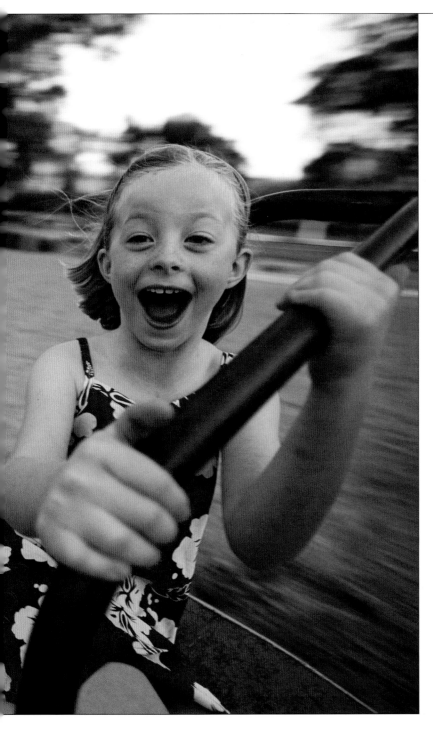

Joel Sartore positioned himself in the center of the merry-go-round and set the camera to a slower shutter speed. Because he was moving at the same speed as the girls, they appeared sharp against a blurred background.

Shutter Priority

Using the shutter priority mode, you can set the shutter speed, and the camera selects the f-stop (aperture) to give the correct exposure. This can be especially useful when you're shooting

This example shows how spot metering can improve a difficult lighting situation.

action pictures and you want to freeze the motion by setting a high shutter speed. By the same token, if you were photographing a waterfall and you wanted the water to blur, you could set a slow shutter speed and the aperture would adjust accordingly. It goes without saying that both modes assume you have enough light to expose your pictures within the range of shutter speeds and apertures you're using.

Program

This setting leaves all the decision-making to the camera. The camera sets a combination of shutter speed and aperture so you don't have to think about exposure at all. In some cameras this may be set up as subject programs such as "portrait," "sports," or "landscape." Be careful though. If there's not enough (or too much) light to achieve the effect you're after, your camera won't be able to work miracles. Even on this setting, check the LCD to make sure you are getting the images you want. And remember that you can still use autoexposure compensation to override the camera's decision.

Manual

This mode enables you to manually set the shutter speed and the aperture independently of each other, referring either to the camera's built-in meter or to a handheld meter. Professionals tend to use manual exposure and handheld light meters. This allows them to take multiple meter readings in various points of the subject frame. In this method the photographer has total control over the pictorial effects that various shutter speed and aperture combinations can achieve. When film was dominant, this method tended to be the exclusive realm of the professional

or the advanced amateur. Today, the immediate feedback of digital photography allows you to shoot a test frame, have a look, make a slight adjustment, have another little look, and get your exposure right.

Most advanced D-SLR cameras have an autobracket setting. This clever little feature sets the camera to take three pictures automatically, in rapid succession: one at the "correct exposure," one overexposed, and one underexposed. I find this very useful when working quickly because I know it will give me a choice of exposures after the fact. By setting the camera to shoot one picture at the "correct" exposure—as the camera sees it—and two frames perhaps one f-stop either side, I'll always end up with one frame that I consider to be the perfect exposure. You can change the increments of the brackets so that they are 1/3, 1/2, or 2/3 stop to either side of the "correct" exposure, depending on the camera model. On most cameras this facility works on all the automatic settings and in manual mode.

METERING PATTERNS

Most advanced D-SLR cameras, along with the automatic exposure modes, have some additional settings that can affect your exposure. The default setting on most D-SLR cameras and point-and-shoot-cameras is multisegment metering. (Nikon calls it matrix metering, Canon, evaluative.) This method of metering divides the image into a number of smaller areas in which the microprocessors of the camera meter the light. The camera then combines these readings with the aperture and shutter speed and produces a near perfect result in almost all cases. I would suggest you leave your camera set on matrix/evaluative metering and switch temporarily to spot metering when the situation calls for it.

Spot Metering

Spot metering is a really good setting when shooting manually. The reading is taken from a very small section in the center of the frame, sometimes as little as one percent of the total image. This is very useful, for instance, if you're sitting in a separate light from the person you wish to photograph. Say you are sitting outside a cafe in the shade of an umbrella. You see your friend has arrived and she is standing in a shaft of sunlight. In order to

For the past 30 years, photographer Ken Garrett has special-ized in photographing stories about ancient life for maga-zines, museums, and books. One of his epic assignments was a ten-part series called "Dawn of Humans," which appeared in ten issues of *National Geographic* magazine magazine from 1995 through 2000. Digital photography, however, was not a frontier he wished to cross until 2004, when he bought a six-megapixel Nikon D70 D-SLR.

"I didn't want to get into it until it reached critical mass," admit-ted Garrett, who watched the technology change every six months or so, outdating and devaluing the previous generation of expensive cameras quickly. His trip to King Tut's tomb converted him entirely.

Garrett's assignment was to photograph the four walls of the tomb. The photographs would help exhibit designers re-create Tut's tomb in a life-size display. He was also to photograph Zahi Hawass, head of Egypt's Supreme Council of Antiquities, who would be present when a CT scanner would scan the mummy from head-to-toe to render a 3-D computer model of Tut as he was 3,300 years ago. Garrett had a 35mm Nikon F6, loaded with Fujichrome Provia 100, and his Nikon D70 D-SLR. "The room with the scanner in it was lit with fluorescent lights," recalled Garrett. "I didn't have fluorescent filters with me, so I changed the white bal-ance on the D70 to fluorescent, reset the ISO, and used available light. It came out great."

The same happened 30 feet below in the tombs. With a few well-placed strobes, Garrett photographed the walls of the tomb with the D70 and there was enough detail to create the exhibition. By the end of 2005, Garrett had sold his film cameras and added the Nikon D2X to his digital collection.

His digital gear includes an Apple PowerMac G4 laptop with a 15-inch screen, four portable hard drives, two Lexar card readers, two batteries for each camera, PhotoMechanic software to organize the RAW files and make JPEGs, and, on long trips, a small $700 Honda generator that weighs about 20 pounds. "After 9-11, you can't take anything on the plane that uses gas or oil, so I usually leave the generator behind with whomever I have been working."

An Egyptian tomb isn't the only place where Garrett has ben-efitted from the virtues of digital. "I used to worry about the mercury

When photographing the removal of the mummy of King Tut, Ken Garrett chose his digital camera over his film camera.

vapor lights in my son's gym when he played basketball," said Garrett, cupping his hands as if holding a camera. "But now I don't have to. The digital pictures look great."

To see Garrett's work, go to *www.kennethgarrett.com.*

expose a picture of her correctly, use spot metering. You need to set the camera to expose for the sunlight around her, not the shade around you.

Center-weighted Metering

Center-weighted metering is more biased toward the center of the frame. Less attention is paid to the corners and edges. Personally, I don't have a use for this function except on some cameras in which automatic flash is more reliable on this setting. Other photographers like it because this kind of metering tends to underexpose the photograph, which worked well with slide film once and, likewise, digital. As always, experiment to find the best combination of settings for your camera.

Handheld Meter

This is an exotic accessory for the digital photographer and is really only necessary for a professional working with additional lighting or strobes. A handheld meter today is often a combination of an exposure meter and a flash meter, and is generally used as an incident light meter. This means that the meter measures the light falling on the subject rather than the light reflected off the subject, the way your camera does its metering. This highly accurate and precise instrument is used by holding the meter in front of the subject with its white dome pointing towards your camera. You take the reading and transfer these settings to your camera while your camera is set in the manual mode. This system does not take into account the color or density of your subject and produces settings suitable for a mid-toned, average subject. The main use for this meter in the digital world is when using supplementary strobes/flashes. It has the ability to measure the brightness/intensity of a non-dedicated studio flash, a capability that is not found in the meter in the camera. This tool is essential when setting up complicated shots with studio-type lighting.

UNDERSTANDING HISTOGRAMS

As you've heard before, one of the best things about digital cameras is the ability to review your images on the back of your camera. When I harp on about checking the exposure on your LCD screen, sometimes I hear this: "You silly old fool.

Stephen Alvarez used his spot meter while photographing a man standing in front of a skylit cave waterfall at Stephens Gap, Alabama.

Using a Mamiya RZ67 camera fitted with a 110mm lens and color negative film, Justin Guariglia set the lens aperture at f/2.8 to create shallow depth of field, which softened what might otherwise have been a distracting background. The shutter was set at 1/500 second for this portrait.

In the sunlight I can hardly see the screen. How can I possibly judge my exposure?" Most D-SLRs have the facility to display a histogram on the camera LCD screen. Whereas 99 percent of photographers think a histogram is some sort of family tree, it is in fact a fairly simple bar chart. The chart illustrates how the pixels in an image are distributed by graphing the number of pixels at each color intensity level. This shows you whether the image contains enough detail in the shadows (shown on the left side of the histogram), mid-tones (shown in the middle), and highlights (shown on the right side) to create good overall exposure.

As you get used to viewing histograms, you'll find them a great tool for checking and double-checking your photographs, especially in adverse lighting conditions. Knowing what sort of histogram a well-exposed image produces eliminates the chances of being fooled by an LCD screen that is not set to the correct brightness.

If the histogram looks all right, it doesn't matter whether the image looks light or dark on the screen. The truth is in the histogram.

A good exercise is to take some pictures of a subject with a full range of colors and tones. Set your camera to manual exposure and expose one frame as the meter suggests. Then take the same picture in a range of frames at half or one-third stop increments, from three stops under to three stops over. Look at the histograms of these pictures to learn how to read and understand them, taking into account how the chart varies with under- and overexposure. Very, very crudely speaking— and I may get criticized for simplifying to this degree– you're looking for a mountain range in your histogram window that starts at one edge, finishes at the other edge, and reaches toward the top of the histogram frame. Obviously, since every picture has different content, your mountain ranges will vary.

AUTOFOCUS

Most beginning photographers leave their autofocus function on the factory-default setting of "on all the time," like most of the other settings on their digital cameras.

To start with, and as you learn, this is just where you should leave this setting. Only when you've mastered the other functions and facilities of your camera should you begin to tinker with these options.

Like most settings on your D-SLR, autofocus should really be referred to as automated, rather than automatic. There are many options within the menus of your camera to fine-tune the focusing. I can't stress enough the importance of gradually learning how to use these and all the functions of your camera as you progress. Using this automated (as opposed to manual) mode does not in any way mean that you're taking the easy option. If anything, you're proving that you are a master of technology and that all that hard-earned cash spent on your new advanced digital camera has not been wasted.

Perhaps the first autofocus function found on high-end cameras that you should learn to use right from the start is commonly known as "one-shot" or "single servo." Use this in cases where you want to compose your picture when the subject is off-center. In your viewfinder there will be either cross hairs or AF (autofocus) points to signify the point on which the camera focuses. Point your camera directly at the subject so that the AF point is aimed at the part of your picture that you wish to be the primary point of

Because Richard Olsenius wanted to hold detail in the trees on this bright wintry day in Wyoming, he set the camera at f/11 and 1/250 second using Kodachrome.

focus. By using this one-shot/single servo mode, the autofocus is activated as you initially depress the shutter. It will then lock into place as the camera focuses on the point you've chosen. Holding down the button halfway to hold the focus, you may then recompose your picture perfectly, allowing better composition. Be aware this feature is totally unsuitable for moving subjects, because once locked in, the focus does not move until you press the shutter. Every picture you shoot will, of course, need refocusing.

There are some scenes that are unreliable in the autofocus function. They are:
- Snowy scenes
- Wide-open blue skies
- Very low light
- Extremely backlit or reflective subjects

When the camera is unable to focus on any point against the snow or blue sky, for example, set the one-shot function, lock the focus on something a similar distance from the primary subject, and then recompose your picture.

Another function, which in use is in some way similar to one-shot, is commonly known as back-button focusing. In this mode,

you enable one of the function buttons on the back of your D-SLR to activate the focusing. So before you shoot, and in fact while you shoot, you can enable and disable the focusing at will. On some advanced D-SLRs when you combine this with the ability to manually select one of the many focal points, you're using the camera's autofocus system to its full potential.

Once you've started to master your camera, there are many more settings that you can learn to use within the autofocus menus. These vary a lot from manufacturer to manufacturer and take into account many different factors, sometimes even the type of picture and color of the intended photograph. So you'll need to refer to your camera instruction manual, which I'm absolutely sure you'll have taken the time to read by now. No doubt you'll need to read it again and again!

The only occasion on which I would recommend manual focus is when you are photographing through netting or similar screening. When photographing soccer, for example, shooting from behind the goal through the netting can give a dynamic and graphic effect. This situation will usually foil all autofocus cameras. Switch off your autofocus when taking this kind of shot. This would apply equally to taking pictures of animals behind cages at the zoo.

DEPTH OF FIELD

Depth of field is the distance between the nearest and the farthest objects in an image judged to be in acceptable focus. The focal length and the aperture of the lens you're using and your focused distance govern your depth of field. The longer the focal length, the less the depth of field. The shorter the focal length, the more depth of field. The smaller the aperture, the greater the depth of field, other things being equal. In layman's terms, telephoto lenses have less depth of field than wide-angle lenses, and a more powerful telephoto lens gives less depth of field. It also follows that extremely wide-angle lenses provide the most depth of field.

When you see a beautiful landscape photograph hanging on a wall in a gallery, it

Bob Martin climbed high into the stands to get a cleaner background for his picture.

TIP:

The sunny f/16 Rule:

If you are attempting to make a landscape photograph without a tripod, inverse the ISO in selecting your shutter speed, i.e., with a 200 ISO you would select 1/200 second at f/16.

Preceding pages: Sarah Leen photographed the spot near Alaska's border where the Stikine River meets the Iskut.

was very likely was shot on a very small aperture (large f/stop number) to get as much depth of field as possible. Even on a sunny day, using the smallest aperture may require a rather long shutter speed and may therefore require the use of a tripod.

This can create a dilemma. For instance, you would ideally want to use a high shutter speed for shooting action photographs. Yet the subject is traveling at speed, so a small aperture would give you more of the subject in focus, thus making it easier to get the picture sharp. Some people would just use a higher sensitivity for their sensor, thus enabling higher shutter speeds and lower apertures. But this comes at a price—and perhaps the most expensive price when it comes to photography—the all-important quality of the image. The sad fact is that as you increase the sensitivity of your sensor, the image quality can decrease. (Camera manufacturers are improving greatly in their high-ISO performance as we write this.)

So now it's decision time: You can't have everything, so you have to choose what is most important to you. Even on the brightest day of the year, with the sun on the subject, if using 100 ISO, your exposure at 1/1000 second would be f/5.6. This would not give you much depth of field on a long telephoto lens. And if you were photographing floodlit football, you would really be in trouble. A typical exposure setting would be 1/500 second at f/2.8 at 800 ISO.

When you would like as much depth of field as possible, remember that the depth of field extends farther behind the point of focus than in front of it. If you focus one third into your subject, you will know that the depth of field will extend by equal amounts before and after the point of focus. Some lenses have depth-of-field markings showing approximately how much depth of field is available at a given aperture. To give a crude example: with a 20mm lens set to f/11 and the focus set approximately 5 feet into the picture, your depth of field will extend from 2 1/2 feet to infinity. Using a 400mm lens set at f/4, your depth of field with the focus set at approximately 30 feet would be less than a foot.

Remember that you can use depth of field creatively by using a wide-open aperture to isolate your subject. Your subject will stand out sharply as the rest of the image surrounding it remains pleasantly blurred. Equally, with a wide-angle lens and a small aperture, almost everything in your picture can be sharp, enabling you to fill the frame and isolate your subject in the foreground while keeping a sense of place with a sharp background. To sum up, the smaller the f-stop, the more depth of field you will get. But always remember to use a shutter speed that is suitable for your subject.

COMPOSITION

Unfortunately, when it comes to framing your pictures, there is no auto-composition button to come to your rescue, so this is one skill that you really will have to master.

This section is about developing an "eye" for a picture. Photography is about seeing something pictorial and recording it in an interesting and graphic way. If the subject doesn't have the content to begin with, you can't mysteriously add it. If the colors and shapes of the subject don't complement each other, guidelines will not help you. They are there to help you make the most of what you see and photograph. Unless you are constantly looking and thinking, you will not get great pictures.

To compose your pictures properly, in very simple terms, is to produce a pleasing picture. This is easily achieved in most cases. Sometimes it may be as simple as turning the camera vertically

Bob Sacha composed this picture on the Yangtze River in China in an unusual way.

to take the picture as opposed to the more commonly used landscape, or horizontal, format.

The important thing is to really think about your picture and not get too bogged down in technical details. This may sound hypocritical, as the bulk of this book deals with the technical

aspects of digital photography, but it's essential to understand that the technical side is there to enable you to express your creativity. Unless you fully grasp the basics of composition, no matter how technically advanced you become, your pictures will always be lacking.

To start with, be bold and fill the viewfinder with your subject. If the subject is predominantly upright, shoot the picture vertically. If your subject lends itself to a horizontal picture, shoot it in a landscape format. In the early days of your photography, when you review your pictures at the end of the day you will be surprised to find that the subjects are much smaller in the frame than you expected. You must make sure that when you look through the viewfinder you are looking at *everything that is in the viewfinder*. Take into account what's around your subject and ask yourself if it contributes to the picture you are trying to make.

One of the advantages of the compact digital camera, which is lacking on nearly all D-SLRs, is the ability to use the LCD screen on the rear of your camera as a viewfinder. I find that people tend to frame their pictures far better when using the LCD, because they tend to look at the whole picture. The LCD is so small that your eye cannot wander around the frame. When you're looking through a normal eye-level viewfinder, it's easier for your eyes to wander and, therefore, not consider the frame as a whole.

As you start to shoot more pictures and you become more accustomed to filling the frame, start making use of your zoom lens (which most digital cameras now come with) and zoom in on your subject. Don't be afraid to shoot, for example, an extreme close-up of your friend, or your baby, or a flower.

When you shoot close-up portraits, try experimenting with your framing. Your subject doesn't always have to be in the center of the frame and looking directly at

TIP:

Your virtual viewfinder:

A very good way of comprehending composition is to form a rectangular frame (your very own virtual viewfinder) with your hands by linking your index fingers to your thumbs. Hold your frame at arm's length for that telephoto look, or close to your face for the wide-angle effect. You will find that by eliminating the superfluous information from your view, you will see it more the way your camera will photograph it. This may sound absurd—after all, you can always look through your viewfinder—but just try it.

Sometimes unusual framing can reveal details better.

Chris Johns applied the rule of thirds to capture the glinting eye of a leopard in a dramatic way.

the camera. Perhaps when photographing, say, your daughter, it may be more pleasing to compose the picture with her on the left or right looking into the center of the picture. Now that you are beginning to frame your portraits, you have started to compose your pictures well.

Since the time of Leonardo da Vinci, budding artists have had the rule of thirds drummed into them at art school. I personally find rules extremely boring, but I grudgingly admit that this one is actually very useful to photographers.

Look through your viewfinder and mentally divide the screen into three horizontal and three vertical sections, like a tic-tac-toe grid. The points where the lines intersect are the places that your eye naturally seeks out when looking at a photograph. It's logical, therefore, that you should try to position your subject near one of these four focal points. When photographing a landscape, it's also good compositional practice to place the horizon or skyline on one of these imaginary lines. At this point we must also mention that it's important to keep your horizon straight. Failing to do so is the most common mistake when starting out. It's a real disappointment to see a photograph in which the skyline runs downhill.

Changing the angle from which you take a picture can hugely transform it. For small subjects, such as pets and babies, try to get down on their level. Lie down and look up at your one-year-old child's first steps for a far more interesting picture. A tight portrait of your bulldog asleep on the rug is far better photographed if you are lying down on the same level. Choosing a dynamic viewpoint can help your photography and accentuate your pictures. Don't be afraid to be radical and stand directly above the sleeping dog. This may or may not give a more interesting viewpoint; the point is to keep experimenting and looking to find the most dynamic picture.

I know I sound like Polly the parrot, but keep reviewing your images on the LCD screen on the back of your digital camera. A good tip for cameras with an LCD screen that can be used as a viewfinder—if it's the sort with a hinged, adjustable screen—is to hold the camera on the floor or above your head to gain a more dramatic viewpoint and view the image using your LCD to control your composition. This way you can sometimes achieve a viewpoint that wouldn't be possible if you had to compose a picture through your normal viewfinder. The less agile you are, the more useful this can be.

If your frame contains visible or long, continuous lines, such as roads, rivers, fences, buildings, etc., take advantage of these lines when composing your image to lead your eye into the main subject of the picture. This works particularly well when the lines originate from the bottom corners of your photographs. A winding road, for example, leads to the old church you are photographing, or the Great Wall of China starts in the bottom corner of your frame and then leads the eye into the center of the picture.

One last word on color in your composition. It's pointless to try to apply any rules to this; it's up to you as the photographer to see and appreciate color and the aesthetics of different combinations. Colors can give a warm or cold feeling to a picture, reflecting our preconceived views on color. A winter scene can be enhanced by the use of blue in the picture to give that chilly feeling, for example, or a red beach umbrella on golden sand can

TIP:

When you observe with the naked eye, you are comprehending what you see in three dimensions—you can perceive depth. But remember that photography operates in two dimensions. So to give a sense of depth to your picture, you'll have to accentuate it either by use of a wide-angle lens to isolate the foreground, or through lighting.

Following pages: Sandra-Lee Phipps photographed herself right before giving birth using a Pentax 67 II and a 45mm f//4.0 lens. She set the shutter speed at 1/30 second at f/4.0. The film is Kodak Portra 800 ASA rated at 400 ASA (in other words, one stop overexposed). She used available afternoon light coming through a window.

Fredrik Brodén's conceptual photograph, "Blue," highlights the importance of color in photography.

evoke the feeling of warmth. Although it's not usually possible to add colors to your photographs, be aware of color as you're looking to make that award-winning picture.

COLOR BALANCE

On most digital cameras today, photographers tend to use the auto white balance (AWB) setting. For most subjects, this is fine.

In some cases, however, it's better to use some of the preset WB settings, such as sunlight, shady, fluorescent, or tungsten lighting, and match them to the existing lighting. With advanced digital cameras, you also have the facility to set a manual white balance. This is achieved by photographing a neutral gray card, using one of the options of the camera. The camera then makes an adjustment to give very accurate color. Where the light is constant, this is the best way to achieve perfect color balance with mixed or difficult lighting.

A good trick I use frequently is to set the degrees Kelvin (a measurement of color) in the camera slightly warmer than the light at the time. For instance, on a normal sunny afternoon, the correct color temperature would be 5,500 degrees Kelvin. I set my camera at 6,000 degrees Kelvin, which makes the camera think the light is cooler than it really is. This gives me a pleasing, slightly warmer effect similar to shooting Fuji Velvia film.

Many of today's cameras measure the color balance through the lens. As with through-the-lens automatic exposure metering, if the subject is a predominant color or density, the camera's automatic exposure or color balance tries to achieve a neutral effect and can be fooled. So if you were photographing a red Ferrari against a red wall when shooting on auto white balance, the camera would try to make your picture less red. Obviously, this isn't good. In the same way, if you shot a snowman in the snow on automatic exposure, the camera would underexpose the subject.

You can preset your color balance to get a more desirable picture. You can do this by:

- Making a manual color balance reading with the camera
- Using a color temperature meter and then entering the reading
- Using your experience and entering the color balance in degrees Kelvin manually

To sum up color balance:

- In 90 percent of cases, auto white balance, like auto exposure, produces great results.
- In unusual or mixed lighting conditions, or with subjects of one predominant color, try to manually set your color balance.

FILE FORMATS

Digital pictures can be created in three different file formats: JPEG, TIFF, and RAW. Each file format has its good points and bad points. It is the photographer's responsibility to determine what is the best file format to use. Generally speaking, if you want to send an image through e-mail, use a JPEG format. If you are working with a more sophisticated desktop publishing program, you may prefer a TIFF. If you want to create large prints of your work, or tweak the colors to your tastes, shoot in the RAW format.

Mattias Klum's silhouette of an ant in Borneo

JPEG: This acronym stands for Joint Photographic Experts Group, the gathering of photographers who originally met to discuss formats. A JPEG is a compressed image file format so it is very popular as an e-mail attachment because of its smaller size in megabytes. However, the compression process often results in loss of quality in the image. If the image is compressed too much, the graphics become noticeably damaged. In high-end D-SLR cameras, use higher quality settings of 10-12 if you have memory space to do so. JPEGs are also cross-platform. This means the same file can be viewed equally on both a Mac and PC.

TIFF: This acronym stands for Tagged Image File Format. It is a graphics file format created in the 1980s to be the standard image format across multiple computer platforms. The TIFF format can handle color depths ranging from 1-bit to 24-bit. Since the original TIFF standard was introduced, people have been making many small improvements to the format so there are now around 50 variations. Like the JPEG, the TIFF format is a cross-platform format for both Macs and PCs.

CAMERA RAW: Camera RAW files are unprocessed images, sometimes referred to as digital negatives. This mode does not compress the images. As a result, you can have more control over the color correction and processing on the computer. This is also the preferable format if you plan to make large prints. The downside is that a RAW file takes up to two or three times more space on your memory card. More expensive D-SLR cameras have ability to shoot in RAW which, in most cases, is a proprietary format exclusive to the camera manufacturer. These cameras come with special editing software allowing you to open RAW files, edit them, and save them into TIFF and JPEG file formats.

- Don't be afraid to warm your pictures up slightly by manually setting a cooler color balance than called for by the light.
- If you are using an advanced camera and shooting in RAW, many of the color balance adjustments can be made on the computer after you've taken the picture. However, don't be lazy and rely on this to avoid making the correct settings. The more accurately you adjust your camera settings, the better the final result.

THE IMPORTANCE OF BACKGROUND

One of the most common mistakes made by amateur photographers is not thinking enough about the background. When I'm taking pictures, one of the most important elements I consider is what the background of my picture is going to be. After all, no picture can be a "great" picture without a complementary background. This does not mean always getting a neutral background, although that can be a good start. The background should not distract from the main subject of the picture, be it an action picture, portrait, or even a landscape. In many cases, it can be used to complement or add to the picture content.

Just changing the angle of the picture slightly can help a lot. For instance, if you are photographing someone outside on a sunny day and the background choices are dreadful, duck down low and photograph against the best—and my favorite—background in the world: the blue sky. Equally, if the weather is bad, many great portraits have been photographed against a cloudy, dark, moody sky.

Bob Martin chose these colorful houses as the perfect background for a photograph of an Australian swimmer.

Unusual perspectives and composition can make familiar subjects more fun.

Sometimes, when the background isn't great, a good trick is to use a telephoto lens and shoot at the widest aperture. This puts your background extremely out of focus and helps your subject stand out. Also, since a telephoto lens has a smaller angle of acceptance, this allows you to be more selective with your background.

Let's consider a familiar scenario to illustrate the importance of the background. You are taking a photograph of the bride at her wedding. By framing the church in the background, you can turn a straight, boring portrait into a much better photograph. In this case, the background is complementing the picture, not distracting or overpowering it. You must be careful not to let the background take over the picture. Remember what you're setting

out to photograph and use what's around the subject to help with your composition and framing.

It almost goes without saying that background awareness is one of the essential elements of well-composed photography. Some really good portraits are helped by the pitch-black background on which they are photographed. Some fantastic still life pictures are enhanced by the completely clear, white background on which the subject has been placed.

Finally, here are a few points to bear in mind when you photograph your next family outing:

- *Always, always, always* think about what's in the background.
- When taking a photograph of your sister in New York, don't have a skyscraper growing out of her head.
- Don't photograph your brother at the Grand Canyon with the horizon coming out of his ears.
- When photographing your father fishing, frame the picture with the lake in the background—not the car parked next to the lake.
- When photographing your aunt at her birthday party, make sure that the illuminated exit sign in the restaurant is not distracting your eye from the cake.
- When photographing your son's first football match, choose a position with the green woodland, not the ugly sports hall, behind the action picture you intend to take.
- When sneaking a picture of your friend sunbathing on the beach, wait until the man walking his dog behind her has gone.

FLASH PHOTOGRAPHY

At this point I should be completely honest with you: I usually don't like flash photography. I like to use any natural light that's available and manipulate the subject to achieve the affect I'm after. There are occasions where using flash is a useful technique, and there are a few things we need to know about the best ways to use flash.

Flash on Camera

We've all seen plenty of examples of how not to use flash—pictures in which the subject is lined up against a wall and the flash casts a huge ugly shadow that overpowers the shot. If

Following pages: Bill Allard photographed this couple with Kodachrome and a small bit of flash.

A bounce card can be as simple as a business card attached to a flash unit with a rubber band.

the flash is built into the camera, it's often hard to avoid this situation, but there are a few simple tricks that may help.

Move the subject away from the background; the farther away from a surface on which a shadow can be seen, the better the result will be. The distance between the subject and the shadow will determine not only the size of the shadow but also the hardness of the edges, so the greater the distance, the softer and less obvious the shadow will be.

On some occasions where it's not possible to achieve this separation of subject and background, a shadow behind your subject is unavoidable, and the best you can do at these times is to make the shadow as unobtrusive as possible. Take the picture from an angle that will project the shadow behind the subject's head rather than behind the face, or use Bounce Flash.

Bouncing the Flash

By redirecting the light from your flash you can reflect it, or bounce it, off another surface to change the angle and quality of the light reaching your subject. The effect of bouncing the light produces a less directional, less harsh light that will result in a much softer effect with fewer shadows.

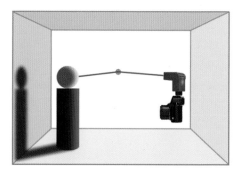

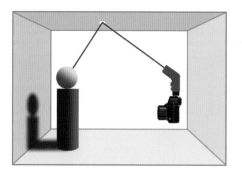

A simple piece of white card can be used to change the angle of the light from your flash by placing it on the back of the flash unit and extending it past the face of the flash. Adjust the angle of the flash unit to direct the light in the required direction—usually off a neutral wall or ceiling—and then onto the subject.

Diffusing the Flash

One of the biggest problems with on-camera flash is the hard light that is produced; hard light, as we have previously discussed, creates hard shadows that produce unattractive pictures.

We can combat this problem by diffusing or softening the light produced by the flash with a proprietary flash diffuser, or we can make our own. This is as simple as placing a white handkerchief or some tissue paper in front of the flash. The light passing through the handkerchief or tissues will be spread out, or diffused, producing fewer shadows and a softer look, making even your great-aunt's wrinkles look less noticeable.

CORRECTLY EXPOSED FOREGROUND, BLACK BACKGROUND

Another bad flash scenario we've all experienced is the "bright foreground, black background," where the subject is correctly exposed but the background is completely underexposed and pitch black. A friend of mine has a complete album of pictures like this. "This is Margaret in Paris," and "This is Margaret in Rome," etc. All the pictures look the same—shots of Margaret with black backgrounds.

The cause is simple: the shutter speed is too fast. The flash will produce enough light to expose the subject correctly, but the shutter is opening and closing too quickly to allow any of the ambient light of the background to be captured.

Setting the shutter to a much lower setting will help alleviate the problem. The flash will "freeze" the subject while the longer duration of the shutter will allow more of the ambient light to pass through the lens. Capturing ambient light allows more of the background to be seen in the photograph.

Shutter speeds as slow as 1/8 of a second or even slower can be used, though if you don't want to risk blurring of the ambient-lit

When the flash is too close, skin tones blow out and you lose detail in the background. Try using a slower shutter speed to capture more ambient light.

A slave unit helps you create another light source for your photo.

portions of the scene, you should brace the camera (e.g. with a tripod). Experiment, and see what results you can produce. If it doesn't work the first time, delete the image and try again using a different shutter speed.

Portable Flash

Even if your new digital camera has a built-in flash it's worth considering buying an extra flash. This will give you much more flexibility when it comes to flash photography. There are too many of these units on the market to mention them all here, but a good quality flash unit is worth the money spent.

Many of the larger camera manufacturers produce their own flash units, and if you buy one that is the same brand as your camera you won't go too far wrong. A flash unit that is dedicated to a particular camera offers the full range of through-the-lens functions and wireless/multi-flash capabilities. Having an extra flash unit gives you many more options when it comes to creating different lighting situations.

Few D-SLR cameras have a flash sync plug, relying instead on an attachment, or "hot shoe," on top of the camera to connect the flash

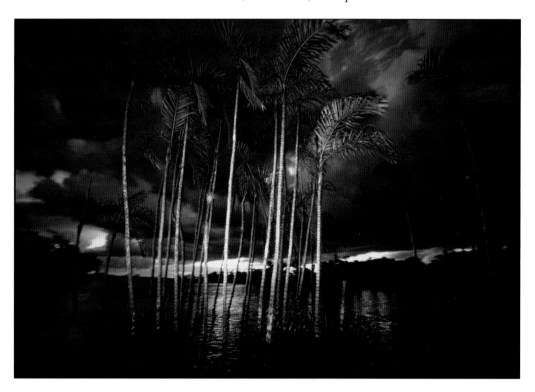

to the camera. This is a convenient way of connecting your portable flash to the camera, but it also limits what you can do with the flash.

I like a flash that can be removed from the camera and placed to the side of the subject to produce a highlight, or placed in other positions to create different lighting effects. If your camera does not have a sync plug—the plug that connects the flash to the camera via a cable—there are other ways that the flash can be operated away from the camera. There are devices that fit onto the hot shoe of the camera and can then be connected via a cable or sync lead to an off-camera flash.

There is also a small inexpensive device called a slave unit. This electronic device is activated by the firing of a flash. Connected to the external flash unit, it fires that flash when triggered by the flash from another unit.

If your camera is one with a built-in flash, then this flash can be used to trigger another one equipped with a slave unit. This allows the use of a second source of lighting placed almost anywhere you want it. Most brand-name manufacturers now build this wireless

TIP:

Placing a colored gel over the front of the off- camera flash will produce a colored highlight that can add interest to your picture.

Nick Nichols chose to photograph the same landscape in the Ecuadorian Amazon with a flash and without a flash to see which he liked better.

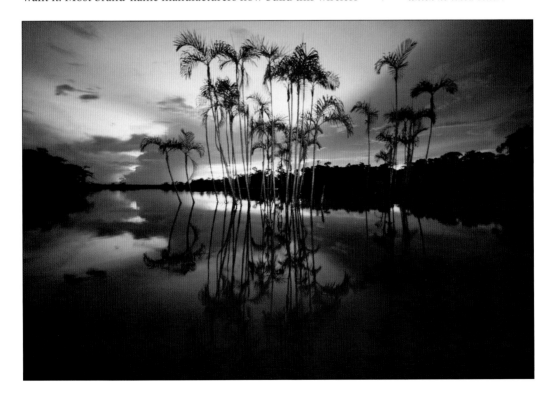

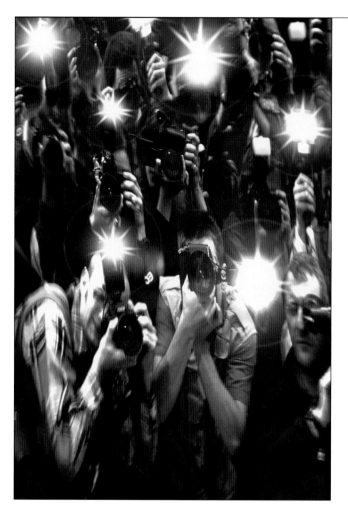

*Paparazzi rely on flash
even during the daylight
hours.*

capability into their flash systems, providing full automation without the need for cables.

Used in this manner the off-camera flash can provide a highlight, or key lighting, that adds an extra depth to your picture. Placed behind the subject, it will highlight the subject's hair beautifully.

Fill Flash

Although I live in England, there are still times when the sun can cause problems when I'm taking portraits outdoors.

On the rare occasions when the sun shines, the brightness can cause pictures to have too large a variation between highlights and shadows. The pictures can have uneven lighting. If we expose for the highlights, the shadows will be black and contain no detail. This is when we need to use fill flash.

Fill flash is simply using a flash to provide more light in the shadows. This technique produces an evenly lit image where the highlights are more balanced with the shadows.

To use fill flash, we must first know at what speed our D-SLR camera synchronizes with the flash. If the flash is not synchronized, it will have little effect.

Most D-SLR cameras have a sync speed of 1/60 second, although some more expensive cameras have a sync speed of 1/250 second. The relatively slow speeds used by most cameras to synchronize with the flash mean that to achieve a correct exposure we need to set CCD sensitivity to a much lower ISO rating or the entire image will be overexposed.

Once the shutter speed has been set at the correct sync speed, the next step is to take an overall exposure reading. Let's say we get a reading of 1/60 second at f/11 at 100 ISO; all we need to do

now is set the flash to the appropriate distance setting and the power to f/8 (one stop less than overall exposure reading). This will produce enough power to "fill" the shadows, but will not completely remove them.

BLACK AND WHITE

Most digital cameras have the functionality to allow you to shoot your pictures in black and white. While this is an option, I would suggest that you capture your images in color and convert them to black and white later in your computer using a proprietary imaging software. This not only gives you the option of reproducing your images in either color or black and white, but I have found that capturing the image in color and converting it later produces better detail in the shadows than it would in an image captured initially in black and white. Please refer to Chapter Five where we will go into the reasons why and how to manage it.

QUALITY OF LIGHT

People often ask me, "What is the best time to take photos?"

This is a question that doesn't really have one answer; there are many opinions. However, I do believe that being able to identify what lighting conditions will prevail at different times of day—and how to use these different lighting conditions—is one of the great skills in photography.

The optimal times for photography are usually late in the afternoon or early in the morning. Even though the position of the sun is low in the sky during both times of day, the process of photosynthesis creates a very different color palette in each. Photosynthesis is the chemical process that keeps leaves and grass green in reaction to the sun. But particles of dust in the air also react to the sunlight, becoming a darker color rather than invisible, as they are in the morning.

Early morning light is a very clean, white light that provides crisp vibrant colors. Late afternoon or early evening brings a warmer, softer light. And the low angle of the sun in both situations casts long, strong shadows. The nature of the late afternoon light—a warm soft light, diffused and softened—makes it an ideal time to shoot against the light. Placing the sun behind

Preceding pages: Sisse Brimberg captured the moodiness of the streets of Denmark during a rainstorm.

James Blair got up early to capture the mistiness of morning fog in California's Redwood National Forest.

your subject and using a reflector or a little fill flash, you can produce portraits with a surrounding golden glow that gives an almost ethereal effect.

A good way to discover for yourself the effect of light at different times of day is to go to a local scenic spot in the early morning and shoot some pictures. Take the exact same picture at midday, and then again in the evening. Compare the pictures and you will see for yourself how the light changes at different times of day.

My least favorite time of the day for shooting is midday. The sun is at its highest so it creates deep, sharp shadows that you need to control. Again, fill flash or a couple of reflectors can help manage the shadows created by high, harsh light.

Wet and overcast days can also make for visually arresting images if used well. A rocky coastline with crashing waves can be spectacular with menacing, cloudy, gray skies as a backdrop. A person looking through a rain-streaked window can evoke many different feelings. Immediately after a thunderstorm, I love the light that streaks through the blackened clouds as they

Bill Allard photographed the Charles M. Russell National Wildlife Refuge in Montana during the late afternoon.

move away. Those streaks of light can illuminate the landscape like large spotlights.

Light is essential for photography, and learning how light behaves at different times of day, and indeed, at different times of the year, is a skill that one must master to be a successful photographer.

Here are some basic tips, in summary:

- In the early morning, when the sun is still low in the sky, the light is clean and white. This is a good time for landscape photography because the extra length of the shadows adds a three-dimensional effect to your pictures.
- At high noon, when the sun is directly above, the shadows are short and deep and the light can be very contrasty. Portrait photography is especially difficult because you must employ a fill flash or reflectors to soften the effect of the shadows.
- Late afternoon brings a warm diffused light with long soft shadows. It is an ideal time of day for most kinds of photography.
- Light is dynamic. Plan your photography around the light if possible. If you see a picture but the light is too harsh, wait an hour to see if conditions improve. They probably will, and so will your picture.
- "Good" weather doesn't necessarily equate to good light. Overcast days soften light nicely and reduce its contrast while storms can create rare, surreal effects that can transform an otherwise normal scene.

His story begins with a blurb in the *Washington Post* about the passage of the Victims of Trafficking and Violence Protection Act of 2000. Jodi Cobb read it and wondered if any stories had been done on the illegal trade of trafficking humans. She contacted organizations such as The Protection Project affiliated with Johns Hopkins University. She contacted people at the State Department. She read reports issued by committees at the United Nations. She read Kevin Bales's book *Disposable People: New Slavery in the Global Economy*. In the end, she realized there wasn't a picture story that told the entire truth: 27 million people in the world are slaves.

"I knew it was going to be a very difficult story because it was invisible," says Cobb who spent a year on the project. She started in India and Nepal, where she felt she could make pictures. There she already knew of brothels where women worked and places that employed children. She had located enslaved families who worked to pay off debts incurred by unfair lending practices.

From there she traveled to nine other countries to photograph as many of the three sides of the narrative as she could: the different kinds of enslaved workers, the people who enslaved them, and the people who worked to free the slaves. In Israel she had only four days to work. In Bosnia, she ate lunch with a man known to be very dangerous. She risked reprisal on the streets of Mumbai for using her camera outside the brothels. She cried sometimes while she worked. "I was either in fear or in tears while I was shooting," says Cobb.

"It was the worst of human nature—and the best—in that story," she continues. "For every evil guy there was some brave person trying to help."

It is safe to say that "21st Century Slaves," the 24-page story that *National Geographic* magazine published in September 2003, is the pinnacle of a career that has blossomed from her early days as a staff photographer at the *News Journal* in Wilmington, Delaware. After a two-year stint as a freelance photographer, Cobb joined the staff of *National Geographic* magazine in 1977. Since then she has researched and photographed 25 stories, covering subjects as wide open as "London" or "The Enigma of Beauty." But she also specializes in opening the doors to closed worlds,

A brothel in Tel Aviv,
Israel, 2002

as she did in her story "The Women of Saudi Arabia," or in her highly acclaimed 1995 book, *Geisha: The Life, the Voices, the Art.*

To learn more, go to *www.nationalgeographic.com*. Or take a class with Jodi. She regularly teaches at the Photography at the Summit workshop in Jackson Hole, Wyoming.

Jodi Cobb photographed this raft in the early morning on Lake Thun, Switzerland.

A contestant waits to model a swimsuit at a competition in New York City.

Sun lovers frolic on Ipanema Beach, Rio de Janeiro, Brazil.

Jodi Cobb captured the reflection of an advertisement on a bus stop in London, England.

Chapter 3
Advanced Techniques

3 | *Advanced Techniques*

n this section I will address the types of photography that require special techniques or special equipment to make better pictures.

MOTION—STOPPING IT, BLURRING IT, USING IT

The photography of movement isn't just confined to sports pictures. In all aspects of life, things move: the kids in the park, the waves on the shore, animals (from the pets in the garden to the wildlife on safari). Applying these basic techniques to your everyday pictures will add a dynamic and fresh look to your photography, whether you stop/freeze the action, blur the background to accentuate the speed of your subject, or even blur the subject itself. Whichever of these techniques you use, they can help you make great pictures.

Freezing the Action

The best and most common practice for producing dynamic movement in a picture is to freeze the action. This is achieved by using a fast shutter speed.

Let's consider what shutter speeds are necessary to stop the action in everyday situations using a modern digital camera. If your children are playing in the park, running directly towards you, try to use a shutter speed no slower than 1/500 second. If they're running across the frame, you'll need a little bit more stopping power, so shorten your shutter speed to 1/1000 second. Follow the action as you take the picture, trying to press the shutter as gently as possible to capture its peak. If the subject is filling the frame you may even need to use a shutter speed of 1/2000 second, light level permitting. If you can't get proper exposure at such high shutter speeds, don't be afraid to manually set a higher ISO, for example ISO 400 rather than ISO 100. It's better to have a little "grain," the result of increased noise, than a blurry subject. See page 65 for more explanation about ISO shifts.

The reasoning behind all this is that the shutter speed necessary to stop the action is relative to how fast the subject crosses

the digital sensor of the camera. Where the child is running directly at you, the movement across the sensor is minimal. It increases if the child is running across the frame. If you're shooting with a wide-angle lens, as the child runs past you the

Bill Hatcher set his camera on shutter priority at 1/30 of a second to make this photograph.

Stephen Alvarez captured the speed of these green parrots as they raced out of their home in Mexico's Golondrinos Pit.

subject passes the sensor in an instant, so you need a really high shutter speed.

Here is another example, this time using a telephoto lens. Your brother wants an action picture of his new sports car. For a head-on picture, as he comes straight at you, use a shutter speed no slower than 1/500 second. For a side-on picture, as he speeds past the house, use a shutter speed of 1/1000 second to freeze the picture with a little movement in the wheels. To totally freeze the moment, use 1/2000 second. These basic guidelines would also apply to photographing your nephew on his sled, for example: 1/2000 second would totally freeze the flying snow as the sled speeds by.

During a stroll along the beach, as the waves are crashing against the rocks, use a shutter speed of no less than 1/1000 second to freeze 95 percent of the action. Again, to totally capture every drop of water, use 1/2000 second.

As your uncle finishes the New York Marathon, in five hours 35 minutes, if you are head-on as he staggers over the finish line, use 1/500 second.

Panning

Panning is a technique that freezes the subject and blurs the

background. For panning, you use a slower shutter speed than is necessary to freeze the action. By moving the camera at the same speed as the subject, the subject is frozen and the background is blurred through motion. It is essential, in the same way as when shooting frozen action, to follow the subject with your camera, holding it as steady as possible and firing the shutter without jarring the camera. It's good practice to continue following the action—to "follow through"—even

after you've taken the shot. This helps to ensure a smooth pan, and your subject will be frozen. Sometimes, by using an even slower shutter speed, your subject will also have some movement or blur; a runner's arms and legs may blur, for example, even when his slower-moving head and body are sharp. This can add to the picture if you get it right, and is a great way of conveying a feeling of speed. Preview the pictures on the back of your digital camera and experiment until you get that "perfect shot."

Your mother-in-law is riding her bike to the coffee shop for the first time this year. From a safe position on the sidewalk, you select a shutter speed of 1/60 second. As she approaches, if you can keep up with her pace, follow the subject in the viewfinder, keeping the camera as steady as you can while you pan as smoothly as possible. And if you have a good relationship with her, ask her to ride by again as you shoot at 1/30 second or even 1/15 second to compare effects.

Your brother wants yet another picture of himself in his new sports car. Using the "mother-in-law" technique, shoot some pictures at 1/125 second and, if he wants to look as fast as a Porsche, try shooting at 1/60 or even 1/30 second to get an even more blurred background. But please remember that at these slower shutter speeds, you'll begin to blur your subject, as well. Therefore, shoot lots of pictures to get one just right. That's one of the great things about digital photography—you can do this without wasting anything except the batteries. Delete the ones that don't look good.

Randy Olson wanted to capture the mystical feeling of night in the forests of the Congo when he photographed this boy getting ready for a ceremony.

Moving with the Subject/Tracking

Now let's get really advanced. This technique is frequently used by automobile photographers. They shoot from a car moving at the same speed as the subject vehicle. This freezes the car they're photographing and blurs the background and foreground in a similar manner to a pan. Again, the technique for this is to hold the camera as still as possible and press the shutter as gently as you can. This same technique has been used to photograph marathon runners and cyclists. When you're next in London, passing through Piccadilly Circus in a black cab, try photographing the classic red double-decker bus traveling alongside. For this to work really well, use a slow shutter speed: 1/30 or 1/15 second. Expect to discard many attempts until you get the perfect shot. This may involve using that classic line "follow that car" (or in this case, that bus).

Raul Touzon panned these people dancing at night in Mexico to accent their movement.

Movement Blur

As you experiment with the techniques of panning and tracking, on many occasions you'll get blurred pictures by mistake. Sometimes, however, this can result in a very pleasing and graphic image. As you improve, try shooting at slow shutter speeds to deliberately blur the subject. One tiny point of sharpness in the picture will provide a point of reference, and in some cases, if the subject is graphic enough, a blurred shot can be beautiful and very abstract. Many great pictures of dance, in particular, ballet, have been photographed with very slow shutter speeds. Birds in flight are also an ideal subject. But even football players can look graceful when artfully blurred.

It's difficult to know where to suggest you start with this. Shutter speeds from 1/30 to 1 second have been used, depending on the subject. Start with 1/8 second and review the results on the LCD on the back of your digital camera. As always, be prepared to experiment.

If you use a tripod and a very slow shutter speed to shoot a moving subject, you can get a dramatic contrast between sharp and blurred detail. For example, if you're photographing a waterfall at a slow shutter speed (perhaps 1 second or longer),

the water will blur so much that it will have the appearance of billowing silk. The background—the trees and rocks—will be completely sharp because your camera is totally still. This can lend another creative element to your picture.

During your visit to New York, shoot a picture out of the hotel window at night and photograph the traffic racing through the streets. Use a very slow shutter speed (approx. 4 seconds), and therefore also a tripod. As in the above example, the buildings and neon lights will be frozen and crisp whereas the lights on the moving vehicles will create blurred lines wherever they go.

Flash with Blur

A technique useful at parties is to shoot a photograph with a slow shutter speed (approx. 1/8 second) and a little bit of light from a camera-mounted flash. As the duration of the burst from a typical shoe-mount flash is in excess of 1/2000 second, the light from the flash freezes the subject/foreground of the photograph. Because everything behind the subject is illuminated mainly by the existing light, it blurs—the result of

David Alan Harvey's assistant held a flash unit to the side as Harvey photographed people on the streets of Nairobi.

camera movement—to create a moody picture. This technique can be done with most D-SLR cameras, but a number of digital compacts have a slow-sync setting that allows you to achieve a similar effect.

Second-curtain synchronization, also called rear-curtain synchronization, is an extension of this technique. Normally, the flash fires immediately after the first shutter curtain opens fully. With second-curtain synchronization, the flash fires immediately before the second curtain closes at the end of the exposure. This means that the flash freezes the moment at the end of the exposure/motion and a blur appears behind the moving subject, as if it is leaving a trail. (With normal synchronization, the blur appears in the direction the subject is moving.) This works really well for action pictures. For example, if you use second-curtain sync to photograph a cheerleader jumping in the air at a night football game, she will create a blur on her way up (since the slow shutter speed allows the camera to record some of the existing light in addition to the flash) and be frozen by the flash at the top of her trajectory—assuming, of course, that you've timed your exposure so that she's not already on the way down! Keep in mind that second-curtain sync is usually only possible with advanced D-SLRs.

Remote Cameras

Remote cameras provide the ability to make a photograph from a place you can't be. This can be done by clamping your camera to the spot (or on a tripod nearby) and wiring a remote-controlled trigger to the camera via a remote-control socket that most high-end D-SLRs have. Different camera manufacturers make different types of remote setups ranging from the basic cable and switch to advanced infrared systems and radios.

D-SLR cameras often come with software that enables you to fire your camera from a computer via a FireWire or a USB cable. This is not a bad way to start, and is referred to as "shooting tethered." It also has the added advantage that you can review your shots on the computer as you work. However, the length of the cable is about 20 feet, and the use of a computer (even a laptop) may be impractical in many shooting situations.

Whichever method you choose for remotes, here are a few scenarios for testing it. Say you want to photograph birds in

your backyard. Set up your camera outside first on a tripod and then snake the cord under a patio door or through a window. Put a few crumbs of bread somewhere in front of the camera and prefocus on the spot. Set your camera on automatic and then move inside—behind curtains if possible. Wait. The noise of the camera may startle the birds at first, but you will be surprised at how quickly they become accustomed to it. You can lessen the noise by "locking up" the camera's reflex mirror if your particular D-SLR permits this.

Another useful accessory for remote photography is an angle finder. It fits on the eyepiece of your viewfinder, allowing you to see through it from above, below, or to the side. This is very useful when you decide to place a remote camera (one you can afford to bang up) inside the goal before your daughter's soccer match. Remember to prefocus on the spot where the action is likely to take place. Set your shutter speeds and aperture if you are setting the camera manually. Determine how the light will move during the match so you don't mistakenly create a silhouetted picture.

For this picture of horse racing in Ireland, I positioned my camera at the edge of the fence on a floor plate—a flat plate with

Bob Martin set this remote camera fitted with a 24mm lens at 1/2000 second, shutter speed priority, during a steeplechase in Ireland.

STAYING WITH FILM FOR NOW

Gordon Wiltsie won't use digital cameras on his extreme assignments. "It's impossible," said Wiltsie. "The temperatures are too cold for the computers."

Wiltsie has worked in some of the coldest corners of the Earth—the Antarctic, Mongolia, Kashmir, and the Himalayas, to name a few—where temperatures can drop to -50°F. He leads skiing expeditions and climbing expeditions. He teaches photography. And in 1998, he realized a dream when he led a big-wall climbing expedition to Antarctica's little-known Queen Maud Land where he scaled the sheer face of Rakekniven, a 2,000-foot high overhanging cliff. His adventure was the cover story of *National Geographic* in February 1998. All along the way he has relied on his Nikon FM2, one of the only cameras on the market that works without a battery. "Even when the light-meter battery dies, it keeps working," says Wiltsie.

Today, Wiltsie speaks Nepali and Spanish, Hindustani, and Mongolian to help him accomplish his photographic goals. An exhibition of his photographs of a nomadic migration through Mongolia during the harsh winter in the Horidol Saridog mountains traveled through the United states. And a retrospective of his work has been published in a book entitled *To the Ends of the Earth, Adventures of an Exhibition Photographer*—a story that includes exploring the North Pole by dogsled, surviving two avalanches (one with a broken back), and the discovery of a lost tomb in Peru.

The three films Wiltsie likes to use—Fuji Velvia 50, Kodachrome 200, and Kodak Professional E200—have all been discontinued. The lab he likes to use has closed its doors. And all the magazine editors seem to want their photographs delivered digitally now. He has had to grow and adapt amid the changing technologies of film and digital photography.

"With digital you have to believe in whatever comes out of the camera," says Wiltsie, referring to the RAW file format. "You don't have a baseline of color to work with. It's how you or the editor interpret it."

For more information about Gordon Wiltsie, his expeditions, and his photographs, go to *www.alpenimage.com*.

Wiltsie used his Nikon FM2 set at 1/500 second at f/8 on Fujichrome Velvia 50 to photograph Conrad Anker as he hovered on the side of Rakekniven in Queen Maud Land in 1998.

a tripod mount on it. I fitted the camera with a 24mm lens that gave a very wide view looking up under the horses as they jumped. I set the camera at 1/2000 second, shutter speed priority. The f-stop was fairly small (higher number) to provide more depth of field, because the horses would be close to the camera. I used a relatively high ISO of 400 to achieve both these settings. The sun was out during the setup period, but I couldn't be sure the clouds would stay away during the race. I attached a motor drive to the camera to capture a number of frames sequentially as the horses jumped.

PORTRAIT PHOTOGRAPHY

As you start to become more familiar with your new camera, it's inevitable that you'll find yourself shooting portraits. A portrait is not necessarily a head and shoulders shot, as you would see in a passport or on a "wanted" poster. It can be an extreme close-up of a beautiful girl's eyes or a wide shot of the local butcher behind his counter.

Portraits can be all shapes and sizes, and you should experiment with your subjects. The important point to remember is that there are two important people involved in making a portrait: the photographer and the subject. Make sure to establish a good rapport between you and your subject; at its best a portrait photograph is a true collaboration.

The three basic types of portraits are:
- Facial portraits or close-ups
- Full-length portraits
- Environmental portraits

Close-up portraits are usually pictures in which the subject's face fills most of the frame with little or no background. The attention of the viewer rests solely on the part of the subject's face that the photographer has decided is particularly compelling. Lighting is especially important in this kind of portrait because it has a strong effect on how much detail you will see in the subject's face. For example, directional light will bring out texture and make wrinkles more pronounced, which might be good for character studies. Soft light tends to be more flattering because it minimizes blemishes and other perceived imperfections.

When you are shooting close to the subject, keep in mind that perspective distortion can produce an unflattering effect—a bulging nose, for example. To prevent this, use longer lens focal lengths. Settings in the 85mm to 135mm range

Randy Olson included as much of the environment as he could when making a portrait of this woman in a ticket booth at the Sun Pictures Theater in Broome, Australia.

(35mm equivalents) are often referred to as portrait telephoto for this very reason.

If you decide a full-length portrait is what you want, pay more attention to the background in your picture. Interesting backgrounds can add a lot, but be careful that the background is not too busy. Too busy a background can distract the viewer from your subject. One way you can prevent this is by setting a wider lens aperture, which will make the background more out-of-focus; try f/4, for example, rather than f/11. Remember, too, that if you get more background than you want in the frame, you can crop it with software and in printing so that its proportions are narrower. A tall, vertical shape can work very nicely for a full-length portrait.

An environmental portrait, in which the person or people constitute only part of the entire image, is particularly useful when you want to give the person some context. The background is almost as important as the subject because it takes up so much of the frame. For this reason, you should probably set smaller lens apertures to ensure that the background and surrounding detail are sharp. Many photographers use a relatively wide-angle lens for this kind of portrait because it allows them to get fairly close to the main subject while still managing to include lots of the

background in the frame. Keep the aforementioned rule of thirds in mind as you do this.

Group Portraits

The secret to any group portrait is in the arrangement of the subjects. Putting tall people at the back and smaller people in the foreground is fairly obvious, but try to arrange them roughly to form the shape of a pyramid or a mountain to start.

When taking the picture it's often a good trick to shoot from above; this will cause the group to look up at you, showing their faces better. Stand on a chair when you take the picture. You might look a little silly, but it works. Ask the group if everyone can see the camera; if they can see the camera then the camera will see them. You should still double-check that the lower portions of peoples' faces aren't covered up by the head of the person in front.

Achieving Good Portraits

Studio portraiture, at least in its professional form, can be a big production, involving make-up artists, photographic assistants, and large studios full of very expensive equipment. But good portraiture doesn't necessarily need loads of fancy and expensive lighting equipment.

Professional-looking portraits can be achieved by using very simple and inexpensive methods. The sunlight from a living room window can be beautiful on someone's face; overly dark shadows can be lightened simply by bouncing light back onto the subject with a white card or piece of white foam core board carefully placed outside the frame. When you use the light from the window as the primary light source, and the white card to reflect this light onto the darker areas of the subject, you can achieve a balance between highlights and shadows that is very professional. Experiment with both the angle of the board and its distance from the subject, studying the subject from camera position to observe its effect.

You should also experiment with the positioning of the subject. The way in which the light falls on someone's face can make him look older or younger just by virtue of its angle and severity. For instance, ask the subject to sit with her back to the

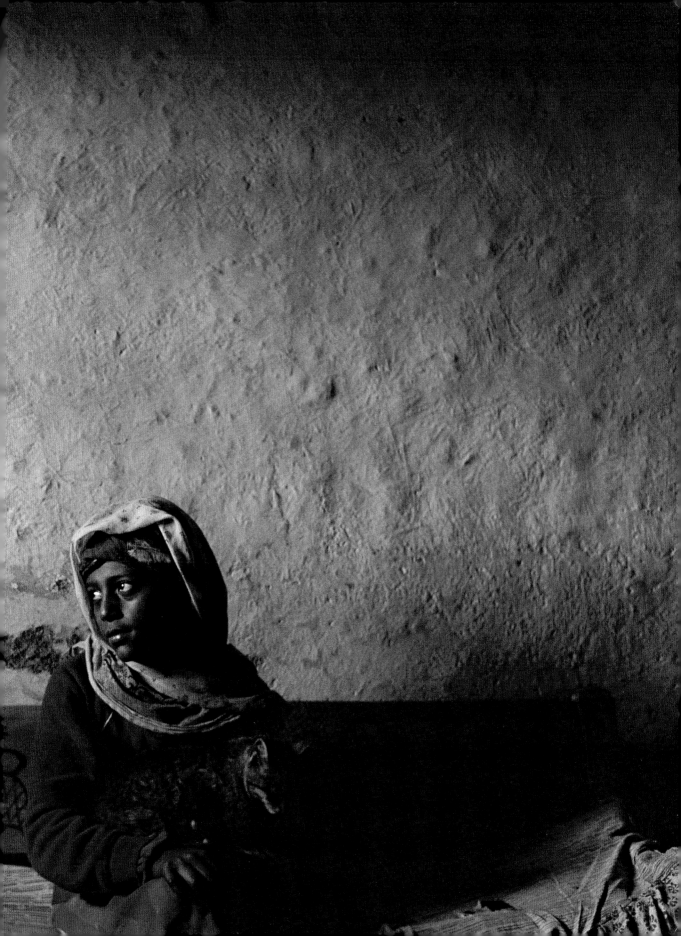

window and then reflect some of the window light back into her face with the white card. This will produce a soft, glowing light that flatters her facial features. Then ask her to turn another 45 degrees to see what the light does to your picture. Adjust your setup accordingly.

One old rule of photography to forget is that you should always have the sun coming over your left shoulder and into your subject's face when making a picture. This was probably good advice when the Brownie camera was in vogue, but it doesn't hold true any longer.

Second, we have all experienced the occasion when the sun is directly behind our subject and the resulting picture is a beautiful exposure of the background but a shadowy, nondescript face in the foreground. This is called a silhouette. We could increase exposure to compensate for the lack of light on the face. However, if we expose the face correctly, the background will be completely washed out.

The solution is simple. Fill flash, as we learned earlier, is one option. Or you can employ the trusty reflector board to bounce the light from the sun and direct it onto the areas of the subject where you want it. If you are unsure about your exposure, shoot a frame and check the camera's histogram display to make sure you are capturing all the detail you want without sacrificing the highlights. Just remember that if you are shooting toward your primary light source, there is a risk that lens flare will create unwanted streaks and other patterns in your image—something else to double-check on the LCD screen.

Time of day can have an impact on the look of your portraits. Light is softer during the early morning hours and late in the afternoon. Use these times of day to your advantage.

TIP:

A piece of board can be made into an even more efficient reflector by covering it with aluminum foil. The foil will work better if it has been scrunched up first and then partially smoothed out. This leaves a stippled reflective surface that will reflect the light more evenly. Keep in mind that the quality of this kind of fill light will still be more directional than that provided by a white surface.

Shooting Portraits in a Studio

Traditionally, tungsten lighting has been used in studio portraiture. However, in more recent years, photographers prefer electronic flash both on location and in the studio because of its lighting power, portability and ease of setup.

Traditional tungsten (continuous) light has the advantage of being a little less expensive than flash, but the drawbacks outweigh the advantages. Anyone who has been photographed with tungsten light will know how the heat it produces can make your subject very uncomfortable. The continual brightness can also cause the iris of the eye to become tiny. With studio flash, the light is only at full power for an instant, so the iris does not react as much. Studio flash units overcome the brightness problem by using a modeling lamp that mimics the light produced by the flash tube but at a much more comfortable level of brightness.

If you look at the front of a typical studio flash head you will see the flash tube and a modeling lamp. (The tube is the circular one with the modeling lamp in the center.) The modeling lamp provides a continuous light just bright enough so you can see how the lighting will be on the subject. The flash tube provides for an instant a "flash" of very bright light that is the same color temperature as daylight.

With tungsten/continuous lighting you will need very bright light to freeze even small movements such as a turn of the head. With flash/strobe lighting the flash duration—i.e. the length of time the flash actually lasts—is typically over 1/2000 second. This means that it will freeze the action as a high shutter speed would, providing it is that much brighter than the ambient light.

With most continuous lights there are also problems mixing the flash with existing daylight. The color temperature of the tungsten lights will tend to be in the region of 3200K. This lighting will have a very yellow/ amber cast when mixed with daylight. (If you're using tungsten light, it's best to close shades and doors to block out daylight.) However, flash/strobe lighting has the same color temperature as daylight: 5500K.

Actress Claire Danes looks different in each photograph because of the distance from the camera and the framing.

KNOWING YOUR SUBJECT IS
KEY TO GREAT PHOTOGRAPHY

"**Y**ou think the ocean is random, but it's not," says Tim Laman, who holds a Ph.D. in biology from Harvard University. He was speaking about a particular adult emperor angelfish that liked to sleep under the same rock every night. Laman made a special point to go back to the fish's bedside one night before 8 p.m. in Bali, Indonesia.

He noticed a younger angelfish—a juvenile adult—nearby. "The young ones can be attacked by the adults of the same species," he says, explaining why it's not so common to see the two together. Laman not only noticed the juvenile, but he managed to photograph him swimming above the sleeping adult, a mix of patterns that made a beautiful opening photograph in a *National Geographic* story on Fiji's Rainbow Reefs.

Laman has worked on diverse stories, from wildlife in winter in Japan (where he grew up), to the study of hornbills, to a feature on proboscis monkeys. He is currently photographing an ornithological exploration in New Guinea. For his dedication and artistry, he has been awarded the BBC Wildlife Photographer of the Year award four times.

In 2004 he switched to digital, beginning with the Canon EOS 1D Mark II. "It has made a big difference in the field," says Laman. "I can be there for months at a time and the immediate feedback is great. Underwater you can get more than 36 frames. I used to dive with two cameras with two different housings and strobes. Now I can get 400 shots on a 4-GB memory card." The bigger cards keep him from missing key moments.

Laman learned photography from his father, who was an amateur enthusiast. He used a simple Kodak camera without a light meter before graduating to a Canon SLR with manual focus in high school. While he was studying for his Ph.D. in rain forest biology, he used his camera as a research tool. Eventually the two interests merged into a life study and a career. Not only is Laman still passionate about his work but he is a frequent contributor to the National Geographic Society. To see more of his award-winning work, please go to *www.timlaman.com*.

Tim Laman captured a juvenile emperor angelfish as it swam by a sleeping adult.

You should start off with a very basic outfit. There are sets available from most of the main lighting manufacturers. These makers often sell "starter" outfits. They include a couple of flash heads, two stands, a reflector, a synchronization cable, and a flash umbrella. Such an outfit, along with a medium-size reflector and a flash exposure meter, will give you the basics to produce very acceptable portraits of your family or friends.

Manufacturers have designed cameras with a place to attach a flash on the top of the camera. There are occasions when it may be easy and convenient to pop a flash on top of your camera, but the trouble is that atop the camera is probably the worst place to put it! This is one of the main reasons to use studio-style lighting. Harsh light from right above the camera causes many problems and is generally unflattering. First, very unattractive "red-eye" can occur. Red-eye is caused by the flash reflecting off the rear surface of the eye. Second, it may create a harsh shadow on the wall behind the subject. Third, it produces a very bland light that gives no shape or substance to the subject. And because the flash is a small light source, it is also a very hard light source. Indirect or suffused light, as seen in the diagram on page 98, is a much more flattering option for portraiture.

Mark Thiessen used three different lights—one on the floor, one to the side, and one in front— when he made a portrait of Lauren Pruneski.

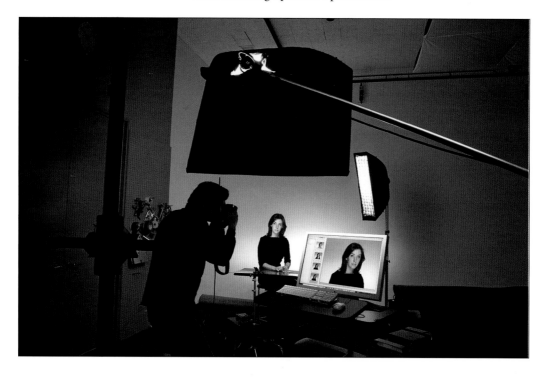

Your First Try

Let's start off with some simple portraits. Sit your subject somewhere comfortable, because it will take a little time to try this. Make sure you have a good background, that all-important contributing factor to most pictures. For now we will use as simple a setup as possible.

- Set up one of your flash heads with an umbrella.
- Set your light up slightly higher than your subject's face.
- Point your camera straight onto your subject with the camera right next to the light source.
- Vary your position in relation to the light source and ask your subject to look directly at the camera for these first few shots.
- Compare how the lighting changes as the light becomes more acute on the subject's face. Do this on your LCD or on a computer monitor. You will now have some pictures that show a lit and an unlit side to the face. You should notice how the shadows change as the position of the light varies.
- If the shadows are a little harsh and overpowering, introduce a reflector.
- Use the reflector to bounce the light from the flash head back into the face to fill the shadows in. It is amazing how much the lighting will change with the introduction of a reflector.

Summary

- Know your subject. If your subject is a family member or friend, this is not really a problem. But if you're photographing strangers it's important that you establish a rapport with them. Take the time to talk to them before and during your session to find out what their interests are, and try to incorporate these into the portrait if possible.
- Backgrounds can make or break a good portrait. Always be aware of what's behind your subject. Use the background to enhance your picture, not detract from it.
- If a poor background is unavoidable, try using a longer lens and a larger aperture to produce less depth of field. This will throw the background out of focus and reduce its overall effect on the image.
- Experiment and give yourself options. Try not to approach a portrait session with a fixed idea of how you're going to take the picture. Sure, it's good to have some ideas going in, but I've

Raymond Gehman made this portrait of his family one evening.

always found that even after I've achieved what I think is a good shot, I do well to try some different ideas.

- Change the lens, lighting setup, background, or the pose of your subject and see what happens. You'll often be pleasantly surprised at the results.

NIGHT PHOTOGRAPHY

Photographs taken at night have an almost mystical way of evoking emotions and stirring memories. Some locations even look better at night than they do during the day. Night photography

can produce magical images of scenes that in daylight can look drab and mundane. And night photography is not difficult if you follow a few simple rules.

Nighttime photographs almost always require long exposures. This means using a tripod to hold your camera perfectly still while the shutter is open, though you can sometimes find a solid surface to rest your camera on and trip the shutter with the camera's self-timer.

Night photography is one area where, admittedly, digital is at a bit of a disadvantage. The image sensor in a digital camera is

an electronic device with a tiny electric charge running through it. When long exposures of dark scenes are made, this can create a condition called noise. Noise is similar to watching a television channel that is not tuned in correctly and can adversely affect your pictures.

On most high-end D-SLRs the maximum exposure before noise becomes a problem is about 4 seconds. Often this is not a long enough shutter speed to expose the scene correctly. In these cases the ISO setting can be increased to allow slightly shorter exposures, though increasing the speed setting may also introduce noise. Some cameras have special noise-control settings that can be activated for this kind of photography. And if noise is inevitable, it can often be lessened or eliminated with special imaging software.

The rules of composition for normal daytime photography apply equally to a night picture, but more attention needs to be paid to what is actually in the frame. Large, intense light sources—like a street lamp in the foreground of the picture—should be avoided, as they will dominate the scene. They will also affect the overall exposure and often obliterate much of the more subtle detail that can make night pictures so appealing. Likewise, large dark areas can throw a picture visually off balance; however, if carefully used they can actually add to the drama.

Particular care needs to be taken with your exposure when you're shooting at night. If you're using your D-SLR's averaging or multisegment meter, any bright lights in the picture may give a false reading of the overall available light. A false reading could produce a picture with correctly exposed highlights but no detail at all in any other part of the image. In essence, the image should be slightly overexposed, which will "blow out" the highlights a little while capturing detail in the darker areas of the picture. Averaging and even multisegment metering systems do tend to overexpose in such situations but can actually cause too much extra exposure—diminishing the nighttime quality you're after.

Mixing flash and long nighttime exposures can produce some interesting effects. Because the duration of the flash is so short, it will freeze any motion in foreground objects, but non-stationary objects such as traffic or people in the background will

still show movement, since the shutter stays open much longer than the duration of the flash. The result is a picture of your friend in the foreground who is perfectly still and sharp, while the background retains all the movement and atmosphere of a night shot.

Digital photography allows us the opportunity to look at each image as we take it, and this is a huge advantage over film. When reviewing your night pictures, pay particular attention to the darker areas of the image. Check that there is some detail in there, as this is often where the magic of a night picture lies. Just keep in mind when viewing night images in a dark setting that a D-SLR's viewing screen may not provide an accurate representation of the actual digital file.

Taking pictures at night gives us the opportunity to experiment and get a little creative. Movement of the camera during exposure will cause blurring of the image, which can produce

More traditional weddings require a good strategy to compensate for changing weather and light.

some very interesting results. This effect can be especially interesting with neon signage because of its complex patterns and colors and also because its lesser brightness often means that more detail is recorded in darker surrounding areas. In addition, depending at what point during the exposure the movement is made, different types and amounts of blur will be produced. Deliberately moving the camera when the exposure is nearly complete will produce ghost-like double imaging, and as most of the exposure has been completed, the blurring will have a less dramatic effect.

If you own a zoom lens—and who doesn't these days—another interesting trick is to change the focal length of the lens during the exposure. With the camera mounted on a tripod, press the shutter release and while the shutter is open, turn the zoom ring on your lens. Try going from short focal length to longer focal length and vice versa, and experiment with the speed at which you turn the zoom ring. I can guarantee that you will get some interesting results.

WEDDING PHOTOGRAPHY

There are many ways to photograph a wedding. To simplify the process, consider two main choices: formal portraiture or documentary. Whichever you choose will determine the equipment you need. The choice should also be a reflection of the couple. A more reserved couple may feel more comfortable with portraiture, and a very active couple may not want to sit for pictures. Documentary style would work better for them.

For formal portraiture you need to scout your locations before the wedding. Determine what the light will be at your chosen location at the time of day you will be there. Knowing the light and the background beforehand will save you time and give you the chance to work at greater length with the people you are trying to photograph.

If you are shooting formal portraits indoors, you will probably need some flash equipment, including light stands, reflectors, or umbrellas. (An assistant also comes in very handy.)

During the ceremony, many clergy will not allow flash inside the church. However, if you want to use flash at any other time during the day, try to use bounce flash or at least

a diffuser on the front of your flash to soften the light. This technique will help to avoid strong shadows and flare from the bride's white dress.

If the wedding is at midday outside, you may need to use fill flash to erase the harsh shadows caused by the sun high in the sky. Most cameras and dedicated strobes now have an automatic setting for this, sometimes referred to as fill flash. If you are using a manual setting, take a light reading and set your flash on automatic so that it is producing one stop less light than needed for an available-light exposure.

If you decide to shoot in a documentary style, you will need a camera body and a good zoom lens such as a 24mm-85mm zoom. This lens is wide enough to capture the atmosphere of the event—like the interior of the church during the ceremony—and

Josef Isayo knelt on the ground to capture the perspective of the flower girl during the wedding ceremony.

PREPARING FOR
AERIAL PHOTOGRAPHY

The first thing you notice about photojournalist Vincent Laforet is how fast he speaks and how much information he crams into those speedy sentences. Camera names. File sizes. RAW versus JPEG. Online archives. Post-production details. Then you suddenly realize why Photo District News picked him as one of the "30 under 30" photographers to watch. He's really into it.

Laforet first learned about film and photography from his father, Bertrand, who was a photographer with the Gamma photo agency. But while still in high school, Laforet glimpsed the future one afternoon when he studied a Photoshop 2 manual. "I think I learned it in a day," says Laforet. "I've always been into computers."

Fast-forward past a bachelor's degree in journalism from the Medill School at Northwestern University, four newspaper internships, and a job with Allsport LA, a picture agency to the turning point in Laforet's career—a job as a web producer at the *New York Times.* At the time, he was one of three people responsible for all of the photographic content at the newspaper's website.

"The biggest problem with digital initially was [camera] delay," says Laforet, who was shooting with a Canon DTS-520. "There were so many pictures missed."

"There was a lot to learn," he admits, remembering the years of trial and error. "You couldn't crop your photos; the resolution wasn't good enough yet. Hard drives were failing. We had to use big, bulky batteries. One guy who came back from a World Series game asked, 'How many stops can I push this disk?'"

Now when Laforet hires a helicopter, he is prepared. He takes three Canon camera bodies. The first camera is fitted with a Canon EF 16-35mm f2.8L USM lens. The second is fitted with a Canon EF 28-70mm f/2.8L. The third has a 100-400mm zoom lens. He keeps a Canon EF 14mm f/2.8L USM in his bag. "Aerial photography is like working in sports," says Laforet. "Using long lenses you try to catch a moment when it happens."

Post-production is now central in Laforet's mind. He stores his images with Photoshelter, an online archive that he can easily access from his Blackberry.

Laforet shot skaters at Lasker Rink in New York City from a helicopter in the afternoon. He titled the photograph "Me and My Human," 2004.

long enough to zoom in a bit and capture the more intimate moments of the day. A longer telephoto such as a 200mm, or an 80-200mm zoomed all the way in, helps you to photograph candid moments without being noticed. Just keep in mind that you will lose some depth of field to capture these intimate moments.

Another very useful item for either style is a small, lightweight stepladder. This tool will allow you to not only gain a new perspective in some of your pictures but it will also guard you from missing important moments when a crowd gathers around the bride and groom. It is also handy when you need to photograph large groups of people, because they can all look up at you.

Different angles can make the story of the wedding much more interesting to look at later. Try getting on the floor and shooting pictures as if you were one of the children at the ceremony. If the church has a particularly beautiful nave, make a vertical picture of the ceremony to feature it. See if there is a place behind the clergyman to shoot from his perspective. Use door frames as frames within your picture. Sit in a pew and photograph from the perspective of the guests.

Because you can be more mobile when shooting documentary style, you potentially could miss key moments because you're not there when they happen. Study the details of the ceremony beforehand and time yourself. Once you know the schedule, strategize about light and camera equipment. If you need to, leave a setup beforehand in a location that you can move to, use, and leave quickly. If you are using available light, be careful with your exposures. They don't all have to be perfect.

WILDLIFE PHOTOGRAPHY

When we think of wildlife photography we tend to associate it with those spectacular nature documentaries on television. But wildlife photography doesn't only take place on the African savanna or in national parks. The possibility of photographing nature exists much closer to home. Your own backyard or a local park is all you need to get started. The most important thing you'll need is patience and yet more patience. Animals are wild. They are timid around humans. They will not stop and pose for you.

Food and water are the two most common tricks for finding animals and getting them to sit still for a moment. Put a little

Josef Isayo capitalized on his newspaper experience when shooting lifestyle pictures at a wedding.

Nick Nichols captured the speed of a western lowland gorilla by panning with a slow shutter speed.

snack on the ground for a squirrel. Move a short distance away and prefocus on the spot where the food lies. Wait.

If your preference is for photographing birds, knowledge of their particular habits can be beneficial in helping you get close. If you're aware that a particular type of honeyeater bird can't resist the blossoms on the magnolia tree down at the bottom of the garden, then study what time of day he eats there. Is it early in the morning? Or late in the afternoon? Once you have pinpointed preferable times, conceal yourself and plan your camera settings.

Care must be taken when using longer lenses to ensure that you have sufficient depth of field. You usually want the entire subject to be sharp; even though an animal may look to be all in about the same plane, with a long lens you can get one part of it in focus and another out of focus. In fact, when you're filling the frame with a small creature such as a bird or squirrel, you may want to shoot at apertures such as f/8 or f/11.

Such moderate apertures may also be a good idea when you're doing a "portrait" (a head and shoulders image) of a larger animal; set too wide an aperture and you may only get one eye or a nose in focus, especially if you're shooting from an angle. This may necessitate using somewhat slow shutter speeds with a tripod or monopod to keep the camera steady.

Reasonably slow shutter speeds (perhaps 1/15 second) shouldn't present problems when photographing most wildlife with a tripod. Unless they're on the run, your subjects will normally be fairly still, especially if they're feeding. If you're shooting a large animal you can often get away with setting the lens at or near its maximum aperture, for example f/4.

Insects make wonderful subjects for pictures and they exist everywhere. A spider spinning silk as the early morning sun glistens and sparkles on the overnight dew that clings to its web makes a beautiful picture. The addition to

TIP:

At the time of publication, there are a few D-SLR cameras available that have full-frame 35mm-size image sensors. Depending on the particular camera body you use, and the length of the lens you are using, the image sensor may have a "field of view" crop of anywhere from 1.3x-2x. For a Canon EOS-1D, for example, a 35mm focal-length lens would be the equivalent, in terms of a 35mm format angle of view, of about 46mm; for an Olympus Evolt E-300, the same focal length would be like a 70mm.

your equipment of a macro lens opens up a whole new world of wildlife photography. (See the macro section later in this chapter.) Insects photographed in extreme close-up make wonderful and interesting subjects and can be photographed outdoors or indoors using a simple studio setup consisting of nothing more than a couple of halogen lamps and a white board to use as a reflector.

Just keep in mind that when you're shooting subjects at such close distances, depth of field is extremely limited. In fact, you may want to stop a macro lens all the way down to f/16 or f/22 if you want to get an entire insect in focus.

KIDS

There are a few simple guidelines and tips that will make the task of photographing children a little easier and help to produce good results. As well as the right photographic equipment, you will need a large supply of one other commodity: patience. If you are impatient, you will not have a hope of taking good baby pictures.

First, a newborn baby is much easier to photograph than a baby who is a few months old. While newborns and young

By placing yourself near the food source and waiting, you can sometimes get intimate photographs of the denizens of your backyard.

babies are incapable of much more than just lying there, older babies and toddlers never stay still. When photographing young ones, I have always found that having the mother behind you is almost guaranteed to attract the attention of the child. With some suitable props like a set of keys or a favorite toy, Mom will usually be able to hold the child's attention, if only briefly, and allow you to get your pictures.

Small children live in a world that is only a couple of feet high. If you want to be successful with your pictures, you have to put yourself in that world. Squat, kneel, or even lie down on the floor with them and see the world as they see it. Pictures taken at the same level as the child can have an intimacy that you simply don't get by just standing there and shooting down on the baby as he or she lies in a crib. You will probably look quite ridiculous as you wriggle your way across the floor impersonating a boa constrictor in pursuit of a six-month-old kid, but the results will be well worth the effort. To start, here are a few basic tips for better photos of children:

- Use a moderate telephoto lens or a telephoto zoom. The wider angle of view of wide-angle lenses mean that you have to be close to your subject, and this can cause distortion. So try to use short to medium focal length lenses or focal lengths like 85mm, 105mm, or even 135mm lenses and make the baby, not the background, the focal point of the picture.
- Try to position yourself to get a nice clean background so your subject dominates your pictures.
- Shoot with available light so your subject will relax.
- Remember that if the subject is moving, you should use a shutter speed fast enough to freeze its movement; in some cases this could be as slow as 1/60 or 1/125 second, but for a fast-moving toddler you might need 1/250 second. Also, stick with autoexposure modes—program or aperture-priority, for example—so you are not thinking about the exposure too much. Concentrate on what matters: how your picture looks.
- Keep your camera with you at all times. Children will continually surprise you, and some of the most exciting moments occur spontaneously and without warning.
- If you can't keep a camera in your pocket at all times, try to install one camera upstairs and one camera downstairs. You may not get all the moments you want but you can get more!

Summary

- Be very, very, patient. Children will do what they want only when they want to do it. Be prepared to wait.
- Take the time to let the child become familiar with your presence. Ideally you want the child to be oblivious to you rather than distracted by you.
- Try to have a parent on hand to attract and help to keep the attention of the subject.
- Favorite toys and other props can often be used to momentarily attract the attention of a small child.
- Put yourself on the same level as your subject.
- Use appropriate lenses.

STILL LIFE

Still-life photography allows the photographer a high degree of control over all aspects of the shoot. It doesn't need a lot of room. It isn't expensive. And unless you're shooting by window light, it doesn't rely on the weather. Basically, it's photographing any inanimate object or group of objects and putting them into a context that tells a story or conveys an emotion.

A disposable waterproof camera might be a good option when photographing kids at the pool.

Digital photography makes learning these skills easier than ever. Using your kitchen table, some simple lights, and a bit of imagination, you can make wonderful still-life images.

The first and most important piece of equipment you will need for still-life photography is a sturdy tripod. You will most likely be shooting with a slower shutter speed unless your lights are very bright or you're using flash equipment. Another good reason for a tripod is that it allows you to maintain the position of your camera—and your composition—as you adjust the lighting.

With still life, your lighting is just as important as what you choose to photograph. Many types of lighting are available to you, ranging from expensive studio lighting to common household desk lamps. If you don't have any studio lights, do not despair. Some homemade reflectors, or a diffuser for the sun, or your flashgun will expand and improve your lighting.

There are two types of backgrounds that are essential for good still life photography—a black background and a white background. These can be made of any surface you prefer: Plexiglas, Formica, cloth, velvet, painted canvas, etc. As you become more adventurous, experiment with patterns or textures. Or buy some light canvas and paint your own designs.

The Black Background

The pure black background is the first type of background with which I suggest you start. I like velvet because it absorbs any light hitting it. As a result, no shadows or reflections appear in my pictures. The velvet should be placed so that the object you are photographing sits on one end of the piece of velvet with the rest draped over a chair or clipped with hardware-grade clamps to a proper frame. The background should be seamless.

The White Background

A white background can be used in much the same way as the black background except that you will get shadows in the image unless you change the setup. For this reason white gets more involved and requires more time and equipment to get it all properly setup. Also consider the nature of the two colors: Whereas black backgrounds tend to add intensity to a

photograph, white imparts a clean, light, open feeling to the photograph. Consider the nature of your subject when choosing (black would be easier if your subject will likely jump or squirm away) and also the amount of time you have to make your picture.

There is also a technique with a white background that can make the objects you are photographing appear as if they are floating in space. The background needs to be lit separately from the subject and should be around two stops brighter than the object you are photographing.

Here's how it works. Take a piece of clean glass and support it between two chairs. Arrange your subject on top of this glass and set up your lights so that the subject is lit the way you want it. Shoot from above with your camera mounted on the tripod. On the floor under the glass, spread out a white bed sheet and light it separately so that it is two stops brighter than the subject.

If the light meter reading from the subject is 1/30 second at f/8, then the light meter reading you get from the bed sheet should be at least 1/30 second at f/16. This will ensure that the background is "blown out," and the distance of the subject from the background will be great enough to make certain that the

A simple dark background helped Robert Clark make this orchid stand out in his photo.

For a story on how the body processes sugar, David Arky made a light switchplate out of sugar cubes and then placed it on Plexiglass to make this photograph.

background is totally out of focus and no texture is visible in the background.

The Translucent Background

By purchasing a large piece of translucent Plexiglas, you can expand your still-life capabilities even further. The Plexiglas will require some sort of frame to support it so that it bends gently in the middle and forms an arc. By lighting the Plexiglas from underneath with a separate light, the subject will have the appearance of floating in nothingness.

Other Backgrounds

There are many kinds of backgrounds you can use in still-life photography. Fabrics that complement the tones and textures of your subject can create interesting contours that can produce pleasing results. Look at the environment around you and be constantly aware of what might make different or interesting backgrounds. A pile of autumn leaves, beach pebbles, or sand can provide texture and form that add interest to your still-life photography.

These are the basic backgrounds, but don't be afraid to experiment. If you decide that still life and product photography are what you're interested in, you might want to look at purchasing commercial studio lighting. I highly recommend trying the do-it-yourself way first, however, even if it's only as a learning experience. The more you learn about lighting the more successful your pictures will become.

A Simple Lighting Example

For this example we will use a white background. First, set up a piece of cardboard at a 90-degree angle to the surface on which you have placed your subject. Arrange your subject and plan your lighting. A good starting point is to have a key light off to one side and slightly above the subject. Put a second light, called a fill light, on the other side and lower than the main light. Using a piece of white card or polystyrene as a reflector, bounce light onto the subject to fill in any shadows. To keep the background a pure white, use a separate light and direct it only at the background. Remember it has to be two stops brighter than the light reading you are getting on the subject.

When you are taking your light reading it is essential that you read the light from the subject and not from the background. Try to use your camera on the manual exposure setting. An automatic setting, which reads the mid-tones, will most likely render the picture darker.

Don't be afraid of getting close to your object. Fill the frame with it and go even closer. Sometimes a section of an object is more visually appealing than the entire object. Look at what you intend to photograph and ask yourself, "What is interesting about this?" It may be that the label on a bottle of wine is the most striking feature, so concentrate on that.

Some objects need to be placed in a setting that gives them a sense of context. If, for instance, you are photographing a kitchen utensil like a cheese grater, you could place the grater in the context of a kitchen. Or you would fill a fruit bowl with fruit before photographing it.

Holly Lindem cut a tomato into two pieces and sewed them together for a story on genetic engineering.

Although the previous paragraph is generally correct, it is always worth experimenting with backgrounds, as sometimes an object photographed completely out of context can create a striking effect. A soft red rose photographed against a heap of black coal, or a sculptured piece of jewelry set against the dirt and grime of a workbench can produce wonderful results. There are no rules; whatever looks good to you is what you should shoot.

Focus is a very critical issue with still-life photography. As depth of field becomes small at short distances, try stopping down the lens to a small aperture and use longer shutter speeds. This is one of the reasons a good sturdy tripod is essential. However, keep in mind that a more "modern" approach to still life has been to use shallow depth of field to throw elements of the still life deliberately out of focus.

There are no right and wrong lenses to use for still-life photography, but there are right and wrong lenses for particular subjects. When you're photographing objects that have straight lines, like boxes, it's preferable to use a telephoto lens or setting such as 85mm or even longer, as the longer focal length will help keep vertical lines from diverging as strongly toward the top of the frame.

Have fun with your still-life photography. Experiment. Put objects in crazy situations. Use different colored gels in front of your lights. Use some natural light from a window. When you are shooting digitally, review your shots as you take them, checking for reflections, shadows, and composition. Try to avoid using the LCD screen in this instance, however, because the computer screen will provide you with a more accurate picture. When using lights it's always better to check your images on the computer.

MACRO PHOTOGRAPHY

Macro photography is photography magnified. Generally, a photograph is considered macro when you are increasing the size of an object in your picture from about half life-size, as represented on the image sensor, to five times life-size. "Life-size" means that the subject is the same size on the image sensor as it is in real life; in this case, your "reproduction ratio" is said to be 1:1. If your

subject is a beetle that's half an inch long, it will also be half an inch on the sensor when properly focused with the lens set to its closest focusing distance.

If you are contemplating macro photography, there are some things (aren't there always?) of which you will need to be aware.

- Specialized lenses and accessories enable you to focus much closer than normal lenses. These may be simple and relatively inexpensive supplementary lenses, or they can be more expensive macro lenses. Some common lenses have a macro function built in; they usually say "macro" on their barrels to denote this.
- Depth of field decreases the closer you get to the subject and as the magnification increases.

Jonathan Blair used an ultraviolet light to make this picture of a bee on a black-eyed Susan flower.

Todd Gipstein used a macro lens to capture the geometry of a palm frond in Bermuda.

- If you intend to use flash lighting, there are specific pieces of equipment unique to macro photography. A ring flash is one of them.
- A good sturdy tripod is essential. There are two options. You can buy a tripod with legs that splay wide enough to allow a very low position. Or you can buy a tripod that has a reversible head stem that allows the camera to hang facing down under the tripod.
- A right-angle prism viewfinder, a camera accessory that enables you to look into your camera's viewfinder from above, below or from the side, eases your ability to work from different angles.
- Some cameras have a built-in macro function. You will have varying degrees of success with these because they can't and don't provide true macro functionality, usually.

Lenses for Macro Photography

By its very nature, macro photography requires that you focus very closely on your subject, much closer than normal lenses will allow. Here are a few basic suggestions from which to choose.

A close-up attachment is a flat, filter-like lens that mounts to the front of your normal lens (it usually screws into the filter

thread) and allows you to focus more closely. You will be able to focus at closer distances, although the maximum magnification will depend on the focal length of the lens to which you are attaching it.

An extension tube is mounted between the camera and the lens to move the lens farther away from the camera body. These tubes are usually proprietary, designed to fit the specific camera body lens mount and lens-mounting hardware you use. They are probably the most cost-effective way of achieving macro pictures. Extension tubes are usually bought in sets of two or three, and combining them gives varying levels of magnification. Because these extension tubes have no glass in them, they will not have a noticeable effect on image quality. However, recheck your exposure. Extending the lens will usually require an increase in exposure.

True macro lenses are the most expensive option but they are simpler to use, in part because they preserve all the electronic connections between the lens and camera, including those for the most automatic setting; they are also optically designed for macro photography. These lenses usually focus all the way from infinity down to 1:1.

Many standard zoom lenses are marketed as macro lenses because they can typically shoot a reproduction ratio of 1:4, sometimes as good as 1:3, which may be enough for most purposes. If you can achieve a ratio of 1:4, for example, you can shoot an area as small as 4 x 6 inches. (This applies to full-frame digital cameras in which the image area is about 1 x 1.5 inches.)

An extension bellows places the lens a greater distance from the camera body, like an extension tube. The difference is that a bellows is continuously adjustable. By turning a knob on the side of it, you can adjust the distance from the lens to the sensor.

A reverse lens adaptor allows you to mount your lens backward on your camera. Whereas this can be an effective and cheap method of obtaining closer focusing, most modern digital cameras rely on electronic connections between the body and the lens that render this method impractical for D-SLR cameras.

Macro Photography Techniques

An important concern in macro photography is the need for depth of field. As a general rule you should use an f-stop no wider/larger than f/16 to get all or most of the main subject in focus. If you are photographing a subject that can't be arranged more or less on the same plane, you will have to decide which part or parts of it you want in focus. Because you have to use a small aperture, your shutter speeds will be much longer. A good tripod is essential to prevent any movement during the shutter duration.

That said, it's fun to experiment with wider/larger lens apertures, which will throw more of the subject out of focus and may produce pleasing artistic effects.

When using any of the macro accessories such as extension tubes or add-on lenses, it is preferable to extend the focus of your lens as far as you can and actually focus on the subject by moving the camera. First, roughly focus the subject at the distance from which you want to shoot. Then move the camera slowly in or out to bring the subject into sharpest focus. This can be awkward if the camera is mounted on a tripod, which it should be. If you plan to do a lot of this kind of photography, you may want to consider purchasing a focusing stage, a device that mounts between the camera and the tripod and allows the camera to be moved back and forth without moving the tripod.

Macro Photography with Flash

It is usually impractical to use your camera's built-in pop-up flash when doing macro photography. The length of the lens, with or without all of its macro attachments, will cause a shadow from the camera's flash.

One solution is to use an external flash. The best type of external flash will have a head that rotates and elevates. A fixed flash can still be used, but one that doesn't can still be used. If the head of the flash is high enough over the lens, the problem of a shadow won't be an issue, but as you know by now direct flash is most unflattering. Diffusion techniques, such as wrapping the flash head in tissue paper or using a diffusion accessory, can help.

A flash with a rotating head lets you direct the light up at a ceiling, on a wall or other surface near the subject. Light bounced off of these surfaces will not only change its direction but also soften and diffuse it. Note that the color of the light will be affected by the color of the object at which you point the flash and bounce the light. White or neutral colors are the best choice. A piece of white posterboard can be quite handy as well.

Finally, there are special flash units designed specifically for macro photography. On these units, the flash tube itself mounts on the end of the lens barrel, connected by a cable to a control unit mounted on the camera's flash hotshoe. The output on these units is specifically calibrated for short distances. Some use a pair of tubes that slide around the end of the lens and can be independently turned on and off, allowing you to control the directional quality of the light. On other units, the flash tube completely circles the end of the lens; these units are called ring flashes, and create an even spread of light without any shadows.

In Brazil, Joel Sartore caught this leaf-cutting ant carrying some dried fruit.

ALWAYS EXPERIMENTING WHETHER IT'S FILM, DIGITAL, OR SHUTTER SPEEDS

Nick Nichols has never met an obstacle he didn't jump over. Want to make a rare photograph of a leopard at night? Find the water source, invent a "camera trap," and let the leopard make the picture. On assignment for months in Africa and run out of daylight film? Use the slower speed film you have. Friends and peers using only black-and-white film? Shoot in color, with flash.

For almost 40 years, Nichols has never stopped experimenting. In the 1970s he shot stories on rafting and climbing for a magazine called *American Geo.* He shot features for *Rolling Stone.* When he saw he could create an edge of movement in his pictures with a mixture of flash and ambient light, he tried it a lot, earning the nickname "photo vivitar." In 1980, when he did a story on mountain gorillas, he applied the techniques he had learned in documentary to wildlife photography, pioneering a whole new way of seeing animals. "I want to capture the mystery that's out there," says Nichols, describing the blurs and pans and fill-flash pictures he brings back now. "I want to honor wildlife in my pictures, not tame it."

Now Nichols has turned his attention to making digital photography work for him. His first story was on the Grand Canyon. Next he takes his digital cameras to photograph the elephants in Chad, where he plans to recharge his computer batteries with a charge from his truck or an available portable generator. He loves the ability of the digital cameras to work well in low-light situations below the jungle canopies. The new technology, he says, is rejuvenating his creativity because he is able to experiment in a whole new way.

"I'm always pushing the boundaries with shutter speeds and now I can see if it's working," says Nichols, who recently documented the latest Rolling Stones tour, "A Bigger Bang."Every night he experimented with a different shutter speed. The first night he shot only at 1/15 second. The second night he only used 1/20 second. The third night he settled on 1/25 second. "I was able to hold features with 1/25, but the pictures still had energy."

Nichols first learned photography in the Army where the rule was *f/8 and be there.*"It meant you've got to get the picture first before you

A black leopard roams the Audubon Zoo in New Orleans.

worry about the technical," says Nichols, who has put himself into unforgiving territory most of his career. After studying fine-art photography, he joined Magnum Photos and the booming world of magazine photojournalism. He has photographed more than 30 stories for *National Geographic*. His latest book, *Last Place on Earth*, is in bookstores now. To learn more about his work, go to *www.michaelnicknichols.com*.

A baby chimp peers through the bars of its cage at the Monrovia Zoo in Liberia.

A leopard breaks the infrared beam from a "camera trap" near a watering hole in Bandhavargh National Park.

African forest elephants tussle at dusk in the Republic of the Congo.

Chapter 4
A Camera Phone
Travelogue

4 | *A Camera Phone Travelogue*

Robert Clark shoots a self-portrait in his rear-view mirror.

In 2005, photographer Robert Clark published one of the first books created entirely with digital images from a camera phone. Like many of photography's greatest contributors, Clark chose a road trip as the vehicle to help him explore not only camera phone photography, but also his very personal world. This is the story behind the making of his book, Image America.

Ever since I first looked at *The Americans,* a ground-breaking photographic book created by Robert Frank in 1958, I have wanted to travel across the United States to produce a set of pictures capturing a certain time and place. The opportunity came my way in 2004, but with an interesting twist: I could embark on this journey, but the only camera I could use was the one in my cell phone. Sony Ericsson provided the phone—a 1.5 megapixel S710A camera phone—and *American Photo* magazine created a website to which I would upload 25 pictures daily during my 50-day odyssey.

GETTING USED TO THE CAMERA

To get to know my new camera, I started to carry the phone with me wherever I went at home. The first picture I shot that I liked was a black-and-white image of a fork from my dinner at a restaurant called "The Diner," in Williamsburg, Brooklyn. I refer to The Diner as my second kitchen. I've been a regular there for several years, so the staff is used to seeing me shoot photographs. This time everyone was amused that I was spending so much time with my camera phone. After all, they're used to seeing me with state-of-the-art professional equipment.

I started as a newspaper photographer and I have used 35mm cameras almost every day since 1977. But after moving to NYC in 1991, I have used 8x10, 4x5, 6x7 cm, 35mm, half-frame cameras— whatever would get the job done. The process of getting "used to" or "comfortable" with a different camera system is both frustrating and fascinating. I had about a month to experiment with this new gizmo. Although I was excited about beginning the journey, I was a little nervous about being able to deliver quality images.

One afternoon, I met with a fellow *National Geographic* magazine photographer, Tomasz Tomaszewski. He's an incredible photojournalist from Poland and a very close friend—one who is always wise, sincere, and brutally frank. He began a huge debate with me about my trip. He could not understand why I would work with a camera phone when there were so many other great cameras available with which to shoot. He told me not to take this challenge and he made some compelling arguments.

Still, I felt strongly that every camera has unique capabilities and disadvantages. It is up to the photographer to learn how to exploit the advantages and to work around the disadvantages. To me, this was not just a gimmick. But I couldn't speak with much conviction at that moment; my journey had yet to begin.

On March 2, 2004, I left my home in Brooklyn after saying goodbye to my wife, my friends, and my 29 professional cameras. Instantly, I felt an intense combination of freedom and pressure—the freedom to shoot whatever I wanted and the pressure that comes with that kind of freedom.

A single candle lit this fork inside a diner at night. The camera phone bumped up the ISO on its own, which explains the grainy texture of the picture.

Clark's vehicle, nicknamed "Moby Dick," hits the road.

Every day I was expected to update the website created by *American Photo*. Fortunately, my assistant, Max Sternberg, was able to help me organize the project and read maps while I was driving. It's a challenge to shoot 25 compelling photographs every day and then have to figure out how to upload them. It took a couple of weeks to really get things organized and running smoothly. Eventually I purchased a one-terabyte hard drive, and we would download the images as quickly as possible. Wireless Internet access was usually just a strip mall away, and with a multitude of coffee shops across the country, a great time for a caffeine break too.

CRUISING FOR FEATURES

During this trip, I would learn about the country and rediscover the thrill of "cruising for features," something I first experienced in my days working at several daily newspapers. I was constantly searching in good light, bad light, and no light for pictures. I was up for the hunt.

On day one we ran into a huge snowstorm as we drove towards Toronto, Ontario. Yes, I realize Toronto is in Canada and not in the United States. But it's a beautiful city and it was tough to resist. Max was driving. Steve Miller was on the stereo. The sun was shining and yet the road was barely visible because of the blizzard. It was bitter cold, so I was happy to be in the warm van. When I looked up, I saw Max in the rearview mirror and I shot off a few snaps. I was already starting to appreciate the ease and simplicity of this camera phone.

The choice on the phone's menu to shoot black and white or color was mine, and it was determined by several different factors. The light on the situation, the color in the scene to be shot, and the initial gut reaction I have when I first decide to shoot a photo are just some of the criteria. It really is about your gut. While some pictures work well in color, others are controlled by the color. The viewer can sometimes get "seduced" by color and the content becomes a secondary consideration.

TIP:

Get close. The lens on my camera phone had a great depth of field range but this is not so with every camera phone. So check out your lens. See what it can do by stepping in closer and placing something in the foreground. What happens to the background? Is it fuzzy or sharp? In my case I knew that whatever I put into the foreground, the background would be equally as sharp, so I shot pictures with that in mind.

Sometimes pictures are just about color and they're boring. Other times they're about color and they're art.

Back on the road, I was trying to get used to approaching strangers and also trying to decide what I wanted the pictures in the project to be about. I wanted it to be a trip, a journey, but I also wanted it to be human in visual terms. I wanted it to surprise the audience. I decided right from the start that if I saw something interesting to shoot, even just a little bit interesting, then I would pull the car over, go back if I needed to, and shoot the picture. I was sure that the real beauty of the trip was going to come with pictures of the unexpected or the unexplained.

After about a week on the road, visiting cities in the Midwest, such as Detroit and Chicago, I began to settle into a rhythm. I'm not talking about the blues, although I did get a chance to see some live music in Motown and the Windy City. I guess you could call it my road rhythm. As I left the East Coast behind and traveled further west, things became increasingly familiar to me.

In the late afternoon Clark juxtaposed the blue colors of twilight against the warmth of a streetlight.

Clark combined the shadow on a concrete walkway and another tree to make this picture in Roswell, N.M.

The flat open spaces outside of Chicago started to remind me of the plains in Kansas where I grew up.

I didn't have any road rules to speak of, but I did set out with the intention of seeing as many members of my family as possible. Kansas would be a focal point. My brother and my nieces

live in Kansas City. My sister and her kids live in Randolph. My parents still live in Hays. I would then wend my way west to see another sister in Port Orford, Oregon, before heading south to Galveston, Texas to see the oldest sibling in my family. I'm the youngest of six, so the camera phone was going to get a workout.

Although Robert Frank's book was definitely my first inspiration, literature is just as powerful a tool in my photography. I thought of John Steinbeck's *The Grapes of Wrath* and *Travels with Charlie*, Jack Kerouac's *On the Road*, and William Least Heat Moon's *Blue Highways*. The comfort of the teepee on wheels—which Least Heat Moon called Moon Dancing—I came to understand well. I felt very safe and at home in my 2002 Arctic White Volkswagen Eurovan, or as my brother Patrick named it, "Moby Dick."

In discussing my trip, my brother Steve quoted Steinbeck— "People don't take trips, trips take people." In keeping with that spirit, I started to shoot pictures of what struck me. I saw a beautiful farmhouse on the road in Illinois, the kind I grew up seeing in black-and-white pictures in the *Topeka Capital Journal,* pictures like a sign that said "Exit 0," horses in a field, cattle grazing, the open fields, and a blank canvas.

WATCHING PEOPLE

In Missouri I decided to watch people in a Wal-Mart parking lot for a change of pace. Wal-Marts, and parking lots for that matter, have become foreign to me after living in New York City for 14 years. I found an older man who had a great face. He had a handlebar moustache and the earned wrinkles of a Midwestern farmer. I introduced myself and told him what I was doing. Clifford let me shoot his picture while he sat in his car and we talked about the dying small towns in the area, the war in Iraq, and the fact that things keep changing no matter what. Our encounter was brief (but you can see his picture on the next page) and one of hundreds I would have during this 50-day journey. With each passing mile, it was getting easier to connect with strangers. Having a chance to meet people like Clifford is one of the things I enjoy so much about photography.

Clark changed his settings to black and white before he approached Clifford to make a portrait of him inside his car. He solved the problem of back light from the sun by going in tighter on his face.

FAMILIAR PLACES

As Max and I headed toward Kansas City, I found myself shooting color when the light was good and black and white when the colors were drab. The objects of my attention could be anything—a tree, a bench, or a person. Or, if the light was bad but the subject was good, I practiced my composition in the black-and-white mode.

When we reached my brother Patrick's house, we used the optimal time of day—4 p.m.—to photograph my nieces, Ava and Meredith, at a nearby park. While the kids played, I shot pictures. These images are good examples of the freedom that digital provides. The cartwheel by Ava was one of several frames that I made and reviewed until I got what I wanted.

A lot of digital cameras have a delay. Use the camera until you can guess the delay, then anticipate the moment that you want. Shooting action photos is all about timing. It took a while to understand that there was about a second and a half delay with my cell phone camera. The portrait of Meredith backlit by the sun was possible only because I could review the image and know that the flare was just the right amount and in the correct place. When shooting film, I never would have allowed the sun to hit my lens like that. The odds you can get the exposure right are not high with film, but digital provides instant review and the chance to revisit a picture and learn from your mistakes on the spot.

After Kansas City, we drove about 170 miles to Randolph, population 850. My sister Cindy and her two kids, Russ and Dora, live there. I spent most of the time at the high school so I could photograph my niece and her friends. The kids were great and very open. I shot two pictures that I really liked: one was of my niece in her prom dress and the other was of some of her friends in their makeshift, wood-fired hot tub, a.k.a. the Hillbilly Hot Tub.

As I headed off to return to my hometown of Hays, I reflected on how isolated I had been growing up in western Kansas. One of the reasons I worked so hard to become a photographer was

to travel and explore the world. It was ironic that my current trip took me on a journey through my past.

For years I had driven from Kansas State University in Manhattan, Kansas, to Hays, and I had regularly seen a beautiful church along the way. It sits at the Sylvan Grove exit off I-70 and it looks as if it was placed there for the sake of your eye, giving it a place to rest as you look at the horizon. The church has always had a cross in front that illuminates at just the right time. I photographed it in 1985 for the cover of the student newspaper at K-State, but I was never totally satisfied with it. The 1985 version had a huge thunderstorm cloud in the background, but the cross was not lit. It seemed like two-thirds of a good effort.

Heading west on I-70, I saw the church again and decided that this was the kind of iconoclastic shot that would help give the book the sense of place I was looking for. For two hours,

Backlight from the sun created a nice flare that matched the playful mood of a cartwheel by Ava in the park after school.

I looked at the church from every angle while the light changed as the sun set. I was finally happy with what I was seeing. I pulled the van into the wheat field across the sandy road from the church and lit the rows of winter wheat with my headlights. The balanced exposure between the lights from the cross, the sunset, and the headlights pleased me. Twenty years later, I was finally able to resolve my photo of the church with the illuminated cross.

As I drove towards my parents' home, I saw a car with Massachusetts plates pulled over to the side of the road. I saw what they were doing and I started to laugh. It brought back memories of the summer of 1985 when I used to drive a truck and deliver liquor to small towns throughout western Kansas. The driver and his wife were trying to pull something out from under their car. Being a Kansan, I decided to pull over and see if I could help. As I approached I saw that they were pulling tumbleweed from underneath the car, and it was being added to the collection of tumbleweed already in the back seat. They

thought that they had found the most exotic plant in the world. So for the next hour I helped them collect tumbleweed for their friends in Boston, just "to show them that they are real!" I have often thought of those folks and I wondered what their friends thought of the gift. For a Kansan, tumbleweed, windy weather, and beautiful sunsets are just part of everyday life.

Waiting for the right light at the church and chasing tumbleweed for New Englanders delayed my arrival to my hometown of Hays. But my parents, Dora Lou and Russell Clark, are used to this. I have been showing up late because of photography ever since I was old enough to drive.

The next day I visited the *Hays Daily News,* where I got my first job. I spoke with two young photographers and they wanted to drive around with me as I spent some time in downtown Hays. Hays is your typical small U.S.A town. Things seemed a little slower and a little more vacant. When I was a teenager this was the gathering spot for hundreds of kids to meet and "drag Main." We wasted a lot of gasoline and countless hours here. But some things remained the same. In the center of it all is a giant grain elevator, the tallest structure in town. The elevator was damaged in a fire years ago but still exists as a silent witness to the changing community at its base. I knew this shot had to be in black and white.

SEEING AMERICA

After spending time with my parents, I felt pressured to make up time on the trip as I headed towards Nebraska on I-173. My mistake. Just 30 miles outside of Hays, a policeman pulled me over for doing 82 mph in a 65 mph speed limit. The ticket was a wake-up call. I wanted to make good time, but I also wanted to let things happen naturally. From this point on we drove more or less at the speed limit and never booked a hotel more than two hours ahead of time. Where we were was where we were going. To borrow a term I have always liked, "the journey is the destination."

So the days started to blend: Rapid City, South Dakota; Jackson Hole, Wyoming; Arco, Idaho. I had never driven through this

part of the country. Eastern Oregon is the most isolated and lonely place I have ever seen in the United States.

We hit a large dust storm near Lake Albert. Ansel Adams loved this lake. The rocks are white because they are covered

The dust that hung in the sky as part of an oncoming windstorm in Eastern Oregon acted like a gray card for the spot meter, rendering a perfect exposure that looks like the palette of old Kodachrome film.

with alkaline content from the soil and the ground water. Lake Albert is a vast open area. As we drove around it, I thought about the cost of real estate in New York—$1,000 per square foot—in comparison. This was the only place where we almost

ran out of gas on the trip. My new assistant (Max had to go home), Chris Farber, and I had calculated the distance between the gas stations correctly. But we didn't factor in the power of the headwind, a 40-60 mph relentless barrier on the front of our car, as we tried to make it to our next destination.

We spent the night in Klamath Falls, Oregon, at a Days Inn, and uploaded pictures until 3 a.m. The next day we skipped Crater Lake—a place I still want to see—in favor of reaching my sister Sara in Port Orford, Oregon. Her house rests on the westernmost piece of land in the continental United States.

Seeing Sara is always fun. She's a massage therapist and a real estate agent with a law degree. Her boyfriend, Paul, is an amazing potter. He sells every item that he makes. I shot some pictures of Paul fishing from the coast. I think they worked well. It was nice to be in the surf and nearly halfway done with the trip.

For the first time throughout this entire trip, I was able to sleep in the same bed for more than one night. At a local diner, I ate the largest pancake in the world and then it was time to leave Oregon and head to California.

As long as I can remember I've wanted to see the redwood forest, so we drove to Avenue of the Giants near Eureka, California. Driving amidst these colossal trees, I honestly couldn't find words to describe them. I still can't. I've heard they are the oldest living things on the planet. It was a very humbling and peaceful place.

Shooting these behemoths with a camera phone was uniquely challenging. I yearned for my wide-angle lens, but after a lot of trial and error, I realized that I could get lower to the ground with my camera phone than with my larger professional gear. I captured small plants at the roots of the trees in the foreground with the redwoods towering above. I was reminded again that each camera has its advantages. It's up to the photographer to exploit them.

While working on a story for *National Geographic* a while back, I was fortunate to meet Evan Green, a ten-year-old boy with debilitating, and sometimes life-threatening, allergies.

I wanted to check in on him and I knew he would make a great photo. So we bypassed San Francisco and headed to Evan's home in the East Bay area. He's a great kid and he's the proud owner of a pet pigeon named Pearl. Evan is extremely photogenic, but he has a tendency to ham it up quite a bit. Sometimes that's good, but it also means you have to be patient. When a subject is too active, or too self-conscious, it is difficult to capture a truthful, candid moment. By the end of my visit, I was able to get a picture with my camera phone that is more reflective of Evan than pictures from my first visit with him.

A mural provides an interesting backdrop for this portrait of a waitress one morning.

The Southwest

You can't take a trip across America without stopping in Las Vegas. It was a seven-hour drive, but I wanted to get to a place and settle in for a few days. My last visit to Vegas was in 1994 when I was the designated driver for a group of friends traveling to a Grateful Dead concert. Sin City has changed. It has taken on an amusement-park quality, but it's still a great place for people-watching and

for photographs. Leopard-skin carpets and short skirts seem to be ubiquitous here.

The best thing about Las Vegas was that my wife joined me for ten days. We were able to work out time away from her busy life as a producer around the time my assistant had to leave for his next assignment. We intentionally planned this part of the trip to be more spontaneous, less like work. So we picked Las Vegas as the meeting point and while it was great to have my wife with me, the workflow routine of uploading the pictures fell completely to me because my assistant was gone. Furthermore, Lai Ling realized that her driver's license had expired, which meant I had to do all of the driving. Still, nothing's better than being on the road with my wife. We were able to reconnect after weeks of being apart, and she really enjoyed shooting photos with my spare camera phone while I was driving.

After Vegas, we headed north to Utah. When we reached Bryce Canyon the sun was just going down, and we were suddenly driving into a snowstorm. We had missed the good light and the park was closing. With a little regret, we skipped Bryce Canyon and drove through the night to Monument Valley and positioned ourselves to get into Navajo Nation at dawn. Navajo Nation is the park where a large number of John Wayne movies were filmed. The land is amazing, not just the color or the light, but the shapes of the rocks.

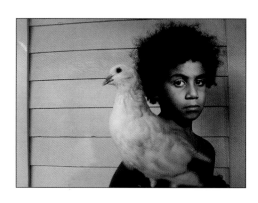

The rock is a beautiful red sandstone. The valley formations are called mittens because they are shaped like a hand in a mitten. Their composition is so delicate and beautiful that it's hard to remember that they are rock formations. To me, it is like trying to describe the difference between 8x10 photography and 35mm. There is something about the internal dimensions of the medium. It seems to have more internal space, if that makes sense. It's like our relationship to time, which changes as we get older.

Lai Ling decided it was too difficult to shoot the mittens with the camera phone, so she spent her time shooting clouds. But I was much more accustomed to it at this stage of the trip. I knew that shooting the monuments would be cliché without adding more to the composition. A piece of wood on the sand provided

A camcorder light off to the right helped to lift Evan's face away from the background and give the picture dimension.

a perfect arch to the mitten. Again, I was able to get a more interesting low angle because the camera was so small.

I shot all day and we stayed until the light was gone. The last picture of the day was a photo of the mitten. Everything was in shadow, and then the light came out for a few seconds. The image came alive with good light and it added depth to the scene. It was a great shared experience with Lai Ling in a beautifully serene place. I felt more peaceful than at any other time on the trip.

Albuquerque was about 380 miles away, so we planned to leave early the next morning. But the chance to sleep in was too tempting. We stumbled out of bed at noon. Most days I was up in time to catch the morning light. But this was Day 29 and I was growing tired. The light in the middle of the day can be so harsh overhead, and lifeless, that the time is better spent driving. So we headed to New Mexico, racing to catch the sunset.

I had always heard people talk about the light late in the day in New Mexico. They weren't wrong. It seemed that everything

The camera phone selected a slow shutter speed in the Mix, a Las Vegas nightclub. Clark held his breath to keep the camera steady.

Placing objects in the foreground can help make compositions more interesting.

Sunlight through the car window lit Lai Ling's face as well as the men on the street behind her.

I was shooting I was seeing with new eyes—a bench at a bus stop drenched in golden light, the light in the van hitting Lai Ling's face juxtaposed with the homeless men on the street. It was like living in an Edward Hopper painting for the day. The city

seemed sad and hardbitten, yet it didn't seem like a place that felt sorry for itself. The people that I met were poor but hardly desperate. They were all hard-working or trying hard to find work. It seemed like a place that would allow you to start over if

Clark moved this musician closer to a yellow wall lit by a street lamp and over-exposed by one stop to get the proper exposure.

you were willing to pick yourself up and try.

Our next place, Roswell, New Mexico, was not quite as cerebral. I had always wanted to see if we could find any space men there. All we saw were the shadow aliens. One of them looked a lot like Lai Ling in silhouette.

Texas

We rolled across west Texas with its amazing sunsets and wide-open space. For two hours we kept passing the different entrances to the 6666 (Four Sixes) Ranch, which spans thousands and thousands of acres. It is one of the largest cattle operations in America. With its rolling hills, countless cattle, and cowboys on horseback, the Four Sixes is the type of place I would love to photograph for a month, or two, or three.

We eventually made our way to Odessa, Texas, which is where I worked on the pictures for my first book, *Friday Night Lights*. It's a story about a local high school football team called the Permian Panthers and the excessive importance placed on winning at all costs. Journalist Buzz Bissinger wrote honestly about that and about the impact that pressure had on the players and the community. The project had changed my career in many ways, and I wanted to get back there to see if the place felt the same as it had during my previous trips.

A few hours later, as we made our way into Lubbock, Texas, Lai Ling saw an amazing building. It was huge by any city's standards. Lai Ling was impressed with its beauty. Was it a library? A courthouse? No, it was the facade to the Texas Tech football stadium. I was told once that religion in Texas was big, really big. They kept comparing it to football. Now I could see what they meant.

When we checked into the Days Inn, the attendant at the hotel told us she was going to give us a room with a view. She did. We could look right down at the Taco Bell drive-thru and the motel's parking lot. I suppose I should have asked, "A view of what?"

In Dallas, we stopped in Daley Plaza where JFK was shot. I spent a little time there years ago on assignment for *Texas Monthly,* but Lai Ling had never been there. We parked along the street that passed beneath the Book Depository building and walked the same route that JFK's motorcade took on the day he was murdered. We were debating the details of the assassination when a local guy came over and gave us a midnight tour. Our guide was animated and made us see the absurdity of the "single-bullet theory."

On the way to Austin, Texas, we met some interesting people: a handsome cutting horse trainer from Olney named

> **TIP:**
> Shoot a lot of pictures. Remember it's digital, so you can. I tend to shoot everything that interests me.

Chet Burrows, a paleontologist named Joe Taylor, some oil field workers, and a few college students. The West is full of guys like Chet Burrows—happy and hardworking, with a strong sense of who he is.

In Austin, we stayed with my friend D. J. Stout and his girlfriend, Julie. We ate lots of ethnic food, drank a fair amount of beer and tequila, and listened to great live music on 6th Street, where hundreds of students were running around the streets. The next morning we raced to the Houston airport so Lai Ling could fly home. We said our goodbyes and I promised to get home as soon as I could.

Alone, I drove to see my sister Lynn and her husband, Michael, in Galveston. It was comforting to eat a couple of home-cooked meals and sleep in a familiar bed. Both of them are great musicians, so we went to a local pub and listened to a Hungarian folk band. In the morning we walked along Galveston Beach, and the seagulls swooped down for my popcorn. In return, I was able to get some nice, close shots of them in flight.

Clark made this image as a simple ode to a famous picture in Robert Frank's book The Americans.

New Orleans

On Day 35, a new assistant, David Coventry, joined me on my five-hour drive to New Orleans. David and I have worked together since 1995, mostly for *National Geographic.* We've traveled to ten countries together shooting ten different projects for the magazine. We were excited about staying in the French Quarter. Little did we know that just months later the city would be changed forever by Hurricane Katrina. It's a great reminder not to take things for granted.

Keep lines straight when making most landscape pictures.

New Orleans was one of the cities on my "must-see" list. An editor at *National Geographic,* Kurt Mutchler, recommended a few of his favorite restaurants in New Orleans, his hometown. At Giacomo's we had alligator quince appetizers. Forgive the cliché, but it really tasted just like chicken. Delicious.

Walking along Bourbon Street, I started to feel nauseated, but not from the alligator. It was a familiar unease—the way I used to feel when I was a young photographer working at newspapers in Philadelphia and Cincinnati. It happened occasionally when I had to introduce myself to strangers and ask them to let me shoot their photos. I never knew when it was going to strike me. That first night on Bourbon Street it happened again and I don't think I shot a frame.

The next day the feeling was gone and I was very eager to start shooting, but it was raining so hard I couldn't see a picture anywhere. Later that afternoon, when the rain subsided, I saw some young men performing marching band music, jazz style, for cash on Bourbon Street. The tuba player performed against a beautiful yellow wall. It's a clean, graphic photo. All it takes to really get my excitement back is to make one picture that I really like—my energy returns and I can work for hours. For the rest of the night I shot the bouncers at music venues, strip clubs, men rolling cigars, and drunken people stumbling along Bourbon Street.

At 8 a.m. the next day we went to Lafayette Cemetery. New Orleans is known for its unusual above-ground burials. If you dig too deep, you're going to get water (a fact even before Hurricane Katrina). I found some flowers in a cement vase that looked

hand-tinted because the concrete and the marble are colorless. The epitaph was simple and haunting: "Husband."

We ate breakfast on the outskirts of the French Quarter, near the streetcar tracks, and I was reminded of a photo in *The Americans.* I love that picture and I shot a photo of the same streetcar line in the same city that was shot decades ago by Robert Frank. Yet, my photograph is not about race, class, and culture—as his was. I'm reminded of the power of Frank's work and that I have miles to go.

Wrapping up the Trip

As we drove toward Alabama, I shot a picture of the map on the dashboard of the van. I was anxious, so we barely even stopped for gas, food, or the decidedly unpleasant rest areas. I reasoned that the faster I drove, the sooner I would get home.

My aunt Anne lives in Leesburg, Florida, in a retirement community. Being from Kansas she had a huge sunflower on her front door. I had not seen her since 1991 when my Uncle Pat was buried in Ness City, Kansas. We spent about three hours with her before we left for Jacksonville, Florida, to pick up another assistant, Alex Disuvero, at the airport. David and Alex and I live in the same building in Brooklyn and we have worked together on different projects for years. It was nice to have both guys with me if only for a day or two. We spent the day in Amelia Island, Florida, and enjoyed the lazy nature of the island. The area has become very wealthy. One thing I have realized on this trip is that there is very little coastline left that is not built upon. It is just one in a thousand useless observations from 40 days on the road.

The trip was on autopilot from there. I had made a few good pictures those last few days, but my thoughts were on the future now: seeing my wife and setting up my next assignment. Alex and I stopped in Washington, D.C., and we met two men—both quintessential American types—yet so different from each other. The first was Larry Ward, who had been a marine for 31 years. I told him I wanted to shoot his picture because I liked his face. He told me that his dad always told him that he had a kind face,

"the kind you would like to throw s--- at." He spends a lot of time now at the Iwo Jima Memorial as a volunteer.

Later, we met another man at the Arlington National Cemetery. Benoit is a groundskeeper from Haiti. He was running a high-pressure hose—the kind you would use at a car wash—and he was cleaning the headstones of the people buried there. He is working in a low-wage, low-status job, but he may have been the happiest person I met on the entire trip. After driving 9,000 miles, I had met two men who helped me understand how much America has to offer. For Larry Ward it was about country and service, and for Benoit it was for his family. Both men were selfless and optimistic.

During the final hours, I started to think about what would become the most important part of the trip for me. I had the chance to see many members of my family; that was the best part. I was able to make some important and beautiful photos using a new technology. I learned a lot about the way I want to show pictures.

Most of my photography today includes a lot of production work as well as strobe power to create the images the editors

If there are too many colors and bad light, switch to black and white so that the content of the picture dominates rather than the clash of colors.

Because of the dark scene, and the ability to review a picture instantly, Clark overexposed for the foreground until the picture looked good to his eye.

at the magazines want. This trip allowed me to return to the roots of photography—just making the photograph with what life presents to me. I shot whatever I found to be interesting, funny, beautiful, or sad. Photography is the language I use to communicate more effectively than anything else. I have learned

a lot, and I now know how much more I have to learn. A trip, in a way, has a lifetime of its own, which has an inevitable end. The difference is that afterward I get to go home. And there is the Williamsburg Bridge, my wife, my home. I have missed New York.

By 2007, 71 percent of all cell phones owned in the U.S. are camera phones, according to the InfoTrends Research Group. Where will all these images be and will we want to look at them? Sometimes, yes. News organizations are creating pathways for people to send in their pictures for spot news stories. Some cell phone stores and photo websites feature galleries of camera phone pictures. There has been a camera phone film festival in Shanghai, and also in France. Film schools are sponsoring contests for films made with camera phones. And an online community of "moblogs" is available for people who want to blog on their cell phones.

Start experimenting. By 2009, four out of five people will own a camera phone and undoubtedly the cameras will be even better. See Clark's work at *www.robertclarkphoto.com.*

Clark allowed the camera phone to read the light from the lit hotel wall so the woman would be in silhouette.

"I love signs," says Clark, who found this Hopperesque scene in Arco, Idaho.

Clark came across this tumbleweed in Oregon.

Chapter 5
The Digital Darkroom

5 | *The Digital Darkroom*

Making a great photograph takes time and effort, whether it's waiting for the right moment, finding the right composition, meeting the right subject, or waiting for the right light. The pursuit may be literally exhausting; sometimes it requires lots of patience. Other times it may fall right into your lap. That is what makes photography great: The journey you take, whether literal or figurative, to make an image is as important as the final photograph.

In the pre-digital world, darkrooms were an odd antithesis to the pursuit that involved making the photograph. The final step in its creation happened in a place devoid of all light, colors, and subjects. Through what now seems like a miraculous, mysterious process involving carefully mixed liquids, diligent agitation, precise timing and—most important—patience and experience, photographers would turn what was previously only a concept that they experienced into a tangible, "living" thing.

The convenience of digital cameras has taken much of that mystery away. In its place is the ability to immediately view what you have shot. The darkroom has been replaced with glowing computer monitors and what seem like miles of wires. At a basic level the technical knowledge required is relatively simple compared to the learning curve of darkroom techniques. But to become an advanced user of the techniques that follow requires, arguably, an equivalent amount of expertise.

All of the tips below were available to a photographer in the pre-digital age, but the ease with which they can be accomplished with a computer is astounding compared to the methods used in a darkroom. Yes, the vital darkroom "craft" is essentially missing. But so too is the nose-burning stench of fixer, clothing permanently stained with daubs of developer, and a trash can full of test prints. (Some sincerely lament the passing of all of those; others gleefully left them behind.)

As convenient as digital is, there are already photographers who have been viscerally turned off by the complexity that going completely digital involves. The equipment can get outrageously expensive, and archiving digital photos is a process under con-

stant debate. (A file cabinet, though big and bulky, doesn't spontaneously "crash" and disappear the way files on a hard drive can.) The cameras themselves are not as readily serviceable or (some will claim) reliable. Film is pretty amazing stuff. It doesn't

A job that was once achieved by hand-tinting can now be done more quickly on the computer.

require power to view or store. Your cameras don't become outdated. You don't have to lug laptops, hard drives, card readers, backup hard drives, backup laptops, and lots of batteries with you to use film. Had film been invented after digital cameras, people would perhaps think it's downright amazing.

UNDERSTANDING HOW WE SEE THINGS, WITHOUT THE CAMERA

Photographs are a wonderfully expressive art form because of their ability to instantly make us feel a certain way. But rarely do we question how and why a photograph can be so powerful. (Nor do we really want to—part of the enjoyment is just having that happen.) Perhaps it is exactly because this link is so direct that we don't require any further understanding of it. But to make great photographs, to create images that make you and other people feel, it's important to understand how and why we respond to them. This chapter touches on a small part of that how and why by using a computer to recreate traditional darkroom techniques.

Our eyes and brains are stunning examples of visual technology. Before you go out and spend money on a digital camera, stop for a moment and consider the camera you already have in your head. You have the fastest autofocus system ever devised. Your brain has a complete automatic exposure capable of immediately interpreting some of the most visually intricate scenes and enough memory to store 70-plus years of these images.

Many people do not understand how their eyes and brains function to understand what is around them. For instance, there's an easy way to fool the automatic white balance of your eyes. If you're outside at night or at dusk, walk by office buildings or houses and notice the color of the light inside them. Offices often emit a green hue, while houses will look distinctly yellow. This is because the fluorescent lights commonly used inside offices are actually very green. Once we go inside an office our brains quickly set a different white balance so the light appears white. But when you're outside, your brain color balances for a different scenario, so the light now appears green. It's the same thing with home lights, which are often tungsten bulbs. Tungsten light is much warmer (meaning more yellow/orange in nature)

and also less energy efficient. Its poor energy efficiency is a big reason why not many tungsten bulbs are used in commercial buildings. Seen from the street, houses have a warm yellowish glow. But once inside you often won't be aware that your eyes have compensated for the warmth.

Our eyes and brains can also see, or understand, a huge range of lightness and darkness in one scene, whereas photographs are quite limited in what they can render. As advanced as cameras and computers have become, we often forget that we are rather advanced ourselves. Learning the limitations of a camera as compared to how we see is one of the best ways to begin taking better photographs, as well as the best way to understand how to enhance them on a computer.

Cameras, whether digital or film, will always be inferior to our eyes and brains. Your experience of making a photograph along with your computer can help you change your image to how you remember it—or how you would like to remember it.

Fluorescent lights glow green. Our eyes correct for this automatically, seeing only white light. It's one of the many "advanced" things we do without realizing it.

Exposure

Whether you're using the newest technologically advanced digital camera or a vintage Kodak Brownie, exposure is always going to be central to the quality of your photograph. With film, camera exposure was always something of an art. One had to rely on experience, science, or faith (or most likely a combination of the three) to achieve the right exposure in difficult situations. There are so many books written on this topic alone, a library could be dedicated to them. And while the learning curve has been greatly reduced with the advent of digital cameras, a person with a solid understanding of exposure will always create a better photograph than someone who

relies on the intelligence (or lack thereof) of the camera to do it for him.

When you create a photograph, you want it to have detail, or information, in most all areas—the shadows, the mid-tones, and the highlights. Why? Because essentially that is the way we see, and therefore photographs are most often pleasurable when they capture a wide range of tones, each having subtle details to discover. And yes, it's certainly okay to break this rule if your creative whims say so. But first learn what goes into making a classically beautiful photograph: It is detail, or information, in all of these areas—and it is achieved first and foremost by proper camera exposure.

Light plays a crucial role. If you look closely at the car's tires, you can see the reflection of the sun on them. The sun was low enough that it was lighting the car, but the sky and the car's surroundings were dark. Combine this with a slow shutter speed and a steady hand, and the result is a feeling of speed.

Without going into arcane detail, a camera generally bases its automatic exposure on an "average" of all the tones in the scene you're shooting, and arrives at an exposure based on the assumption that those tones average out to a "middle gray." Thus the best scenario for a camera to accurately and automatically set an exposure is to photograph a gray box, in the middle of the frame, on an evenly lit day. It just so happens that clothed people are roughly in this middle gray zone— and so are many other commonly photographed things.

By changing the camera's automatic modes, you are helping explain to the camera that "I'm taking a picture of a street at night" or "I'm taking a photo of my friend attempting to snowboard." This helps the camera function differently in a variety of ways, one of those being how it chooses to expose the image: The night setting will allow the camera to understand that the image will be darker all around than the snow scene, which will be very bright. Just as it is with film, it's definitely important to get this right when taking the photo, although digital can allow flexibility if it isn't correct, assuming you are shooting in your camera's RAW mode. The adage "quality in, quality out" holds true here. Thus the first tip in successfully using a computer to enhance your photographs is to begin with a properly exposed photograph.

Your Computer and Monitor Settings

Color and tone adjustments admittedly can be one of the most confusing and technical parts of a digital darkroom. Because there are hundreds of manufacturers of computers, monitors, and printers, what you see tends to vary widely on different computer setups. If you ever walk into an electronics store and see the same TV station on many different TV sets, you'll see what I mean. The color and tone looks different on just about every one. Thus the color you see on your monitor is only as accurate as your computer's setup.

At its most basic, you want to make sure your computer is set to display the most colors possible (in your display preferences), and that your monitor is showing colors with decent accuracy. The most reliable way to accomplish the latter is to use a high-quality monitor that is also relatively new. Cathode ray tube

MONITOR CALIBRATION TOOL

A B C D E F G H I J K L M N O P Q R S T U V W X Y Z

One goal of monitor calibration is to make sure that tones immediately lighter than true black are clearly distinguishable from true black, and tones immediately darker than true white are distinguishable from true white.

Above shows a range of grayscale tones, equally spaced, from true black through true white.

On either side are objects rendered with the various darkest and lightest tones.

Adjust the **brightness** and **contrast** of your monitor until you can **just about** see the difference between the grouped tones.

REMEMBER:
After calibration, true black should still look black, not gray.

Dim the lights. Hit **F11** on your keyboard if you're using **Internet Explorer** or **Firefox**. This will put your browser into full screen mode, temporarily removing much of the bright surrounding browser interface. (**Hit F11 again to exit.**)

Give your eyes a moment to adjust, then look at the black bordering this page. If it doesn't look satisfactorily black, re-adjust your monitor's contrast and/or brightness settings.

HOW EFFECTIVE IS THIS? Try it and see. We've found it works quite well, and you can't beat the price!

Brought to you by photofriday.com - Enjoy!

monitors (CRTs) have traditionally produced the most accurate color, but many high-end flat panel monitors have now caught up and can also be reliably used.

If you've met the first criteria of having a high quality, relatively new monitor and your computer is set to show the most colors possible, your chances of seeing accurate color are reasonably good. To make what you see even more accurate, you can also calibrate your monitor.

Monitor calibration works on the theory that since every monitor shows color slightly differently, you can take known color samples and display them on a monitor to measure how far off your colors are from the true color. Then you can adjust your display and color setup to compensate for any discrepancies.

There are many different methods for calibrating monitors, but the most acceptable results are achieved by calibration systems that use an "eye" attached to the monitor. The eye reads the colors being produced by the calibration software and records what adjustments are necessary. This eliminates human error in interpreting what is being shown on the monitor.

At the very least you can check your monitor's most basic settings (brightness and contrast) on websites that have test strips made of blocks of tones that go from completely black to

There are many web sites that feature color calibration tests to check that your monitor's setup is correct for viewing photographs accurately. You can also purchase color-calibration software.

completely white. With a correct monitor setup, you should be able to see differences in these shades of black, gray, and white. With most monitors you will turn the contrast to its highest setting, then adjust the brightness until you can see the test strip with all of its tones. Cheaper or older monitors may not allow this, however.

Also, set your computer's desktop to a neutral gray color when working on your images. Your perception of color is easily thrown off by many common desktop colors. Changing to gray while working on your images helps you see color more accurately.

This chapter explains features found within Adobe® Photoshop®, one of the popular image-editing applications. These tools are found in most versions of Photoshop (except its online counterpart, Photoshop Express) and in many other image editing applications. Even though various applications may look different, the same concepts apply.

Shoot in RAW Mode and Process Your Images Yourself

If you created your photo using a digital camera set in the RAW mode, you have the option to change the basic ingredients that comprise the image to a certain extent by using RAW conversion software. This is the reason why shooting in RAW mode is recommended for optimum image quality. RAW is an apt description for an image that has yet to be developed, to borrow the traditional film term. More simply put, RAW mode is a "digital" negative. Images that are no longer in their native RAW format, those which are JPEGs for example, were processed within the camera using the camera's software to interpret what you saw and create an image based on what it thinks were the right settings of color temperature, tonality, hue, etc. This, of course, may be entirely different from what you did see. The file is also a more compressed file, and thus lacks information, as opposed to a bigger RAW file that holds the most information. The RAW conversion software offers you the chance to process the image the way you saw it—or even the way you wish you saw it.

Even if you got the exposure wrong by jostling the controls on your camera or if the light changed dramatically, you have a

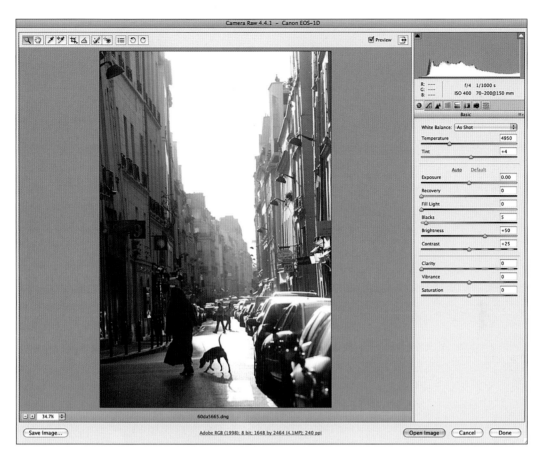

This photograph shows the original image as it was shot and opened in the Camera RAW plug-in feature of Adobe Photoshop software.

good chance of maintaining everything that a well-exposed photo offers by shooting RAW: detail in all of the tones, from the bright areas (highlights), neutral areas (mid-tones), and dark areas (shadows), good color saturation, and an overall crisp image. You can understand why professionals will always keep their cameras set to RAW. It lets them "develop" their digital negatives themselves in a way they deem best (rather than what the camera deems best). It also affords them some insurance in case there was a mistake during the shoot.

If you shot film, or if you don't use RAW mode, your images won't be privy to the developing features of a RAW converter, and it isn't possible to make a RAW file from an image that is no longer in its RAW state. That would be like trying to extract the ingredients from an already baked cake. You still, however, have a plethora of adjustments available to you.

In the Camera RAW plug-in feature, you'll work your way from the top controls down, beginning with white balance and ending with saturation. Adobe deliberately orders these

controls so that you achieve the best image quality when making adjustments.

Before you begin, there are three controls that should be activated: the preview box, and the shadow and highlight clipping warnings (the two boxes located on either side of the histogram display). Turning the preview button on will allow you to see the changes you are making as you make them. The next step is important: As you make changes to the image, some areas may lose detail, shown either in red (the highlights) or in blue (the shadows). If the red indications appear in your image as you are making adjustments, it means those are areas that have lost all detail, meaning they are completely white. Blue areas mean there is nothing but complete black. Photographers say that the highlights or shadows have been "clipped." It's okay for an image to have certain areas where there is a loss of detail, as long as they are areas that are not fundamental to this photograph.

There is the option of selecting the "Auto" function in the settings palette. This allows the Camera RAW plug-in to automatically set values for each slider, which for the purposes of learning isn't helpful, and often may not produce the desired results anyway.

White Balance and Color Temperature

Digital cameras are often set to auto white balancing, meaning their computers analyze the image and attempt to correct the colors to a neutral white overall. For example, the camera will attempt to whiten the very warm light of candles in a room entirely lit by them, or it may remove much of the pink and orange from a beautiful sunrise. This is why more advanced cameras have different white balance settings—so you can capture more of what your very intelligent eye and brain are seeing. Changing the color temperature will restore a photo to what you remember seeing, or will enhance it so that it is even more dramatic. This is where using the camera's RAW mode is extremely useful. There is much more detail available in a RAW file so you can change the color temperature as if you shot it on that setting, resulting in dramatic shifts to the image and often a more life-like photograph.

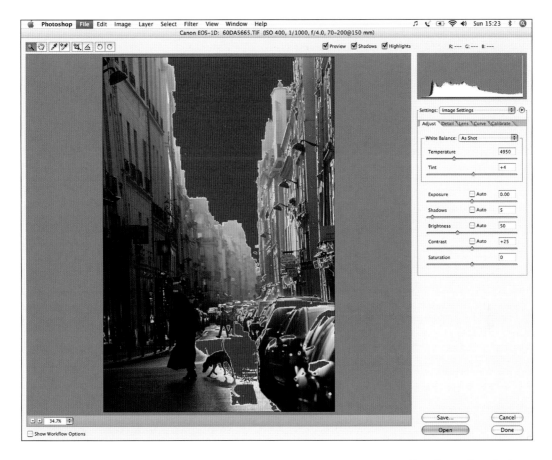

Exposure Setting

This setting adjusts the overall brightness of all tones in an image, with an emphasis on the bright values. The adjustment values correspond to the same f/stop adjustments on your camera: +1 equals a one f/stop increase in exposure, while -2 would equal two stops difference.

Begin by moving the exposure slider until you see your highlights begin to "blow out," meaning they turn completely white (or red, since you have the Highlights box checked). At first glance this may sound confusing, because you may look at part of an image and see nothing but white. But within that white are thousands of small variations of white as the painter Mondrian showed us in his work. Retaining such detail is often crucial to making an image look its best. An overexposed image (to start) will have highlights that are blown out and may not have any detail, no matter what adjustments are made to the image. Experiment with a few photographs to see the difference in them as you adjust the exposures.

After the preview, shadow, and highlight controls have been turned on, the red areas indicate areas that contain no detail. It's okay in this case because of the backlit nature of the photograph. The sky is so bright there is no detail to be found in the background no matter where you set the exposure slider.

Here is the final image after all the above adjustments have been made. The camera was originally set to auto-white balance, which caused the image to be very blue. Raising the color balance to 6500k allowed the sunlight to regain its warmth. The brightness was increased, as was the contrast. Also, a small increase in vibrance added a pleasing glow to the sunlight.

Recovery

The recovery tool is used to regain detail in the bright areas that have lost detail. This can happen either in the original image's exposure or when you adjusted the exposure slider too extremely. Camera RAW will try to increase details in the highlight areas examining all the color channels and reconstructing details in those channels that have gone completely white. This is a great tool if you are looking to regain detail in skin colors, clouds or other highlight areas.

Fill Light

Adjusting the fill light changes the lightness of the dark tones. It uses a similar process as the recovery tool: Camera RAW will attempt to reconstruct detail in the shadow areas using all color channels, while keeping areas that are completely black alone. This tool is great for an image that has too much contrast.

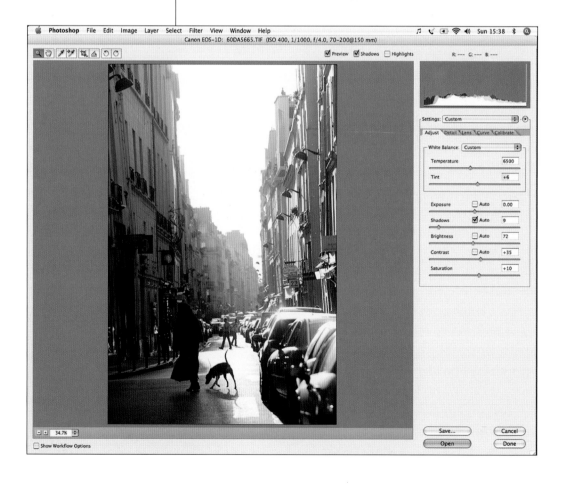

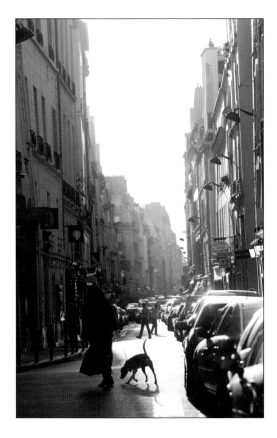 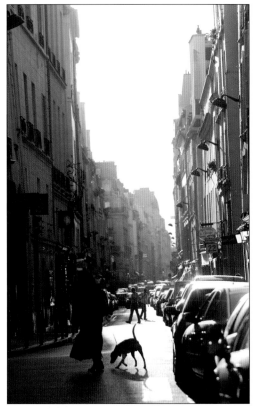

Blacks

The blacks adjustment controls the darkest tones in an image, and being able to control only the blacks allows more precise control than the contrast slider is able. Most images need some true black in them to look good. Adjust the dark areas so that a portion of the darkest tone areas can go completely black. Watch the blue clipping warning as you adjust your slider; areas that are completely black will turn blue, alerting you that there is no more detail in them.

Brightness

Move the brightness slider to adjust the mid-tones of the image. This is often important to your photograph's integrity once the shadows and highlights are set, because most of the values that comprise a photograph are within this range.

Contrast

Finally, the contrast slider will adjust the difference—or contrast—of the lighter and darker tones within the mid-tones of

Above left:
This is the original image as it came from the camera.

Above right:
This is the image with Auto Levels applied. Note that the contrast has increased and the colors appear a bit more blue overall. It's an improvement over the original image, but I'd prefer it to be warmer, or less blue. Also, the woman is lost in the dark tones, which became darker when the contrast was increased.

your photo. Many images can be helped in a nice way by a 10-15 point increase on the slider.

Clarity

Clarity is a control that can make a big difference in the apparent crispness of an image. It does this by increasing midtone contrast, which is the contrast between areas of light and dark in the tones between white and black. A good way to use it is to increase it until the edges of an image begin to blur or look unusual, then back it off until these just go away.

Vibrance and Saturation

Vibrance, which is only available in the Camera RAW plug-in, is the smarter brethren of saturation: it increases the saturation of colors in a relative manner so that those colors that are already saturated are increased less and those that aren't as saturated are increased more. This results in a natural effect, especially for skin tones. Saturation, on the other hand, equally raises all colors the same amount, which can cause colors to "clip" or become so bright they aren't printable.

EDITING YOUR IMAGE IN PHOTOSHOP

The following steps apply to any image, whether it is a processed RAW image, an image taken directly from your camera, or scanned film. For explanation purposes we will work with the following image with no changes made in the Camera RAW plug-in, simulating the file that you would work with if your camera doesn't have a RAW mode, or if you are working with an image scanned from film.

Tone Adjustments

The tonality of an image—the relationship of the shadows, mid-tones, and highlights to one another— influence the clarity and emotional impact of a photograph greatly. The adjustments you make need not be huge in order to make a better-looking image. Accenting a highlight here or bringing out the mid-tones slightly there might be just the tiny moves you need to make to turn your reasonably good photograph from okay to memorable.

Brightness/Contrast

Brightness: +50

Contrast: 0

OK

Cancel

☑ Preview

☐ Use Legacy

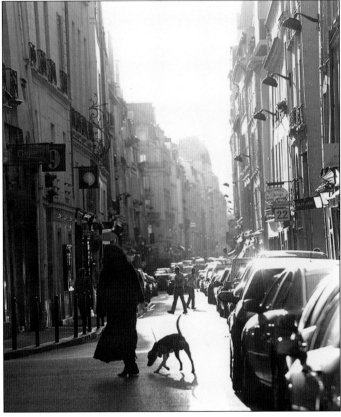

When you increase the brightness too much, the image definitely looks wrong. Every tone is too bright, resulting in a washed-out image.

The different tools used to adjust the tonality within an image all do roughly the same thing, but they do it with varying degrees of precision. Here, they are described in order from least complex to most complex.

Brightness/Contrast

Brightness: 0

Contrast: 50

OK

Cancel

☑ Preview

☐ Use Legacy

Increasing the contrast loses detail in the shadows, darkens the mid-tones, and brightens the highlights.

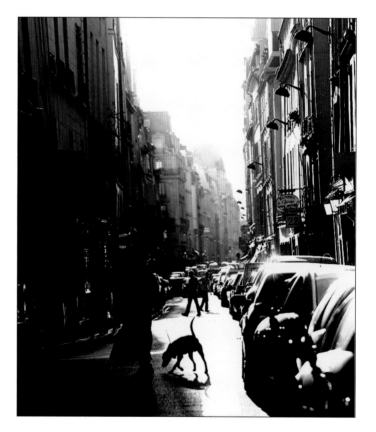

Auto Levels

Photoshop: Image > Adjustments > Auto Levels

Photoshop Elements: Enhance > Auto Levels

This function is similar to your camera's auto-exposure function. It looks at the highlights and shadows and bases the overall

brightness on these values. On normal images, those with most of the image detail in the mid-tones and with an average color balance, Auto Levels can work wonders. But it may cause weird color shifts or make the subject look too dark or light. Try it and if it doesn't work, select Undo.

Brightness and Contrast

Photoshop: Image > Adjustments > Brightness and Contrast

Photoshop Elements: Enhance > Adjust Lighting > Brightness and Contrast

Most of us know a fair amount about contrast and brightness from trying to adjust our TVs. Before digital, contrast was influenced by the type of film photographers chose, the filters on their lenses, how the film was developed, and finally how they printed their photographs. Complicated? Yes. The computer makes this tremendously easier.

After opening the levels, the histogram reveals what appears in the image—the shadows are too light.

Moving the shadow adjustment to the right (the dark slider) and the mid-tones to the left (the gray slider) increases contrast.

Brightness and Contrast was, for the most part, a tool that photographers avoided because of its brutish nature that changed all tones the same amount. It was of little use except for quick, basic changes when quality didn't matter so much. But the newer versions of Photoshop, including Elements, offer a revised version of the tool that allows much better control.

The new version makes a proportional change to the dark, middle and light tones, resulting in a much finer (and usable) adjustment that reduces the amount of detail that can be potentially lost. The "legacy" button in regular versions of Photoshop uses the old method: the changes to brightness and contrast are made in a linear fashion to all tones.

Shadow/Highlight

Photoshop: Image > Adjustment > Shadow/Highlight
Photoshop Elements: Enhance > Adjust Lighting > Shadow/Highlights

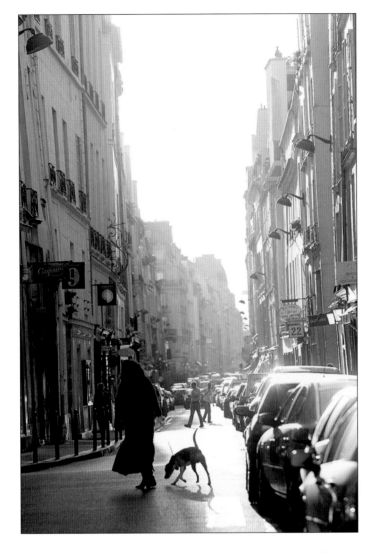

Here is the image after level adjustments have been made. The woman and her dog now have a rich, dark tone, and they both stand out better against the mid-tones.

Your eye is capable of seeing the range of tones in highlights, and shadows and this tool easily enhances the range of tones in your photographs, making them much more lifelike and dramatic. It can be thought of as an "intelligent" brightness and contrast tool.

You can lighten shadows, darken highlights, and control the contrast within the mid-tones. The only catch here is that you are working with whatever detail you originally captured in your initial exposure. If your sky is blown out, no amount of highlight darkening will bring it back. The same holds true for the shadows. But there's often detail lurking in your photograph that you may not have noticed and this tool will reveal.

Levels

Photoshop: Image > Adjustments > Levels

Photoshop Elements: Enhance > Adjust Lighting > Levels

Levels are a more advanced way to adjust the shadows, mid-tones, and highlights of an image in a way that more accurately controls the amount of change in each. You are thus able to make changes to the specific tones of an image, thereby preserving detail in those you wish to leave unchanged. Open the Levels tool and you'll see three color-coded triangles for each of the tones they alter. Note that when you adjust the shadow or highlights, the mid-tone slider will move as well. This keeps the relationship of the mid-tones to the highlights the same, which may look good,

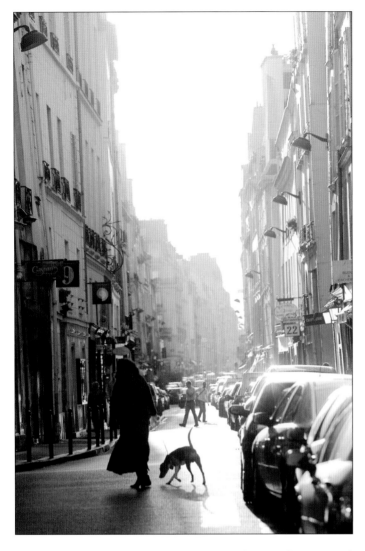

The shadows have been darkened, the mid-tones lightened, and the highlights mostly left unchanged after altering the curve by moving the adjustment points.

or you may need to readjust the mid-tones back to their original position. A good method is to begin with the slider that controls the areas most important to your photograph, then adjust the other two accordingly.

Curves

Photoshop: Image > Adjustments > Curves
Photoshop Elements: Enhance >Adjust Color >Adjust Color Levels

Curves are the most precise adjustment method because you can control the brightness or darkness of an exact tone, whether it is the shadows, mid-tones, or highlights. The line that is shown when you first open the curves tool represents all the tones of

Adjusting the color balance of the highlights, mid-tones, and shadows creates an effect similar to adjusting the color temperature in the Photoshop Camera RAW plug-in. The highlights were adjusted first, since they are very apparent in the image.

your image, from the deepest shadows (the lower right of the line), to the mid-tones (the center of the line), and finally the highlights (the upper right of the line). The dark gradient line at either side of the box helps identify this as well.

If there's a part of your image that you are interested in adjusting specifically, you can move your cursor over it and option-click (Macintosh) or control-click (PC), and an anchor point will be placed on the line that corresponds to where this tone falls. You can then move this anchor point to adjust that tone with your cursor keys or your mouse, or if you don't want that tone to be adjusted but only want to adjust the tones around it, you can adjust the line around the anchor point.

But be careful, as a usual image curve has gradual fluctuations, meaning it has a progressive transition from the shadows through the mid-tones to the highlights. Different people will find different tones within the scale more pleasing than others. Spikes in it will look distinctly unnatural. To get started, you may want to make a copy of an image and play with the variations first so you can begin to understand their impact.

Auto Color

Photoshop: Image > Adjustments >Auto Color
Photoshop Elements: Enhance > Auto Color Correction

First, like Auto Levels, which also affects the color balance of an image, there is an Auto Color tool. This is similar to

Color Balance

Color Balance

Color Levels: `+4` `0` `-9`

Cyan ———————△——————— Red
Magenta ——————△—————— Green
Yellow —————△+————— Blue

OK
Cancel
☑ Preview

Tone Balance
◯ Shadows ⊙ Midtones ◯ Highlights
☑ Preserve Luminosity

Auto Levels but uses a different algorithm that may produce different results depending on the image. Try it. If you don't like its results, simply undo it.

Levels

Photoshop: Image > Adjustments > Levels
Photoshop Elements: Enhance > Adjust Lighting > Levels

We revisit levels, this time to reveal how to use each slider to adjust color balance. Within the tool there is a Channels menu. By selecting red, green, or blue, you can control the amount of each of these colors in the various tones of your photograph. Be sure the Preview button is selected so you can see your changes, and you may want to use an adjustment layer here as well, so you can always make changes to your image in the future.

Color Balance Tool

Photoshop: Image > Adjustments > Color Balance
Photoshop Elements: N/A but an alternative would be to use Enhance > Adjust Color > Variations

The more straightforward way to adjust color is to use the Color Balance tool. This is a relatively simple system of sliders that adjusts the individual color balance within the shadows, mid-tones, and highlights. Again, the degree to which each adjustment will change your image depends on how dark,

Mid-tone color balance adjustments are subtle but important.

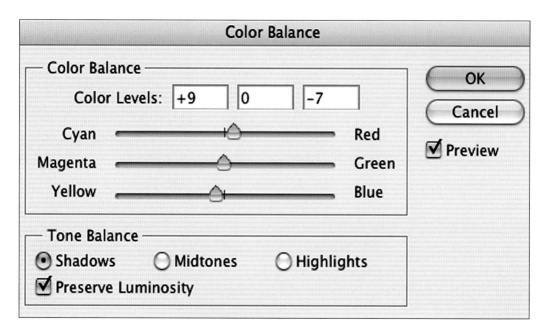

This screen grab shows shadow color-balance adjustments.

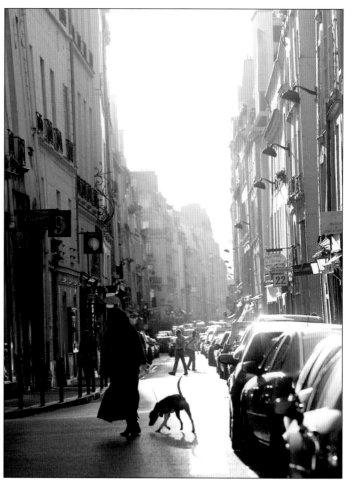

light, or neutral the majority of your image is. If it is a night scene, for instance, the color balance of the shadows will greatly affect its overall look. The opposite will be true for a bright, snowy scene. And if your image comprises mostly neutral tones, the color balance of the mid-tones will affect your image to a greater degree. Keep the Preserve Luminosity option checked in this tool, as it will keep the tonal balance from changing too dramatically.

There are some universal guidelines that are helpful to know when beginning to color balance images. First, shadows are often blueish in appearance whether they come from an overcast day or the shadow of a tall building on a sunny day. Correcting this would involve adding yellow (subtracting blue) and/or red (subtracting cyan) to the image. Next, some films and digital cameras have a tendency to render certain parts of your image, or all of your image, with a color balance that is slightly off what would be considered correct. This is known as a color cast. Some cameras may produce images that are slightly green whereas others may look red. Even very high-end digital cameras will have a tendency to have a color cast of some sort. Photoshop Elements has an interesting feature that attempts to detect these color casts

Here, the color saturation of all colors, or the master, is increased by 15 points.

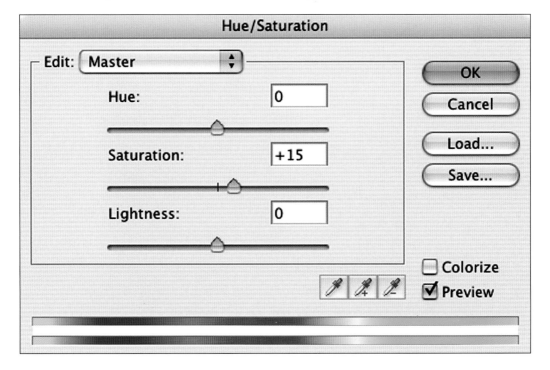

and automatically remove them. Finally, adjusting skin tones can help dramatically in making people look their best. Skin with a blue or yellow tone can be adjusted with color balance, as well as with the next steps of adjusting hue and saturation.

Color, Hue, and Saturation
Photoshop: Image > Adjustments > Hue/Saturation
Photoshop Elements: Enhance > Adjust Color > Adjust Hue/Saturation

Once you've set the color balance, individual colors may not have rendered correctly. There are colors that are difficult for some cameras to render. Among these are skin tones, which, as humans, we are naturally very critical of in photos (often without knowing we are). Fluorescent-lit colors are also difficult. Your sunset or sunrise photos may not look as amazing as you remember seeing them. Changing the hue (a variation within one color) of these individual colors as well as their saturation (intensity) is one of the changes that play directly upon your emotions.

The Hue and Saturation tool is a particularly powerful and easy-to-use tool. You can select any of six shades to adjust, as well as the Master, which adjusts the colors of the entire image. Many digital cameras and files scanned from film will have colors that are a little bit off. If adjusting the color balance didn't fix them, then hue and saturation should do the trick. The one thing to understand, however, is that often what you perceive as one color may actually be composed in part of another color, i.e. what you may regard as green in an image may actually include a large amount of yellow. Green grass, for example, may actually contain a lot of yellow; instead of adjusting the hue of the greens, you might need to adjust the yellow. As in color balance, the colors that are predominant in an image may not be obvious at first glance, but their adjustment with hue and saturation will make a noticeable effect.

Sharpness
Photoshop: Filter > Sharpen > Unsharp Mask
Photoshop Elements: Enhance > Unsharp Mask

The traditional advice in photography is to always buy the best lenses you can. Using the best "glass" means you have the

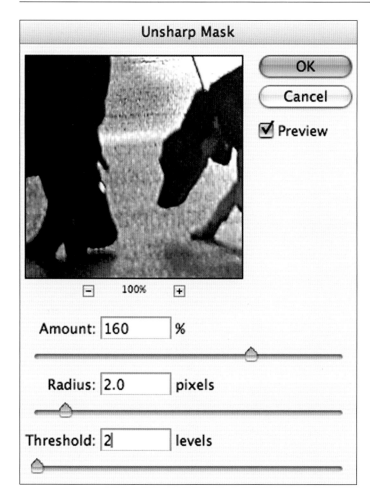

Magnification will allow you to see the effect of sharpening. Note that grain will become more apparent with stronger sharpening.

greatest chance of getting the sharpest photos, along with nice contrast and color rendition. But even with a very good lens, there are plenty of ways an image can lack sharpness, whether it be attributable to the photographer, the subject, the camera, or the manner in which the film or digital image was originally processed or scanned. Sharpening a photograph digitally with a few simple tools will allow many small details to flourish within an image, which translates to a "wow" from your friends when they see it. Even a razor-sharp photo will often be helped by a moderate amount of sharpening.

Sharpening with software plays upon some basics of how we perceive sharpness in an image, which is through a concept called edge contrast. The sharpness of an image, as we see it, is largely defined through the contrast of the meeting of the light and dark areas. These edges of light and dark are what

The Gaussian Blur tool shows a magnification of the image so that you can see the effect well. Notice how the image on the right appears sharper, while on the left the blur is apparent. Had feathering not been applied to the selection, a line would be obvious where the blurring begins.

can be manipulated by the software to produce the look of a sharper image.

In Adobe Photoshop, the Unsharp Mask tool is the oddly named tool of choice for sharpening. (Its name refers to the pre-digital process of using a softened, or unsharp copy of an image in a photomechanical printing process to enhance sharpness.) Essential to this tool is the understanding of its three controls: amount, radius, and threshold. Amount defines the amount of contrast increase between the edges of light and dark. Radius adjusts how far from these edges the increase in contrast is made. Put another way, the radius is how "fine" the sharpening is applied. Threshold determines what areas of contrast will receive the sharpening. A small number means areas with lesser contrast will be sharpened, a large number means only areas with more contrast will be sharpened. A general rule of thumb is to keep the radius as low as possible while increasing the amount, and keeping the threshold value low so that most of the details are sharpened. Lower resolution images (such as those to be used on the Web) require less overall sharpening, while higher-resolution images (those to be printed) require more. (This is why many photographers make sharpening the last step of their image-

The center section has been sharpened using the Unsharp Mask tool and the selection was subsequently inversed [Select > Inverse]. This selects all the pixels that were not sharpened and will now be blurred.

editing process.) Start with a radius of around 1 and an amount somewhere above 100 percent. Experimentation with this tool is the best way to learn how to use it. Note, too, that users with the latest version of software may want to try the very effective new Smart Sharpen tool.

Blurring and Selective Focus
Photoshop: Filter > Blur > Gaussian Blur
Photoshop Elements: Filter > Blur > Gaussian Blur

Blurring out distracting parts of images can simulate the effect of shooting at wide-open apertures. Experienced photographers will choose a wider aperture (smaller f/stop number) to reduce depth of field intentionally to blur a distracting, busy background. If you didn't do this, you can use the Blur tool to carefully reduce

The crop tool is set so that the final image will be 4 inches wide and 6 inches high at 300 pixels per inch.

distracting parts of a photo. Again, the best and most natural results are achieved in-camera. But a little blurring, even of the sort that couldn't be achieved in-camera, can add nice artistic effects while helping to guide the viewer's eye to what's important in your image.

Create a new duplicate layer of your image and use the Blur tool, again with a feathered brush and at a strength of about 12 percent, and paint the blur effect evenly onto parts of your image around your main subject. This is a good way to learn the effect. A more accurate way to blur is to select specific parts of your image with the Lasso or Marquee tool. Feather this selection [Select > Feather] (20 pixels may be enough for a low-resolution image, while 80-100 may work for higher resolutions), and then choose the Gaussian Blur filter. Start with a radius of .3 to .5 and try to use the least blur possible to get the most natural effect.

Cropping

Some people would say this is the first thing one would do with a photograph, and it certainly can be. Purists don't believe in cropping photographs, since there is a certain pride to shooting the picture just right the first time and, just as important, large amounts of cropping actually reduce image quality in either film or digital photography. But cropping a photo may help reinforce what is essential and thus can increase the power of the image. That may lie in your dog's expression, not the glaring red car that entered the frame as you snapped the photo.

This is where we can leave the mind-numbing intricacies of color balance and tonality and go back to what makes a nice image: composition. This is purely up to your own aesthetic preferences. Don't be afraid to leave behind the traditional shape of a 35mm photograph. You can create a panoramic image simply by cropping off the top and bottom of the image, for example. Or you can crop your photo to a perfect square. The 35mm frame may not be the best shape for your photo, and within reason you shouldn't feel limited to it. Film cameras have traditionally had a wide variety of frame styles, from square to panoramic.

The cropping tool is straightforward. You can use it freely, or you can set specific ratios and/or resolution so that your final image is cropped to a certain shape as well as a certain final resolution. The latter is useful if you are making an image for use online where you would set the resolution suitable for use on the Internet (generally 72 pixels per inch).

Keep in mind, too, that for framing purposes, the popular photo sizes differ in their final shape. For example, a 4x6 image has a width/height ratio of 2:3, meaning its width of four inches is 67 percent of its height of six inches. An 8x10 image, however, has a ratio of 4:5, meaning its width is 80 percent of its height. The 4x6 image is much more rectangular than the 8x10 image.

New Layer

Name: dodge and burn

☐ Use Previous Layer to Create Clipping Mask

Color: ☐ None

Mode: Overlay **Opacity:** 100 ▶ %

☑ Fill with Overlay-neutral color (50% gray)

OK

Cancel

Here, an overlay layer has been created to avoid dodging and burning directly onto the image. Any pixels that are brighter than the 50 percent gray will lighten the main image (dodging), whereas pixels that are darker than the 50 percent gray will darken the image (burning).

The mid-tones in this specific area are dodged to increase the separation between the shadow areas of the woman and the mid-tones behind her. This helps her pop out a bit more and not get lost in the background.

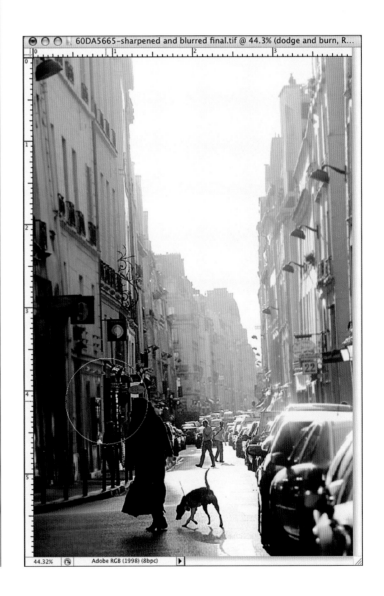

60DA5665-sharpened and blurred final.tif @ 44.3% (dodge and burn, R...

44.32% Adobe RGB (1998) (8bpc)

After applying the dodging tool to the overlay layer you can see where the pixels have been lightened. Click the Eye icon to the left of the layer to show the before and after difference.

Dodging and Burning in

Done correctly, dodging (lightening an area) and burning in (darkening an area) are darkroom techniques that are relatively difficult and time-consuming to master. The names derive from what you would do in the traditional darkroom to lighten an area: You would place something to temporarily block, or dodge, the light from hitting the photo paper when making the print, thus lightening the area relative to the rest of the print. To darken an area, you would only allow light to reach the area you wanted to be darker. A common tool with which to dodge was a round disc with a thin wire handle, thus the Dodge tool's shape in Adobe Photoshop. Burning-in often required a more elaborate scheme of pieces of paper with holes or even a hand placed artfully under the enlarger's light—thus the tool for burning in is a hand icon.

Our eyes are generally attracted more to the lighter parts of a photograph than to the darker areas. This is good to keep in mind when shooting and when using these tools. A common type of dodging would involve lightening a person's face to

Software such as Fred Miranda's BW Workflow Pro™ allows you to change images from color to black and white, as well as apply toning and make many other adjustments.

keep all its features easily seen. Selecting a larger brush and burning in portions of the image that are bright and distracting to the main subject can also be effective.

The tools for both dodging and burning let you selectively dodge and burn—either the shadows, mid-tones, or highlights. Select a brush that has a feathered edge, and set the exposure (or strength) of the tool between 5 and 8 percent to begin with. Both these steps ensure that your changes are subtle.

You can use these tools directly upon the image, but a better way is to apply them to a layer you create that is an overlay of gray. This means that you aren't manipulating the image directly, and if you don't like the results you can discard the layer and start over. To do this, go to the layers menu, select New Layer, select Overlay, and check Fill with Overlay Neutral Color (50 percent gray). Do your dodging and burning on this layer and your changes will be applied to the overlay layer but rendered onto the image itself.

Another method worth mentioning, and often preferred because of its more precise control, is to use the marquee tools to select areas of an image and use the aforementioned tonality adjustments. Feather the marquee selection and then use the levels tool to make these area-specific adjustments.

Digital Photo Filters

Within many image-editing softwares, there are digital filters that replicate traditional filters once physically placed over the lens of a camera or used in a traditional darkroom. For example, if a photographer were shooting on an overcast day and the light was very blue, he could place a warming filter, which is a very light yellow/orange color, over the lens. This would make a subtle change to the color of the image, giving it a pleasing warmth. This filter, of course, is changing the color balance of the image, something that can be done within Adobe Camera RAW or by changing an image's color balance. While many filter effects can be done manually using all sorts of methods, it's often easier and quicker to just apply a pre-made digital filter to the image. Adobe Photoshop software includes some of these digital filters under Image>Adjustments>Photo Filters. The names in parentheses are the traditional names given to these filters. If you were to walk into a camera store and ask for an 81A, they would know you meant a warming filter.

There are also plug-ins for Photoshop software, such as those found in Nik Color Efex, that take filters to an entirely different level. To recreate all of these filters would cost thousands of dollars and also require lots of testing time. This software allows you to preview the effect and apply it or discard it within seconds.

There is a belief in photographic circles, however, that the best quality image will come directly from the camera rather than through software manipulation. Ultimately, this relies upon your preferences and how you like to work. Generally it is true, however, that the closer you can get the image the way you want it in camera, the better the resulting image will be.

Converting to Black and White and Toning

Photoshop: Image > Adjustments> Black and White

Photoshop Elements: Enhance > Convert to Black and White

Even though black-and-white film is becoming scarce, black-and-white photographs aren't any less powerful. Converting your color photos to black and white can be done by using Photoshop's built-in tools or by using third-party plugins. Photoshop's tools work well and allows you to customize the values of gray among the colors that make up the photograph. More specialized adjustments can be made with third party plug-ins such as as Fred Miranda's BW Workflow Pro and Alien Skin's Exposure.

Using such software allows you to control how the various colors within a photograph are converted, giving you more control to create stronger black-and-white images. Furthermore, these plug-ins make experimenting with toning images easy. Adding a slight amount of color to a black-and-white image makes a true toned black-and-white print. This is a traditional darkroom printing process that involves expensive and noxious chemicals, lots of time, and a skilled hand. While a true toned black-and-white print on fiber paper is something wonderful to behold, using software to replicate the same thing can achieve interesting, if not similar, results.

Conclusion

The computer is now an invaluable asset to photography, especially now that the sophisticated image-editing tools available can nearly mimic and/or replace the the technical creativity of the darkroom assistant once totally necessary in the age of film photography. You have the ability to make the same photograph color or black and white by the few clicks of a mouse. But no matter how high tech cameras or computers become, a great photograph will always have its origins within the imagination and skill

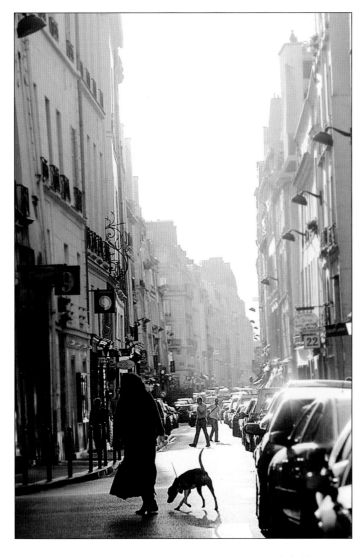

Here is the final image converted to black and white. Note that I selected a warmer tone to the black-and-white conversion by choosing a brown duo-tone effect.

of the photographer. Learning the technology is helpful but even the most basic camera can be used to make a wonderful image.

Staying on top of all the latest and (sometimes, but not always) greatest software, hardware and techniques has become a big commitment in terms of time and money to amateur and professional photographers alike. The internet provides the most up-to-date information. Web site's like John Nack's blog, who heads Adobe's Photoshop development (www.blogs.adobe.com/jnack/) and Rob Gailbraith's DPI (www.robgalbraith.com) are two valuable resources. There are also yearly conventions such as Photoshop World run by the National Association of Photoshop Professionals (www.photoshopuser.com).

INSPIRED BY FLEMISH
PAINTERS AND LIFE AROUND HER

Julie Blackmon studied photography in college. Soon life was crowded with a husband and three children. Being the eldest child in a family of nine children, Blackmon had a lot of nieces and nephews around, as well. By the time she turned her attention back to her photography in 2001, photography had changed. It was now digital. She enrolled in the fine-art program in her hometown school, Missouri State University. Then she taught herself Photoshop, digital scanning techniques, and digital printing.

She focused her camera on things she saw at home that intrigued her. Her first collection of pictures, "Mind Games," investigated the wonders of make-believe play in black and white. She photographed children in the backyard in pools, on trampolines, and around toys. She drew inspiration from Sally Mann, Keith Carter, Henri Cartier-Bresson, Diane Arbus, and Meatyard.

Her second collection of pictures—this time in color—is a fantastical interpretation of her life, both as a mother and as a child growing up in a large family. She has titled it "Domestic Vacations," and some of the pictures show startling, poignant juxtapositions of the real and the imagined. Adults eat dinner while children play under the table. A mother's legs can be seen running up the stairs behind a baby who sits quietly playing on the floor. In 2006 the judges for the Santa Fe Center for Photography Project Competition awarded Blackmon first prize for her work.

For her color work, Blackmon found inspiration in Dutch and Flemish paintings and in the subtle humor of Ian Falconer's illustrations in his popular books for children about Olivia the Pig.

Blackmon works with a film camera, Fuji 160 NPS film, and a few positioned lights. Then she scans the film into her computer with either a flatbed scanner or an Imacon scanner. After she has worked on the files in Photoshop, she uses a large-format Epson printer to make 23x23 prints.

You can see more of her work at *www.julieblackmon.com.*

"Trampoline, Springfield, MO," 2002, from the series "Mind Games."

"Nail Polish,"
2005, from the
series "Domestic
Vacations."

Chapter 6
Making Better Prints

6 | *Making Better Prints*

have to admit that it is already a cliché to comment on how the world is engulfed in a total digital makeover. When I analyze our daily lives and how families and businesses use photography to record moments or special events, I'm amazed at how pervasive the use of digital cameras and printers is today. Even the traditional photographic film and photographic paper companies are reeling from this changeover. Some will fold and some will adjust.

There are a few things that haven't changed in photography, and one is the photographic print. Sure, we send photos, screen grabs, or digital snaps around the world attached to our one-sentence e-mails. But for many there is still something special about a print. We can hold it in our hands or hang it on the wall. It provides a tactile, visual connection to those special moments of our past. A photographic print can force us to pause and reflect about a person or a place or a moment. It is a physical record of our lives not to be lost in some pile of CDs or in a broken hard drive.

Many professionals started in newspaper darkrooms dipping their hands into Kodak chemicals to make prints of their daily assignments. That's how it was done—prints turned into the editor on deadline. Occasionally we'd divert from the standard 8 x 10 format and make a 16 x 20 black-and-white print of our favorites. It was incredibly satisfying to be able to hang these on the wall, and now I have a physical visual record of my first 20 years as a photographer. Color prints were beyond most of us, and if we wanted prints, we sent the film out to a lab.

When the Macintosh and inkjet printers from Hewlett Packard were introduced around 1984, I began to see the potential for taking photography into the digital realm. But the real change in digital printing for me began in 1992 with the purchase of a 36-inch wide printer call Displaymaker from a Minnesota company. It was from this point forward that my journey into digital printing began. I could scan a slide and make a large custom print, without chemicals, from my own home. This was pure joy and a revelation, even though the maximum resolution was only 300dpi (dots per inch). Certainly there are dedicated

photographers who continue to use the traditional darkroom process, but their numbers have dropped dramatically. Digital printing today is neither inferior nor superior to this process, though the argument rages on both sides. More important, it's

Archival black-and-white prints sometimes last longer than color prints in terms of fading or colorshifts.

another tool for the creative expression of what we see and feel about life. It's your choice. But if you're inclined to move into the future, fasten your seat belt.

The first step in choosing a printer is deciding what you really want to do with it. If you have no further desire than to keep the family record of birthdays, baptisms, vacations, or snaps of friends, then I'd encourage you to look at printers that are simple and direct. You might desire a minimal plan from scan or camera to a glossy 4 x 6 print. The key here is simplicity and some archival quality so you don't have to watch your family treasures fade into oblivion.

But if you aspire to break out of your photographic routine, whether it's trying to make a larger print of your photograph of the backyard magnolia or trying to get other people to really notice your work, that's a different kind of printer altogether.

So let's look at the points that define the types of printers and how one might be more appropriate than another. The choices are not clear-cut, since almost all of today's ink-jet printers offer up high quality photographic printing. Let's sort out some of the options to help narrow the playing field.

Keep this simple thought in mind when choosing a printer: It's basically the size of the output that differentiates most printers. But there can also be other factors that separate them, including the type of inks, the number of inks, and the paper types that a printer can handle. In addition, how cameras and printers are connected may also affect your choice. So let's look at some of these details.

CHOOSING A PRINTER

Manufacturers have been listening to people who used to frequent the one-hour photo shops for their snapshots but really wanted to make their prints at home. Consumers just didn't want complicated printers. The result is a number of dedicated snapshot photo printers that have no other

Dedicated 4 x 6 photoprinters eliminate the need for a computer.

TIP:

Five Simple Steps to a Print

- Decide what you want to do with your printing: art or simple prints, or something in-between.
- Examine printer features you need.
- Choose the right paper.
- Align computer and printer settings.
- Make your print.
- Hire someone else to do your printing for you.

function than to directly connect to a digital camera through a dock or USB connection, or to accept a digital camera's memory card into a built-in slot and print standard-size (usually 4 x 6) snapshots. These printers are designed only to print photos—and be inexpensive. The other advantage to these single-purpose printers is their size and portability. Some can print from battery power, so if you're photographing your son's high school band, for example, and want to hand out photos from the front seat of your car, you can.

TIP:

Analyzing Printer Features

- Snapshot printers versus inkjet versus dye-sublimation printers
- Printer connectivity
- Paper-handling capacity, printing speed, paper path, and thickness range
- Dye versus pigmented inks
- Special features
- Cost of printing

Photo-Quality Printers

Inkjet photo-quality printers designed to print from your computer and sized for larger paper widths are more expensive. They have more ink-cartridge options and take up more space on your desk.

In the beginning, inkjet color printers used four colors to create color prints. When six, seven, and eight-color printers appeared, manufacturers were specifically targeting amateurs and professionals who wanted true "photographic-quality" prints. Engineers also discovered that rather than just adding increased dot resolution, the ability to add more colors creates a wider palette

Desktop inkjet printers provide quick-and-easy prints.

of solid colors and a nearly continuously toned photograph. In most cases this was better than increasing print resolution. Today's photographic-quality printers are delivering amazing results. And the price of high-end inkjets, from desktop to 44-inch wide, large-format printers, has continued its downward spiral.

Dye-Sublimation Printers

If you want photo-lab quality from your home printing setup, a dye-sublimation printer is something to consider. In printing, dye-sub printers lay their colors down from cellophane exposed to heat. The dyes transfer the image to a glossy surface in one continuous tone as opposed to the series of dots that ink-jet printers apply. An image made with a dye-sub printer has a more subtle gradation between pixels and looks like a standard photographic print. Some of the dye-sub printers are made to be portable and print the 4 x 6 prints with a protective overlay. You can see what it costs per print by looking up the cost of replacement ribbons. A 24-sheet box contains the paper and dye ribbon for exactly that—24 prints—so simple division will give you the answer. Use the Web to research current dye-sub printer models and read reviews for each particular model. It's a very interesting technology.

All-in-One Printers

An all-in-one printer, often called an MFP or multi-function printer, combines a printer, scanner, copier, and fax machine into one tabletop unit. For a small home business, these units are proliferating in both inkjet and laser models. The printers vary widely in price and features with the simplest offering copying, printing, and scanning. If they also include a fax, they may need to use the modem in your PC. If you plan to do more than one or two faxes a week, you will want a separate fax with its own phone line.

PRINTER CONNECTIVITY

The drudgery of connecting cables between printers and computers, plus having to shut down and restart your computer

Dye-sublimation printers are popular.

before switching printers, is gone. For photographers with recent computers and printers, the universal USB and FireWire connectivity has become nearly plug-and-play. You can switch back and forth between printers with a simple selection change in your computer software.

Another thing about connecting a printer is what to do when Wi-Fi comes to your home. Wi-Fi (Wireless Fidelity) is a wireless radio system that connects computers, printers, and other devices, including the Internet, to a common network without cables. Having a Wi-Fi enabled printer will allow multiple computers to print to it from anywhere within range of the signal. Until recently a Wi-Fi printer was a novelty in printers, but all that has changed.

An all-in-one fax/printer/ copier takes up little space in your home office.

PAPER-HANDLING CAPACITIES

The other consideration you want to think about is how big you want to print. If all you want is 4 x 6 prints, the dedicated snapshot printers may be the way to go. But if you want to make 11 x 14 prints or larger, be sure your printer can handle the sizes you want. If you want to print a quantity of business letters while you're out for lunch, be sure you have a printer that can hold the capacity of sheets that will allow you to do that and provide the crisp type that reflects well on your business.

Be sure your printer can print on the types of paper you might want. There are so many choices of paper: glossy, pearl, smooth, fine-art, watercolor, poster board, and matte. Many papers are acid-free and of archival quality. But the quality of the paper and its surface can alter or change the effect of your photograph dramatically. The combination of ink and paper should be understood before you spend your money on a printer that can handle only a certain size of either.

Experiment with different papers to determine which look you like.

DYE VERSUS PIGMENT

You might not consider this discussion about printing inks important, but think back to when you go through the photo albums that belonged to your parents or grandparents. Isn't it amazing how the black-and-white photos are, for the most part, still good whereas some of those 1960s color prints are beginning to disappear? The same print fading can hold true for your

When you store prints
correctly, you can inhibit
the aging and fading
of colors.

photography. Unfortunately prints from some of the first inkjet printers are now hopelessly faded, and that's happened in only a couple of years.

Isn't it our obligation to provide the next two or three generations a record of our lives and family activities as much as our parents did without everything fading away? I can hear you say, "But these are from digital files and digital doesn't fade. We can just reprint the good ones some day." The problem is this: Who's going to have the DVD player to look at your images 100 years from now or even in 20 years? In my mind a print is still the most accessible way to easily retrieve memories.

Recently, many of the printer manufacturers have addressed this issue, and for their photo-quality printers they are using pigmented inks, which have proven to be much more stable than

dye-based inks. So here are three simple steps to protect your efforts and gain as much longevity as you can from your prints.

- Find out what type of inks your printer uses—dye or pigmented.
- Go to the Web at www.wilhelm-research.com and try to locate your printer and inkset to see figures on their longevity.
- Choose ink sets based on your short- and long-term printing goals. As a rule, pigmented inks are much more stable.
- Also keep in mind that type of paper, storage, light conditions, and types of glass used in frames each play an important part. The good news is that with many of today's ink formulas and archival paper combinations, the prints under proper conditions can last a century or more.

SPECIAL FEATURES

Not everyone wants lots of printer features on their printer, but it's wise to be aware of some of the interesting capabilities.

- Portability—we've talked about this before, but consider your needs as you prepare your travel plans. Do you want to print your vacation prints from your hotel room or from the backseat of your car?
- Are you interested in printing straight from your camera docked to a printer? There are a number of camera-printer combinations that will do that, no computer needed.
- Do you want to print on your CD or DVD? There are printers that will allow you to create beautiful designs to print on your CDs before you hand them out.
- Some printers will print on both sides of the paper at the same time. This is called duplex printing—a cool feature for those doing newsletters and cards. These units cost more, but if you're tired of flipping over sheets of paper, this might be for you.
- Paper capacities. Many printers will only hold 30 or 40 sheets of paper at a time. So if you're interested in volume printing and not in constantly feeding paper to the printer, look into the printers that have large-capacity paper trays.
- Large-format printing. If you've ever watched or made a print from one of the 24-inch or 44-inch-wide printers such as the Epson wide-format printers, you know it is something to

behold. Remember, you can also take a digital image into a shop and have them make a large print for you.

PRINTING COSTS

Initially, many printers had a cartridge for black ink and a single cartridge that contained cyan, magenta, and yellow inks, called a tri-pack. If you ran the yellow down first, you had to throw out the whole unit and waste the remaining cyan and magenta inks. Today, most of the bigger printers have individual cartridges for each color. You replace only the cartridges you have depleted, greatly reducing the waste of ink.

Don't be surprised when you start adding up your printing costs for paper and inks. They will not be cheap. It might be helpful to search the Web for "printing page yield test" or "cost of printing." Nevertheless, one of the "musts" when you're buying a new color printer is finding out how much it will cost to replace all the inks. It doesn't hurt to know what's in store for you. Also research prices on the quality paper you plan to use. But remember, just a few short years ago none of us were printing our favorite color photographs on large sheets of art paper. For me that is worth the admission price, whatever it is.

MAKING THE PERFECT PRINT

Let's dispel the notion about the perfect print. It doesn't exist. What is perfect is an arbitrary notion that resides in each of us. What we are all striving for is a print with the color, contrast, and quality that we had envisioned. We all want to avoid spending hours working on a print and then say, "Well it's not exactly what I wanted, but it's close." The goal for a perfect print is one that pleases you and others.

I've been printing for more than 30 years, and even today when I'm holding a near miss, I still resist tearing it up and starting over. I must remind myself that I'm in control and I can do this better. No one makes beautiful prints without practice and lots of failures. For me, understanding the printer settings, working in Photoshop, and working through various papers and inks has not been without plenty of trial and error. So all I can say is: Take your time, be patient, read as much as you can about printing, and you will be soon making prints of which you can be proud.

CALIBRATING YOUR MONITOR

As I discuss in the chapter on scanning, there are many variables and adjustments when it comes to scanning, printing, and making a pleasing print. It's important to calibrate your monitor (not all cheap monitors can be calibrated) so the contrast, brightness, and colors are adjusted to a standard. Monitors can be all over the place with color and contrast, and you don't want to be adjusting colors for your print when the monitor itself is way out of

Modern color printers can have as many as 6, 8, 10, or 12 colored inks, providing a large color palette from which to print.

Calibrating your monitor may be the most effective tool you have to make better prints.

balance. You'll be going around in circles like a dog chasing its own tail.

Adobe Photoshop and Photoshop Elements have a calibration wizard that can assist you. Macintosh computers have a nifty display calibration built into the system preferences that will walk you through a calibration. With Photoshop loaded on Windows, there is something called Adobe Gamma in the Control Panel section. Also there are relatively inexpensive hardware calibrators that take the guesswork out of monitor calibration. Refer to page 330 in the chapter on scanning and reread the section on monitor calibration.

Refer to page 330 in the chapter on scanning

THE PRINT-DRIVER AND ICC PROFILE
The reason so many people have problems with color in their prints is that they don't correctly match up their settings for paper, resolution, and color management with their printer.

TIP:

POINTS TO CONSIDER

- Should I calibrate my monitor?
- What are the print-driver and ICC profiles?
- Selecting the right paper.
- Setting the correct printer resolution.
- Why not let someone else do it?

The print-driver is software that allows your computer to make settings specific to your printer. When you first connect your new printer, it might ask you to load in the CD that came with it so it can retrieve the print-driver settings for your system software. When you are ready to print, the dialog window comes up asking to set specific settings about your printer and the paper to use.

- Paper size—your printer will be constrained by its maximum size.
- Paper type—paper profiled and recommended by the manufacturer. Other profiles can be added. See ICC profiles below.
- Ink levels (in some printer models).
- Utility actions like alignment and nozzle cleaning.
- Custom color-tweaking options.

What is an ICC Profile?

Many of you will never want to go any deeper into paper profiles than this brief explanation. An ICC profile is an embedded tag of information in an image that adjusts or corrects color or grayscale information as it moves in the workflow from scanner, digital camera, monitor, and then finally to a digital printer using specific papers. The goal is to provide consistent color in a common language through the entire digital process.

Many paper manufacturers supply profiles for their printing papers on a specific printer. These can be found on the manufacturer's website or are included in the print-driver CD that came with the printer. Many of these profiles are automatically downloaded during initial setup. This is where using a printer and paper from the same company simplifies the process, since they are matched for each other and are easily found in the printer window.

Printer Resolution

Understanding printer resolution settings is important. When you first scanned your negatives, it was important to retrieve or scan the greatest amount of digital information from those small 35mm negatives as you possibly could. You want those high resolutions to have enough horsepower in the scan to print or use the image in various sizes later on. (Remember, ppi or pixels per inch is about scanning and image resolution on the

computer, and dpi or dots per inch is used in dealing with print-ers and printing.)

When you choose Print in the computer, a dialog box appears, and it's important to select the correct dpi setting of the printer for that of the paper. Setting the printer resolution at 720dpi is fine for most high-quality photo papers, whereas using a 1440 dpi setting might be the best for fine-art or glossy paper. Printing 4 x 6 prints can look fine at 720dpi or lower, whereas the final quality of a 30 x 40 print will be best served at 1440dpi or higher.

But remember, don't automatically select the highest set-ting. If it's not called for it will only waste ink, time and not add to the overall look of the photograph. The human eye can only perceive so much detail, so it's best to experiment with the dpi settings for your particular paper and see what looks the best. Your eye is the best judge. Your time would be better served experimenting with different types and qualities of paper which has a major impact on the final print.

Testing your printer for these various settings on different papers and taking notes will eventually help you develop a system that will shorten the time you spend dealing with the technical process. After all, the goal is to make this fun.

We've discussed a lot of the technical issues that can help you become a good printer. But more important, I hope I've helped your determination to take your images through this process and create a beautiful print for your wall or gallery. The desire to showcase your work will help you overcome most of the issues you face. Test, print, test some more and make notes, then print again. Eventually you will be photographing and printing to your best capability.

LET OTHERS DO THE WORK

I've left this discussion for last, because at some point if you just can't or don't choose to deal with all the computer technology (which is greatly understandable), there are photography store kiosks or websites that allow you to bring in or download your images for printing. Some websites allow you to download your images from the computer, select the images, pick the size, add any notes, and then have them printed and mailed to anyone you choose. Or you can download to your local drugstore's web site and come in later to pick them up. Either way, your child's birthday party is on the grandparent's refrigerator with a couple clicks of the mouse.

There are many computer aids, such as Apple's iPhoto, to help you organize, display, and print your images. A book of your digital work can appear on your doorstep, bound and fully printed. The choices are amazing, but all require an investment in time to organize (some more than others). I don't think we've seen the end of innovation when it comes to printing and sharing photos. How long will it be before we display our photographs not on the wall but on the screen of our high-definition television in our living rooms? Actually, it's happening right now.

But don't relegate your photos to a hard drive where they may go forgotten about for months or years. I like to keep a folder with copies of photos that I'd like to print someday, so when the mood and time allow I don't have to go digging through hundreds of photos. Photographers also like to trade prints with each other, as there's a lot of work to admire and would love to have on our walls. Over the years you can build quite a collection.

PRINTING YOUR PICTURES
FOR BETTER SAFEKEEPING

Randy Olson loves new digital technology. His Epson 7800 printer sits on top of his 12-year-old Iris 3042 printer in his home office. A closet is stacked with servers so powerful he swears the street lights dim when he turns them on. He preserves RAW files and carefully layers each change he makes in his image-editing software into a brand new file.

Even after learning the latest techniques, Olson still can't forget the advice of photography's guru, Henry Wilhelm, when it comes to archiving. "He says that if you save your images as 1s and 0s, you need something to read those numbers," explains Olson. Since Olson stored his university thesis on a now-outdated Apple IIe floppy disk, he has decided a well-made print is a good solution.

Olson also uses prints as a means of editing his work. "You see things on a print you can't see on a monitor," he says. "Your eye can be tricked by the light source coming from behind the image on a screen rather than light reflected off of a print." Sometimes he makes almost 100 match prints before he edits a story for *National Geographic* magazine.

With dogged attention to detail and a deep respect for the people he is photographing, Olson is the first and only photographer to win both the Newspaper Photographer of the Year award (1992) and the Magazine Photographer of the Year award (2004) administered by the University of Missouri Pictures of the Year annual contest. He has photographed stories in places as diverse as the Sudan, Turkey, Thailand, the Siberian arctic, Australia, and the Congo. He has won the prestigious Robert F. Kennedy award for social documentary work on a story about Section 8 housing. He has also been a member of several of the photography teams that helped to create the *Day in the Life* series of books.

When the time comes, Olson plans to upgrade to the 200 gigabyte Blu-Ray disks. But in the meantime, he is intrigued by the photogravure plates created by Edward Curtis in the early 1900s. "They are still printing from those," he muses. See his work at *www.olsonfarlow.com.*

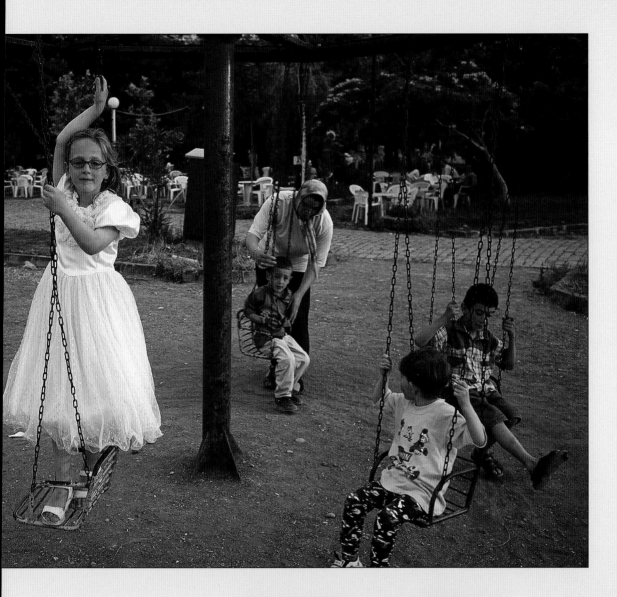

Top: On Sundays in a Turkish town near the Black Sea, families gather in the summertime. Right: Without looking through the viewfinder, Olson captured these Sudanese boys who had caked mud on their hair.

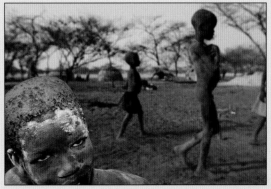

7 Film Photography

A BRIEF HISTORY

An irony about the invention of photography is that the sun created darkness, not light, in photography. Now how is that possible? We love the sun for its warmth on our bodies at the beach. We love it for how it makes the things we eat grow. Sunlight is the main source for making photographs. So why did Johann Heinrich Schulze, a scientist who noticed the darkening effect of sunlight on sensitized paper, call it "bringer of darkness" in 1725?

Johann Heinrich Schulze was teaching anatomy near Nuremberg, Germany. He noticed after mixing several chemicals, including phosphorus, that part of the concoction blackened after exposure to light. This intrigued him. He also noticed that the longer the exposure to the sun, the darker the object became. He prepared a new solution, determined to find out which chemical caused the darkening. Through elimination he realized it was silver nitrate, a result that he reported to the Imperial Academy at Nuremberg.

But Schulze didn't make the leap from this discovery to the invention of photography. No one made the connection during the 18th century between the darkening properties of silver nitrate and the recording of images made with portable camera obscuras. The camera obscura was a lightproof wooden box with a lens built into one side that projected an image onto a ground glass via a mirror for tracing onto a thin piece of paper. Scientists and artists used the camera obscura as a visual aid to make drawings from nature.

The Wedgwood family in England came close to the discovery in the early 1800s. They made fine matte-blue china and they used silver salts to record images they projected onto their creations. Artisans then traced the images onto the pottery and made them permanent by heating them in a fired oven. Thomas Wedgwood tried to fix an image on paper, or on leather, sensitized with a solution of silver nitrate. Light would continue to darken the image until it disappeared. He couldn't make the image permanent.

In 1816 a Frenchman, Joseph Nicéphore Niépce, had limited success creating a permanent image by employing heliography, or "sun drawing." In 1827 he made a very faint image of his courtyard using a bitumen-coated pewter plate, still extant and considered to be the first photograph. The exposure time was eight hours.

The business of photography not being his first priority, Niépce signed a partnership agreement with Louis-Jacques-Mandé Daguerre in 1829 to further develop the photograph.

An early 19th-century portable camera obscura allowed an artist to trace an image projected onto paper.

Joseph Nicéphore Niépce made the first photograph, "View from the Window at Le Gras," circa 1826.

Daguerre was a flamboyant showman, having earned his living as a scene painter for the Paris Opéra and as a co-inventor of theatrical dioramas. The dioramas astonished Parisians because the rapidly changing lights in the darkened theater seemed to put the scenery into motion, like the cinema of the future. Now Daguerre turned his showmanship to making images of the world with a camera lens. He sensed that the camera could grab the public's attention even more than his dioramas.

Daguerre first applied a solution of silver iodine to a piece of silvered and polished copper. Onto this surface he projected an image of an object through a lens. The plate's light-sensitive surface held a pale image. Daguerre discovered this process, according to legend, when he removed an exposed copper plate he had stored in his cupboard and discovered a darkened and much more beautiful image. Employing scientific technique, he put another exposed copper plate in the cupboard and removed different chemicals from the shelves one by one in order to determine which vapor caused the lucky result. In the end, he discovered the culprit was mercury vapor from a broken thermometer.

Rather than keep his method proprietary, Daguerre chose to license the "daguerreotype" method (with the blessing of Niépce's son, Isidore, who carried on for his recently deceased father). They found François Arago, a government minister,

CAMERALESS PHOTOGRAPHY
Experiment with one of the first methods

Before there was Nikon and Canon, cameras and lenses, scanners and film, there was cameraless photography. Using light-sensitive papers, photographers could make a permanent image by placing an object directly onto the paper and exposing the object and paper to light. At first it was sunlight. Soon it was light from an enlarger in a darkroom. What was left was the impression of the object seared into the paper in varying degrees of light and dark. Photographers developed the paper just as they developed film.

William Henry Fox Talbot, using calotype, called his version "photogenic drawings." Anna Atkins, using cyanotype, published the first book of these images in 1843 entitled *British Algae: Cyanotype Impressions*. Other photographers just adapted the name of the technique to their methods. Man Ray, who used silver chloride paper and a lightbulb for his light source, called his pictures of found objects "rayographs." Laszlo Moholy-Nagy called his images of Slinkies and vortexes and film reels "photograms." Today modern artists like Susan Derges and Adam Fuss have created incredible bodies of work mainly by capturing the mundane—a leaf, a child's dress, or a sunflower—in extraordinary ways by using this technique.

Any sheet of photographic paper will do. You can even use architect's paper and expose that to the sun. Vary the strength of your light sources and the angle of the light to find more interesting images.

Adam Fuss's photogram of a sunflower

This daguerreotype of Andrew Jackson was made during his presidency in the 1830s.

who convinced the state to buy the process and give Daguerre an annual pension for the rest of his life.

On August 19, 1839, Daguerre explained his method to a joint meeting of the Academy of Science and the Academy of Fine Arts in Paris. A crowd gathered to listen. Newspapers printed every word. Once the word was out, stores struggled to meet the demand for the necessary cameras, lenses, and chemicals. Scientists and amateur experimenters who had the money could be seen in the streets with their tripods topped by heavy, wooden boxes photographing monuments, buildings, and other inert objects of beauty. The daguerreotype was beautiful in itself; each one was a unique, incredibly detailed photograph.

Meanwhile, William Henry Fox Talbot of England was experimenting with sheets of paper sensitized with silver salts to create the first practical photographic negative. Talbot was a scientist and a member of Parliament who lived on his family estate, Lacock Abbey. In 1833 he had been using a camera lucida (another apparatus for drawing from nature) during a family vacation in Italy near Lake Como. The camera lucida allowed him to capture scenes from nature that were reflected off two mirrors onto paper that he could trace. The tracing he found laborious and not very successful. He was determined to find a way to fix an image to paper without using his hand.

A year later he did so by coating a piece of paper with a solution of silver nitrate. The images were contact prints from objects like leaves placed on the sensitized paper and printed using sunlight. But they were too faint to be of any use and, in addition, they continued to darken from exposure to light. He finally discovered that by adding gallic acids in development he could make useable camera images. He eventually managed to 'fix' an image at least partially by applying a solution of strong salt water. (Sodium thiosulfate later became the accepted 'fixer.') The earliest surviving image was only about one inch tall, whereas a daguerreotype might be up to 6 x 8 inches.

Talbot and Daguerre had each arrived at the invention of photography simultaneously. The silver-mirrored image of a daguerreotype was a much

superior image of great beauty, whereas the Talbotype or calotype (Greek word for "beauty"), as Talbot called his process, was a much less sharp, more inferior image. However, Talbot could make copies of his photographs; the image on paper was the first negative.

Sir John Herschel, an astronomer and scientist who was also interested in linguistics, dubbed the processes "photography," which means "light drawing," a definition that comes from the Greek words "photo" for light and "graphy" for drawing. He also applied the words "negative" to the image created in the camera and "positive" to images reversed onto paper. The same year as Daguerre announced the daguerreotype, Herschel discovered hyposulphite of soda dissolved silver salts so that they would no longer react to light. He applied this knowledge in an effort to make calotypes permanent. It worked.

The medium for holding a negative solution was the next problem. Experimenters realized that glass was the preferable surface on which to fix a photograph. It provided a smooth surface for a sharper image; paper negatives left an undesirable texture in the photograph from the paper fibers.

David Octavius Hill and Robert Adamson popularized the calotype with a series of portraits in the 1840s.

The burned district in Richmond, Virginia, was photographed in 1865 during the American Civil War. Photographers traveled with their wet collodion kits in covered wagons in which they could prepare the glass-plate negatives.

In the late 1840s, Claude Félix Abel Niépce de St. Victor, a cousin of Nicéphore Niépce, discovered that egg whites adhered the photographic emulsion to glass. The process would be called "albumen" after the egg whites. This was a big step, but unfortunately, the exposures were three hours or more. Due to the low sensitivity of the process, there was no question of portraiture under these conditions.

In 1850, Louis-Désire-Blanquart-Evrard coated paper with the albumen process. The length of exposure of negatives onto paper was not nearly as long as when the process was used in camera. These prints were extraordinarily beautiful and far exceeded the salted-paper prints that were in general use to print from negatives. Another French photographer, Gustave Le Gray, improved

the process in 1852 by introducing gold chloride for toning the albumen prints. The photographs were richer and more stable.

Until 1890, the albumen process on paper was the preferred method. One London company that made albumen paper used 500,000 eggs in one year. The United States alone used 300 million eggs a year during the height of the method's popularity. Those beautiful rich, brown-toned prints are much sought by collectors today.

Finally, in 1851 a negative process arrived that could give photographers a more functional exposure time. Frederick Scott Archer, an English sculptor, discovered that collodion from gun cotton, a form of gunpowder, became very tough when its chief component, nitrocellulose, was dissolved in alcohol. This sturdy, strong substance turned out to be the perfect solution for holding the silver nitrate and potassium iodine to glass. Once it attached itself to glass, nothing could make it come off. Unfortunately the glass plates had to be exposed and processed while still wet. When the emulsion dried, the image was impervious to developing. The process today is known as wet collodion.

The wet-plate process was cumbersome for photographers intent on exploration and landscape photography. They literally had to drag their darkroom with them, setting it up before they could begin to work. Once they had found an image they wished to record, photographers had to coat a piece of glass with the emulsion first, before making the image. Then they had to carefully take the exposed plate back to a light-tight tent or a wagon to develop and fix it.

Photographic societies in Europe and the Americas were all offering a prize for anyone who could invent a dry-plate process. In 1871 an Englishman named Richard Maddox discovered gelatin could hold light-sensitive chemicals needed to make a photograph. He also discovered that he could expose and develop the plate when it was dry, since the gelatin did not block the process or wash away.

All the while, cameras and lenses didn't change terribly much. But two men worked to create a standard for shutter speeds that related to film sensitivity. Vero Charles Driffield, a British scientist and amateur photographer, and Ferdinand Hurter wanted to obtain the best quality negative. Using a standard candle, they

This kit for making wet collodion glass negatives in the field belonged to Lewis Carroll, who wrote the children's story Alice's Adventures in Wonderland.

exposed film to increasing increments of light in order to find the most appropriate exposure time for each film.

In a short span of about 40 years, all the basic elements of photography were in place: a light-tight box, a lens, light-sensitive chemicals, printing methods, and a "fixer."

STEREO CARDS AND OTHER FORMS OF HOME ENTERTAINMENT

One of the first visual forms of home entertainment was the projection of glass lantern slides onto a wall. People could purchase images of famous sites around the world and shine a light

A stereo card captures a dancer in motion.

through them to project them larger. The glass plates were expensive, however, and fragile.

Stereo photographics, a pair of images that fused in a viewer to create a strong sense of three-dimensional depth, were another form of entertainment. They became an important way for many middle- and upper-class families to occupy themselves at home when not talking, reading, or playing a game. Before the industrial revolution there was not much leisure time. But now the public discovered that with stereo viewers they could transport themselves to the most amazing, fantastic, and breathtaking places around the world.

These images were made using a special camera fitted with two lenses placed side-by-side. The camera recorded the scene from two slightly different angles, so that when the pair were viewed together through a viewer the scene appeared three-dimensional. They were much more affordable than lantern slides. A manufacturer of stereo cards, Underwood & Underwood, made 25,000 stereo cards a day during the 1880s and sold 300,000 viewers per year.

GEORGE EASTMAN AND
THE EASTMAN KODAK COMPANY

"You Press the Button, We Do the Rest" was the first slogan for the first camera created and sold by the Eastman Kodak Company: the Kodak #1 camera. The camera cost $25 and could take as many as a hundred images on one roll of film. But the slogan addressed the post-production of pictures. George Eastman, founder of the company, knew that he must provide a way to get the film processed easily. Consumers could send in their film and receive each two-and-a-half-inch, round frame mounted inside a paper card.

The Brownie camera was even more popular. Introduced in 1900 for $1, the camera was named after a then-popular children's book of cartoons because Eastman Kodak intended to market it to children. It was easy-to-use, with a flexible roll film that cost 15 cents per roll. George Eastman believed in making products in large numbers on an assembly line (even before Henry Ford), which enabled him to offer them at the lowest possible prices and sell thousands. He also advertised extensively both nationally and internationally. He wanted to make Kodak a household name. The Brownie quickly became a colossal success.

With this simple camera, families eagerly started the tradition of photographing their lives and creating photo albums. Camera users enthusiastically made snapshots, a word Sir John Herschel coined because the new cameras reminded him of a hunter who took quick "snapshots." Photographs provided a sense of truth that drawings or painting could no longer satisfy.

TIP:
Fast color negative films have extremely fine grain. Make ISO 400 color negative film your standard film; if you use a variable-aperture zoom lens and you routinely zoom in to make a subject bigger in the frame, use ISO 800 film. Faster films also let you shoot at higher shutter speeds in dim light without much blur.

The electric light bulb also played a part in making this craze a success. Older developing papers had required long exposures to the sun to print a negative. But a photographic plate-making firm in England created a gelatin emulsion paper that could be printed with a short exposure with the aid of an electric light bulb. Now it was possible to print almost 150,000 prints a day.

COMBINING NEGATIVES
AND OTHER ARTISTRY

As photographers became more familiar with their equipment, they began to experiment with the art they could make. Gustave Le Gray, who believed in the supremacy of nature over man, made large prints of dramatic seascapes. Because the sky was so much brighter than the sea, and the negative was especially sensitive to its blue light, he had to make two negatives, exposing one for the sky and the other for the sea. Then he printed them in register to produce a print with detail in both sky and sea.

Both Henry Peach Robinson and Oscar Rejlander used photography to interpret life in an allegorical way during the Victorian Age. These photographers often mimicked academic painting dominated by sentimental landscapes and genre scenes. They believed photography should not just record what was in front of the camera. That was the terrain of news, scientific, or topographic photography. Rejlander's most famous combination print, made in 1847, was titled "The Two Ways of Life." This photograph, almost three feet by two feet, depicted a father and two sons. One son looked right toward a tableau of religion and industry. The other son looked left toward a tableau of idle life and sin. Rejlander made the picture by photographing a large cast of characters separately and combining 30 different negatives into one print. The project took six weeks.

Julia Margaret Cameron experimented with selective focus in her portraits, which today have great value in the art photography market. With her persuasive personality she had the power to record not only the exterior appearance but also the interior mood of her sitters. She also coaxed them to act out scenes from literature or the Bible. Characterized by sculptural lighting, selective focus, and highly revealing expressions, her photographs

The Kodak Brownie camera was extremely popular with American consumers.

Julia Margaret Cameron is still considered one of the best portraitists of the 20th century.

are unique artistic expressions. Museums around the world have collected her original prints.

BIRTH OF NEWS PHOTOGRAPHY

Almost from the invention of photography, cameras have recorded news events. During the Mexican-American War of 1847, a

photographer captured American troops on horseback. In 1848 daguerreotypes showed a Parisian street before and after a skirmish. In 1853 George N. Barnard made a daguerreotype of a burning mill in Oswego, New York. The images were not seen, however, until they were exhibited. Photographs could not be reproduced yet in publications.

During the Crimean War, the British government sent photographer Roger Fenton to support their claim that the British troops were in excellent circumstances on the Crimean peninsula in the Black Sea. He made more than 400 images of men in uniform in their tents, squadrons suited up for battle in the fields, and portraits. His most famous image—a landscape littered with spent cannon balls—is proof of the limitations of exposure times with wet collodion in the field, showing that it was impossible to capture battlefield action. (The required exposure times were too short to freeze action.) Fenton exhibited his photographs in London where people reacted to them because they were so real compared to the drawings and paintings of war to which they had grown accustomed.

The American Civil War was the first time that photography played a decisive role in the American public's perception of a war. Portrait photographers like Matthew Brady, George N. Barnard, Alexander Gardner, and Timothy O'Sullivan traveled from their studios in Washington D.C. or New York to photograph war. Wood engravers employed by popular magazines of the day like *Leslie's Illustrated Weekly, Harper's Weekly,* and Scribner's copied their photographs at a time when they could not be directly reproduced. An image by Alexander Gardner of dead soldiers lying unburied two days after the Battle of Antietam that left 26,000 men dead shocked readers with its realism. The detail of the translated images was sharp enough to allow the dead to be identified.

One year after the war Alexander Gardner published an album with 100 original photographs titled *Photographic Sketch Book of the War,* and George Barnard published one with 61 images titled *Photographic Views of Sherman's Campaign.* They became the two most important documents of the war.

TIP:

Use chromogenic black-and-white film. The negative can be made using dyes rather than the standard metallic silver for black-and-white processing. The same color lab that makes your color prints can process this black-and-white film in the same chemicals as color negative film, saving you an extra trip to a more traditional black-and-white lab.

This is a salted paper print of a photograph made by Roger Fenton during the Crimean War in 1855.

THE HALFTONE

When photographer and social worker Jacob Riis was making his landmark photos of the slums in the Lower East Side of New York City in 1889, an engraver still had to hand-copy them as line drawings so they could be printed in high-quality journals. Less than ten years later, inventors devised a screen to place between the negative and a light-sensitive metal plate that could break up the photographic image into a grid of lines or dots. More tightly packed dots mimicked the black areas of a black-and-white print whereas fewer dots in other areas created highlights and lighter tones. These plates could then be easily inked and printed.

The *New York Daily Graphic* published the first halftone photograph in March of 1880. It was a photo of an infamous shantytown in Central Park. It was not a stand-alone image, but part of a group of 14 illustrations depicting different types of graphic processes used by newspapers.

Some newspapers later produced special photography sections using rotogravure, a high-quality process that made extraordinarily rich and tactile images. Printing plates were etched, creating reservoirs to hold more ink in the shadows (dark areas) and little ink in the highlights (white areas), which were smooth. They

acted as a magnet for subscribers and were often used for special features midweek or in Sunday editions. Now that photography was essential to publications, more and more news photographers, or photojournalists, began to work.

Sensing the publicity potential, Eastman Kodak sent a portable darkroom to Cuba where *Colliers* magazine sent photographer Jimmy Hare to cover the Spanish-American War. Hare processed his film before sending it by boat back to New York City. Fresh photography attracted advertisers to the highly competitive newspapers and magazines.

PICTORIALISM AND THE PHOTO SECESSIONISTS

In Europe at the turn of the century, some photographers embraced the rules and trends in the painting world in an effort to establish a new way of making photographs. They called themselves Pictorialists and they believed in applying the art of photography to capture everyday objects and situations in a new light. This included the printing of the image as an expressive act. George Davison, Robert Demachy, F. Holland Day, Alvin Langdon Coburn, and Baron Adolphe de Meyer were among them. Soon an American named Alfred Stieglitz would join them.

Peter Henry Emerson was one of the first pictorialists in England. He photographed life in the marshlands of East Anglia in England. Mainly farm workers, fishermen, and basket makers populated the area. His images captured rural life at its most beautiful as nearby cities were industrializing. "Gathering Waterlilies," an 1868 photograph, shows a man and woman rowing through the wetlands as the woman picks up a water lily. His style became known as "naturalism."

In 1902 Alfred Stieglitz declared the central tenet of pictorialism should be the importance of the photograph as a work of art for its photographic qualities. He formed a group called the Photo Secession, seceding from the main group of Pictorialists who often approached photography like a painting or drawing. Edward Steichen, Gertrude Kasebier, F. Holland Day, and Clarence White were some of the photographers who joined him. They believed in the photographic artistry of everyday scenes and common objects.

SOMETIMES THE SIMPLEST
CAMERAS CAN BE VERY CREATIVE

Believe it or not, these soda cans are cameras—pinhole cameras. Photographer Wes Pope designed them for a class of fifth graders. His mother, a schoolteacher, had asked him to talk about photography in her school, and Pope thought pinhole cameras might be the most interesting and the most engaging. Pope made 30 of the soda-can pinhole cameras with the kids, who created self-portraits in the class. Later Pope used the pinhole cameras during his trip up Route 66 from Los Angeles to Chicago.

"You learn the basics of how an image is created," Pope says of his experience. Using a handheld meter, Pope used the light reading as a base and then adjusted the length of the exposure. For instance, if the light meter told him that in full sun using ISO 100 film he should be shooting 1/250 second at f/8, the exposure would be eight seconds. With ISO 400 film in the camera, the exposure would be two seconds.

The design of the camera was also a series of calculations. Using an Exacto knife, Pope cut the tops off two soda cans. He slit the side of one so he could slide it over the top of the other can, creating a light-tight cylinder. (Some people like to make square pinhole cameras, but Pope wanted the curvature the round cylinder provides.) Then he cut a small hole in the side of the can with the tip of the Exacto knife. Over the hole he taped a small square of tinfoil in which he had pierced a tiny hole.

"The secret to pinhole photography is the roundness of the hole," says Pope who often makes 60-80 foil squares before selecting the 30 he wants by looking at them through a loop on a light table. He makes the hole in the foil by puncturing it with a sewing needle, anchoring the tip of the sewing needle into a piece of cardboard. He then spins the cardboard while holding the other end of the sewing needle to create a centrifugal force on the edge of the hole in the foil. This action helps create a perfectly smooth hole.

Finally, he created paper tabs that he could slide up and down easily to act as the shutter. Over time, he has fashioned his own size of film by cutting off one inch from 4 x 5 color film to create a 3 x 5-inch negative to fit the cameras. This is why his pictures

Wes Pope traveled the length of Route 66 with only these pinhole cameras he made from soda cans. Enroute he met these former Las Vegas girls.

are somewhat elongated in their proportions. Pope now uses the cameras in-between assignments for the *Chicago Tribune*, where he works.

An oatmeal container has been a common first pinhole camera in high school photography classes. But you can use any cylinder or box as long as you create a light-tight container you can easily open in the dark to load with film. Some photographers have even figured out a way to make a pinhole camera out of a D-SLR: they drill a 1/8-inch hole in a spare lens cap and cover the hole with a piece of gaffer tape to use as a shutter.

To learn more about Wes Pope, go to *www.wespope.com.*

To further the cause of the group, Stieglitz opened an art gallery called 291 and created a magazine entitled *Camera Work*. The art gallery, located on lower Fifth Avenue, was the first to exhibit photographs among paintings and sculpture. The magazine was a luxurious mixture of high-quality paper, avant-garde photography printed in rotogravure, and essays about art from some of the most highly esteemed artists and writers of the day. Stieglitz published 50 issues of the magazine from 1903-1917.

His favorite image came to be a prime example of the efforts of pictorialism. "The Steerage, 1907" showed European immigrants returning home from America on the lower decks of the *Kaiser Wilhelm II*. Stieglitz had been standing on the upper decks watching them when he noticed abstract forms like the round shape of a man's straw hat, the tilting smokestack, the drawbridge that separated the social classes, and the crossed suspenders of another man. The shapes were symbols for him of the details that could separate the social classes. He fetched his camera and made an image of the scene.

AUTOCHROME AND THE INVENTION OF COLOR

Louis and Auguste Lumière patented the first practical method to make color photographs in 1904. They coated a piece of glass with a layer of varnish topped by a translucent layer of microscopic potato-starch grains. Red, blue, and green colors were infused into the grains before the final coating of light-sensitive gelatin bromide was applied. The glass plate was then placed in a camera with the glass facing the lens. The color-infused grains filtered the light before the emulsion recorded the image. You had to make a contact print positive and re-sandwich it with the negative. Although the result was beautiful, the process of exposing an autochrome could be as long as 40 times that for black-and-white film. Thus there was not much consumer use for it.

SPEED GRAPHIC

The Speed Graphic camera, introduced in 1912, was indispensable for news photographers. You

TIP:

Consider deviating from the exposure indicated, or set, by your camera. You can do this either by adjusting the autoexposure (AE) compensation control or changing the ISO from the official speed indicated on the film.

With **color negative film**, increasing exposure can actually reduce grain and improve shadow detail without injuring highlights.

With **slide film**, reducing exposure—either by setting AE compensation to the minus side or raising the ISO—can increase color richness and prevent bright highlights from losing detail. In either case, changes of 1/3-, 1/2-, or 2/3 stops can produce significant results.

Auguste Lumière made this Autochrome of his niece in La Ciotat, 1912.

could view the scene on a ground glass that showed exactly what the lens saw; or you could use a finder on top to quickly capture action. You didn't need a tripod. Just carrying a Speed Graphic was like a press card because it weighed nine pounds and few amateurs used it. Photographers today still covet this camera.

The Speed Graphic used 4 x 5-inch sheet film, flash bulbs if you needed extra light, and came with extra lenses. While the sheet film was a high-quality film, using it was laborious because the photographer had to remove it after each shot and replace it with a new pre-loaded holder. The flashgun was perfected in the 1930s. Previously a photographer used magnesium powder ignited on a flat holder. It was terribly dangerous and photographers were often injured from the explosive flash. William Randolph Hearst banned flash powder after he witnessed a photographer lose a finger as the result of igniting flash powder.

American photographers used the Speed Graphic beyond its practical years. They were slow to switch to the 35mm camera introduced during the 1920s in Europe. Some photographers resisted the tiny camera because they worried they couldn't get a

USING OLD TECHNOLOGY
IN MODERN WAYS

I was trying to find a way to make pictures before the war in Iraq started," says David Burnett, who was assigned by different newsmagazines to photograph President George Bush, Vice President Dick Cheney, and Defense Secretary Donald Rumsfeld. Digital cameras were everywhere at the press conferences, and photographers were using the same lenses—17-35mm lens or a 70-200mm lens. "The pictures all looked physically similar."

Burnett dusted off an old Speed Graphic he bought from the *Salt Lake Tribune* for $200. The WWII lens he prefers he found on eBay. By virtue of the heft of the camera—15 pounds with tripod—and the manual labor involved in loading the film, he found the camera forced him to work creatively in a different direction from digital. "It was a rediscovery of what I loved," he says, "of finding that one moment that tells a story."

Burnett decided to take the camera with him on assignment to cover the Kerry campaign in 2004. On his shoulder he kept a Rolleiflex camera and a Holga camera for moments when he needed a camera quickly. The rest of the time he patiently found his positions, set up the camera, and waited for a quintessential moment to use the 4x5 camera. For exposure checks, he carried a Polaroid camera and some film, as well. Each time he e-mailed a low-resolution scan of a favorite picture from the 4x5 camera to a picture editor, someone usually bought it.

Burnett has been equally as successful with the Holga camera, a plastic medium-format camera that retails for around $15. It has one shutter speed—1/100 second—and one f-stop—f/8. When used wisely, a Holga camera can make atmospheric images with selective focus that renders subjects more interesting. Burnett made one of the most interesting pictures of the outed CIA agent Valerie Plame with this camera, and in 2001 he won an award for a portrait of Al Gore at a lectern. The Salt Lake Olympic Committee hired Burnett as one of six photographers to capture the Olympic Games in 2002. Burnett used the Holga in innovative ways for this assignment, as well.

For other photographers who are eager to try old techniques,

Photojournalist David Burnett, above right, used the Speed Graphic camera while covering John Kerry's campaign. At the Salt Lake Olympics in 2002, Burnett used the Holga camera.

Burnett has a few words of guidance. "Don't be frustrated at first if the pictures are really terrible," he cautions. Burnett practiced with the camera when he he wasn't on assignment to get a better sense of it. He even experimented with the camera by covering and uncovering the seams with tape where light leaks typical of the camera can occur. "Adapt yourself to the camera," he advises, "not the other way around."

To learn more about David Burnett and his award-winning career, go to *www.davidburnett.com*.

While other photographers experimented with various color methods, Sergei Mikhailovich Prokudin-Gorskii used his own methods to create color images at the turn of the century.

good photo from the tiny negative. Much of this had to do with the way photographers recorded scenes at that time. They shot scenes in a wide fashion; cropping of photographs was widespread and accepted. Only later did photographers like Henri Cartier-Bresson insist the image should be cropped in the camera.

35MM CAMERA

Smaller cameras using 35mm film took almost 30 years to become popular. In 1889 Thomas Edison was the first person to load 35mm motion picture film into a still camera. He wanted to take still pictures on the sets of his motion pictures. Twenty-five years later a German scientist named Oscar Barnack threaded 35mm film into a small camera he crafted for the Leitz Optical company. Manufacture of the camera didn't happen until after World War I. Leitz called the new tiny camera the Leica. In 1927 Zeiss Ikon introduced the Ermanox, noted for its lens with a remarkably large aperture. With the Ermanox camera, European photographers could cover news events indoors without the use of disruptive flash.

Quickly, small improvements came along to diversify photography from 35mm cameras. Leica introduced a rangefinder to its camera for more precise focusing, along with seven interchangeable lenses in 1932. One of the first black-and-white films from Ilford was ASA 32, the old system for designating film speed. By 1933 Kodak and other companies were selling a ASA 100 film.

The 35mm camera reflected a newer, more fluid way of framing a photograph now that photographers were switching from heavier cameras. Photojournalists like Carl Mydans, Alfred Eisenstaedt, and Robert Capa used them during World War II.

COLOR

Kodachrome, introduced by Kodak in 1936, was the first truly practical, widely processed color transparency film. It required a unique developing process during which lab technicians diffused color dyes into the film's red-sensitive, green-sensitive, and blue-sensitive black-and-white layers to match the colors recorded. These dyes made Kodachrome the most realistic color film ever produced.

The first color negative print film, Kodacolor, was introduced in 1942. Kodak had invented it for use during the war to make sharper and better aerial photographs. Ektachrome followed in 1946 and was the first color film that photographers could process themselves.

Because Kodachrome and Ektachrome were slide films, families purchased slide projectors for their homes. As in the days of stereo cards and lantern slides, they made slideshows of their vacations and their lives. Photo albums were still the preferred display and storage option for most people, however.

DOCUMENTARY PHOTOGRAPHY
AND THE FSA

"The contemplation of things as they are without substitution or imposture without error or confusion is in itself a nobler thing than a whole harvest of invention."

Dorothea Lange tacked this quote from artist Francis Bacon onto her darkroom door.

During the American Depression in the 1930s, Roy Stryker of the Farm Security Administration (FSA) hired some of America's

most talented documentary photographers. His goal was to document the impact of federal aid for farmers who had been displaced by serious droughts and for families in search of work. The photographers included Arthur Rothstein, Ben Shahn, Walker Evans, Dorothea Lange, Carl Mydans, Russell Lee, Marion Post Wolcott, John Vachon, and Jack Delano. The FSA made the photographs available free of charge in the hope that newspapers and magazines would publish them. During the first three years, most of the photographs focused on the suffering of the most unfortunate. During the next three years the photographs were more positive, as they concentrated on projects that helped people. In the eight years of its life, the FSA filed more than 160,000 images, which are archived at the Library of Congress. The images can still be seen on their website: *www.loc.gov.*

The iconic images are the most recognizable. Dorothea Lange's "Migrant Mother" showed a woman sitting at the entrance to a tent in a resettlement camp with a small child in her arms and two children on her shoulders. The woman's face embodied the terrible ordeal people had to endure while showing a firm determination to survive. Arthur Rothstein photographed a father and his sons crossing the barren, ravaged landscape during a dust storm in Oklahoma in 1936. Gordon Parks made a dignified portrait of a charwoman standing in front of the American flag.

But Roy Stryker also encouraged invention with the work. Russell Lee used a flash to penetrate the dark shanty interiors that otherwise could not be recorded. Sometimes he even used a right-angle viewfinder, which allowed him to photograph people without their knowledge. Walker Evans modeled his work after Eugene Atget's documentary style in Paris. He used an 8x10 view camera, and his images were direct without being sentimental or dramatic. For instance, a simple photograph of a kitchen in a rural Alabama home said volumes about the people who are not even in the frame. Ben Shahn, a painter as well as a photographer, infused his pictures with a more personal style. Margaret Bourke-White posed real people to create more dramatic compositions.

TIP:

Don't skimp on film. Film is the cheapest component of photography and taking lots of pictures helps you improve as a photographer. If you're using commercial photofinishing and you don't want to pay for extra prints, tell your lab to "develop only." This way you can save money by printing only the pictures you want.

WORLD WAR II AND LIFE MAGAZINE

Photographers accompanied the troops to the fronts of war on both sides during World War II. *Life* magazine carried story after story of the battles in Europe and at home. Their staff included some of the 20th century's most recognizable names in photography: Margaret Bourke-White, Carl Mydans,

Dorothea Lange's "Migrant Mother," 1936, became an iconic image.

Right: Elliott Erwitt made a playful self-portrait of himself as photographer.

Gordon Parks, and Alfred Eisenstaedt. Founded in 1936, *Life* magazine would become a reflection of American life during its nearly 40 years of existence. The photographers working with the troops wore military uniforms as members of the service. Sometimes an assistant traveled with them just to take notes and write caption information.

The archetypal war photographer whom others sought to copy was Robert Capa. Born Andre Friedmann in Hungary, he adopted the name Capa, which means "shark" in Hungarian, during the Spanish Civil War. He was famous for taking risks, and also for saying, "If your photographs aren't good enough, you're not close enough." It was Capa's photographs of D-Day that are most remembered. He shot four rolls of film with his 35mm Contax camera that day. Editors in the London bureau for *Life* received the film and processed them there. As the story goes, Bureau Chief John Morris was trying to get the film onto a scheduled flight to New York, so he told the darkroom technician, Dennis Banks, to dry and contact the film as quickly as he could. Banks closed the vents on the film drying cabinet to rush the process, and when he opened the door he found the emulsion on three of the four rolls had melted. Eleven frames remain. They are still some of the most recognizable and emotional images of the war.

Other photographers who would make names for themselves in the theater of war included W. Eugene Smith, David Douglas Duncan, George Rodger, and Joe Rosenthal.

After the war *Life* published memorable black-and-white photo essays. W. Eugene Smith photographed "The Country Doctor"

This is one of the 11 surviving frames from Robert Capa's coverage of D-Day in 1944.

in 1948. Leonard McCombe made an essay about the struggles of a young woman trying to start a career in New York City. Bill Eppridge documented drug addiction in New York City in 1965.

Although color film was available, the photographers preferred black and white for its simplicity and its ability to capture images in low light. One brilliant exception, which signaled the future, was the choice by photographer Larry Burrows to shoot some of the Vietnam War in color. The green hues of the jungle, the orange and red colors of exploding shells, and the redness of spilt blood brought the war into modern times visually. Color television would also help bring more color photos into magazines in the 1970s.

MAGNUM PHOTOS

Robert Capa, angry at times about the way magazine editors treated photographers, organized a meeting of his colleagues in the penthouse restaurant of the Museum of Modern Art in New York City in 1947. The group also included George Rodger, David Seymour, Henri Cartier-Bresson, and William Vandivert. They decided to form a cooperative photo agency called Magnum Photos, an agency that still thrives today.

The photographers' main goals were to demand the best pay for their members and to assert their right to keep the copyright of their images after publication. Each photographer had an equal voice in agency matters, including hiring support staff. To become a new member was a difficult process. Sometimes photographers had to prove themselves worthy of membership after several years of stellar work.

The agency has endured, surviving a tumultuous sea of success, failure, and change in the photographic world. Its founder, Robert Capa, died during the First Indochina War in 1954. David Seymour was killed in the Middle East while covering the Arab-Israeli conflict. Werner Bischof died in a tragic car accident in South America. In spite of these losses Magnum continued with young photographers such as Sebastiao Salgado, who made the world aware of individual struggles worldwide in his landmark book *Workers*. Josef

TIP:

Take care of your film. Though modern film emulsions are pretty rugged, keep it refrigerated if you won't use it for a while, and let it warm up for an hour or so before loading it. If you're taking exposed or unexposed film on a plane trip, *never* pack it in checked baggage because high intensity x-rays can damage it. Take it in your carry-on luggage and ask for a hand inspection.

RUSSELL KAYE
Hanging onto his boxes of Polaroid 55

Photographer Russell Kaye started toting his 4x5 camera, a Linhof Technica 3, on assignments in 1987. Before digital LCDs, Polaroid film was the only way photographers could gauge how their pictures would eventually look on film. Their camera bags were littered with curled Polaroid positives of test shots. As a rule, Kaye stored his negatives from the Polaroid 55, mainly black-and-white ones.

In 1992 he decided to photograph the Festival of Purim in the Williamsburg section of Brooklyn with only Polaroid 55 black-and-white film. When he printed the pictures, he liked their atmospheric quality. And soon photo editors seemed to like the quality of the work, too. He started using the technique more and more on assignment for magazines such as *Men's Journal, Budget Travel*, and *National Geographic Adventure*. Covering the 1992 Clinton-Gore campaign, the Secret Service almost sent him home when they couldn't discern what the negatives were doing bathing in a solution of sodium sulfite inside a watertight bucket in his bag. "Is it flammable? Is it poisonous?" they asked Kaye. "Probably," Kaye replied. Soon he used a tip from none other than Ansel Adams, another Polaroid aficionado. Adams wrote in one of his manuals that you didn't really need to use sodium sulfite—a compound that crystallized at the edges of the tanks allowing water to seep out and ruin the trunk of a rental car or the rug on a subject's living room floor. Instead, Kaye put a few drops of potassium alum in plain water and the messiness problem disappeared.

In 1998 he discovered how durable the negatives could be when he was on a Viking Ship near Greenland on an assignment for the Land's End catalog. After a day's work Kaye pinned the corners of his negatives to a clothesline aboard ship to dry them. "You lost something," a midshipman yelled to him sometime later. Kaye turned to see this photograph floating on an icy sea.

You can see more of Kaye's work at *www. russellkaye.com.*

Russell Kaye rescued this frame from the waters of Greenland during an expedition on a Viking ship.

Black-and-white film was the first choice for documentary photographers during the 1950s.

Koudelka documented the lives of gypsies. And now a new generation of photographers is educating us about Iraq, Afghanistan, China, and Iran in breathtaking, lyrical work. The message of the agency seems to have endured.

POLAROID FILM

Edwin Land was a physicist and inventor who studied at Harvard University in the 1930s. He studied polarized light and invented a polarizer, a clear film that eliminated glare and reflections in optics and sunglasses. Photographers used it too, to control reflections in water and to darken skies in color photos. Land left Harvard in his senior year to continue his experiments in his own lab.

In 1948 Land introduced the Polaroid Land Camera Model 95, which produced the first instant photograph. This camera had a folding bellows (accordion-like material that joined the camera body to a lens so it could be moved for focusing) and a roll of black-and-white film. After someone took a picture, he could pull the film through metal rollers that helped to spread processing chemicals across light-sensitive paper. After a minute, the photo could be peeled apart and wiped with a coating solution to fix it.

The Polaroid was an instant success. In 1965 Land introduced an improved version that did not have folding bellows: the Polaroid Automatic 100 Land Camera. It was a much bigger hit with amateurs due to its easier mode of operation. It could also take color film.

In 1972 Land invented the SX-70, which used "integral" instant film, a drop-in cartridge that contained a battery to power the camera. There was no need to make sure the film pack was properly loaded, which could be a problem with the older models. It also folded flat to the size of a paperback novel. It was also an SLR camera. Even though the SX-70 was quite popular at first, its film was expensive and it began to lose popularity. The advent of point-and-shoot cameras and one-hour photo processing hastened its demise.

ROBERT FRANK AND
ART PHOTOGRAPHY IN THE 1950s

Swiss-born Robert Frank moved to New York in 1947, the year Magnum Photos was created. Alexey Brodovitch was the legendary art director of *Harper's Bazaar,* and Frank shot assignments for him. In 1955, bored with this work, Frank received a grant from the Guggenheim Foundation with the help of his fellow photographer Walker Evans. He traveled across America, and the photographs he made are legendary. He perceived America entering a time of crisis: a crisis of the family and a crisis of definition during the Cold War years. Everywhere he went he saw lonely roads, cars, jukeboxes, American flags, and the glow of television that had just started to claim the American landscape.

The ensuing book, *The Americans*, was not an instant success. The seemingly haphazard, unframed quality of Frank's photographs was radical and unacceptable under the rules of composition. He was not just expressing what was in front of him but also how he reacted to it. More important, he believed that life was not a series of decisive moments but rather the time in-between. At first only a handful of perceptive photographers understood what was happening. Only in the late 1960s did photography students begin to understand what Frank had seen. Photographers began to realize that they did not have to frame their photos in a classic, painterly way.

THE KODAK INSTAMATIC CAMERA

In 1963 Kodak simplified photography for the amateur even more by creating cartridge film. The consumer could simply drop the cartridge into the back of the new Instamatic 126 camera, close the back, and the camera wound the film itself. The film was really 35mm film in a cartridge with its own built-in spools for the safe advancing of the film, frame by frame. It was a simple point-and-shoot camera that even had a built-in flash point where you could install a small disposable flashbulb. Kodak sold 50 million cameras, which meant almost one out of four people in America owned one. Later, Kodak sold 25 million of the Instamatic 110, which was even smaller.

THE 35MM SINGLE LENS REFLEX CAMERA

While amateurs were embracing the Instamatic, more serious photographers wanted single lens reflex cameras, or SLRs, manufactured by companies such as Nikon, Canon, Minolta, Olympus, Konica, and Yashica. The cameras had through-the lens focusing, built-in light meters, and a large variety of lenses. Zoom and telephoto lenses became popular.

PERSONAL COMPUTERS

In 1980 International Business Machines contracted with Bill Gates, Steve Allen, and Steve Ballmer to develop an operating system for their proposed home computer (personal computer-PC). These men called their product Microsoft after microcomputer software. In August 1981 IBM introduced the IBM PC. It could only take up to 256K of memory and could use 160K floppy discs. The processor speed of the computer was just under 5Mhz. Today processors have speeds over 2Ghz. To use the IBM computers you had to learn its DOS operating language. Today almost 80 percent of the world uses the Microsoft operating system. *Time* magazine made the computer "Machine of the Year" in 1982.

Then Steve Jobs and Steve Wozniak introduced the first Apple computer at the beginning of 1984. It came with 128K of memory and a processor speed of 8Mhz. The Apple Computers have become the preferred computers for photographers and designers since then.

THE INTERNET

During the mid-1960s, a United States government agency, the Advanced Research Projects Agency (ARPA), became interested in computer data networks. They engaged Leonard Kleinrock at the University of California in Los Angeles (UCLA) and Douglas Engelbart of the Research Institute at Stanford University to help them create a system in which computers could be linked. Soon the University of California at Santa Barbara and the University of Utah would also be connected to the project.

The government relinquished control of the Internet to the public in the 1990s. No one owns the Internet. No one controls it. No one can shut it off. People can use it to e-mail messages, share websites, send JPEGs, and archive online. Professionals post photographs on FTP sites rather than ship film on airplanes.

DIGITAL PHOTOGRAPHY

In a fundamental way, there is no difference between the film camera and the digital camera. They both make images of the world in front of us. With film, however, you had to wait until the film was processed and printed before you could see what you had captured, unless you had a Polaroid camera. Digital

The Internet was celebrated on the July 25, 1994 cover of Time *magazine.*

Digital darkroom techniques make it possible for photographers to render their photographs like paintings.

cameras allow you to see the image immediately, and you don't have to bother with messy chemicals. The speed factor alone has revolutionized how we make and see images.

Digital photography was born during the 1950s simultaneously with television. Video tape recorders captured images from television cameras and converted them into electronic impulses in analog format. Magnetic tape stored the data. NASA advanced the process in the 1960s when they employed digital cameras to map the surface of the moon. In 1972 Texas Instruments patented a film-less electronic camera. By 1988 Sony was marketing the Mavica electronic camera, the first commercial venture. The images could be shown only on television.

Kodak and Apple were hard at work as well. Kodak made the first megapixel sensor, which could hold 1.4 million pixels of information for a reasonable quality 5 x 7-inch image in 1986. Five years later they teamed with Nikon to put a Kodak megapixel sensor on the back of the Nikon F3 camera. This was the first system to be released for the professional, and the size of the image (or file) was 1.3 megapixels. For the consumer they created the Logitech Fotoman. Apple introduced the Quicktake 100 digital camera with a serial cable so you could download the images to your computer. The VGA resolution was 640 x 480 pixels.

Professionals liked being able to look at their images before they turned them in for sale. Amateurs liked the new technology as well. Photolabs changed their technology to meet the growing

demand for digital prints. Companies like Hewlett-Packard and Epson, among others, developed printers capable of making prints at home.

At the same time, two brothers from Michigan developed a way to work with images on their new Macintosh Plus computer. Thomas Knoll wrote a program to create a grayscale with the computer for his photos. He expanded the program into a product called Imagepro, which his brother, John, took with him back to Industrial Light & Magic where he worked. A company called Barneyscan bundled 200 copies of the program with their slide scanners in 1988. Adobe soon licensed the program and Photoshop 1.0 released in 1990. Today it is a premier imaging software available for both professionals and amateurs. Scanners also became hugely important with the advent of digital photography, translating the data from negatives, prints, and slides into digital data.

Soon the massive amount of digital data being collected required either much bigger hard-drive storage or better-compressed images. A committee of computer experts—the Joint Photographic Experts Group—was convened in 1986. They created a method to remove repetitive digital information so they could shrink the image to as little as 1/10 of its original size. For example, if a picture has a range of colors of similar color and tone as a sky, these pixels could be grouped together rather than saved individually. The pixels could be restored when the file opened again. The experts called the system JPEG after their group.

As photojournalists and consumers alike embraced the digital revolution, some photographers and artists rediscovered old processes in fresh new ways. Sally Mann reinvestigated the wet-collodion process in her *Deep South* work. Chuck Close photographed model Kate Moss and others with the daguerreotype process. Adam Fuss sold large color photograms at the Fraenkel Gallery in San Francisco. Abelardo Morell returned to the camera obscura.

As some photographers have noted, we may stand in the future one day and realize that film was a fad in the timeline that tells us the story about the history of photography. Only time will tell.

CDs and DVDs are the modern way to store images.

"YOU CAN'T BE INDIFFERENT AND DO SUPERIOR WORK."

This is what Bill Allard tells his students when he is teaching photography. More important, this is the mantra that Allard tells himself, and for more than 40 years it is how he has kept himself vibrant as a photographer, a writer, and a mentor. He loves music. He loves the American West. And when he used film in his cameras, he loved Kodachrome.

Allard's first assignment for *National Geographic* magazine was a story on the Amish population in Pennsylvania, which the magazine published in August 1965. He has covered topics as varied as Cajun life, baseball's minor leagues, Bollywood, and Cyprus. He has earned a reputation from the beginning of his career for knowing how to capture the essence of people. He can see them as they see themselves. He is also known as a master at color photography, knowing how to capture the telling image without allowing colors to clash and obscure what he is trying to show.

"I hated going around with different emulsions," says Allard. Different films in the bag could lead to mistakes. So Allard learned how to use Kodachrome in every possible place: outdoors in full sun or inside using ambient light and a tiny shoemounted strobe light every now and then.

When Kodak announced they were discontinuing Kodachrome 25, someone at National Geographic bought a thousand rolls. When Kodak tried to discontinue Kodachrome 200 a few years later, professional photographers protested vehemently. But the reality is that in a few years there will be fewer labs that process Kodachrome. The film-developing business is shrinking with the meteoric rise of digital photography.

In 2005 Allard photographed his first story with a digital camera. He revisited the Hutterites, a community in western Montana. The experience rejuvenated his love for the American West. And it sparked his newfound interest in digital technology. "With transparency film you reach a point where there is no exposure," says Allard. "This camera can see in the dark." For the first time, Allard dialed in an ISO of 800, a speed he had never used in film before.

Young Parisians dine in the Marais district of Paris in 2003.

To learn more about Allard's work, you can go to *www.
nationalgeographic.com.* Or pick up a copy of one of his books:
*Portraits of America; Vanishing Breed: Photographs of the Cowboy
and the West; A Time We Knew: Images of Yesterday in the Basque
Homeland; The Photographic Essay;* or *Time at the Lake:
A Minnesota Album.*

Two dancers, Diann and Scandalicious, dress on the bus for a show in Greenville, Mississippi, 1997.

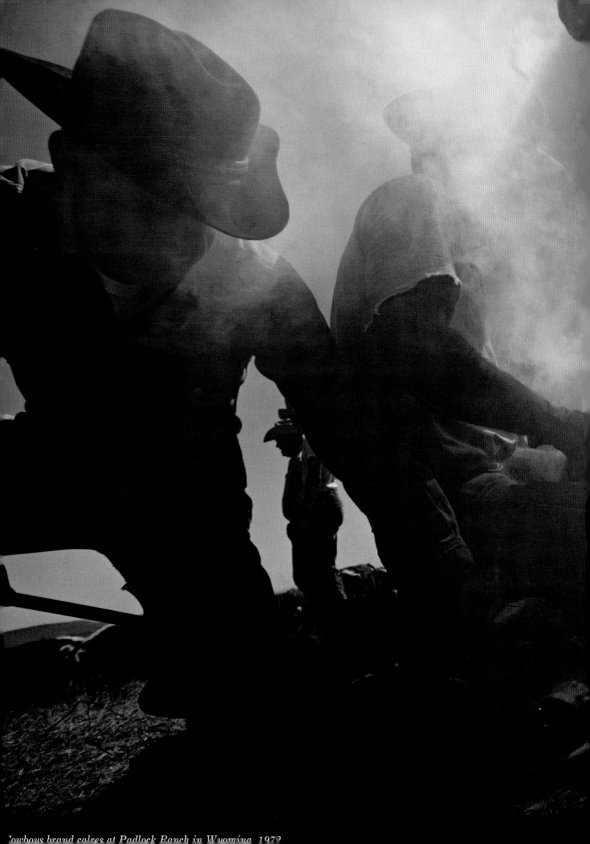

Cowboys brand calves at Padlock Ranch in Wyoming, 1972.

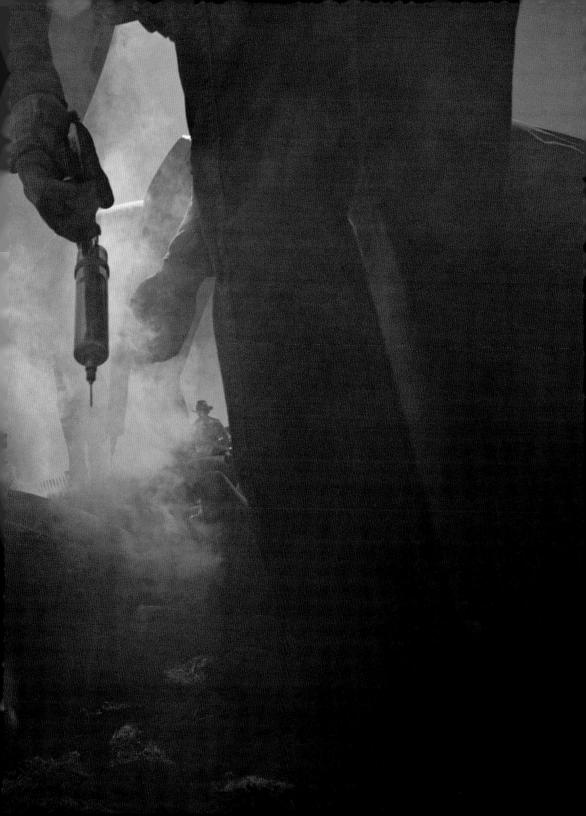

An approaching rainstorm darkens the landscape in Winifred, Montana, 1996.

Chapter 8
Scanning

8 *Scanning*

During the past decade the changeover from traditional film and chemical photography to a digital process has revitalized interest in photography and motivated millions of adventurous photographers into scanning and printing their own work. It seems like only a few years ago that I longed to make my own color prints. I couldn't have imagined that I'd be able to view my images on a website from a hotel room halfway around the world.

While digital photography has moved many of us into new and exciting territories, it has also introduced a confusing maze of cables, software updates, scanning procedures, and printing tribulations. It can create digital overload. The goal in this chapter is to try to take the mystery out of scanning and explain it in understandable, bite-sized chunks.

One of the major reasons for our interest in scanning, outside of the needs of professional photography, is to manage the boxes of slides, prints, and negatives from our collective past. To protect and modernize this work, there has to be a concerted effort by the family archivist to learn how to scan images or prints to protect that history.

The art of scanning is not relegated just to salvaging old slides and prints. There are many beautiful images residing on slides and negatives that now deserve to be printed on the new ink-jet printers. Some of my best prints have been made from scans and not from a digital camera. You can copy or scan precious documents. There's no end to what you will find yourself doing with your scanner once you take the time to learn how to do it right.

WHAT IS A SCANNER, EXACTLY?

A scanner is essentially a camera housed in a box that is designed to digitally copy transparent (film) or reflective art (prints) that's placed on or in it. The scanner moves a row of CCD sensors across the image surface, or its projection, to translate it into a pattern of electrical charges that is in turn converted to digital information readable by a computer. The image (file) can then be

displayed on a computer for further tweaking or storage. Some scanners called film scanners only digitize film, such as color slides or black-and-white negatives. Other scanners that look like table-top copy machines are called flatbed scanners. They have a glass surface that allows a light source to illuminate the object

Archivists have been scanning negatives of famous photographers such as pictorialist Alvin Langdon Coburn.

A large flatbed scanner is capable of scanning many photographs at once.

to be copied. Both types of scanners connect to the computer by either USB or FireWire cables.

WHAT CAN I DO WITH A SCANNER?

One of the primary uses of scanners by photographers is to digitize their personal collection of slides. Over the past few years I have scanned in thousands of slides I shot while on assignment for *National Geographic* magazine. I had a choice to let them stay in a box or make them available to others through my website.

But besides the photographs that photographers want to digitize, there are millions of slides and prints from family histories that are fading in their boxes or picture frames. Most people will notice the fading of their color drugstore prints or early Ektachrome slides shot in the 1970s. Certainly any color prints made in the last 15 years and hanging on the wall have long begun to fade. I have saved many prints and slides from a slow and agonizing death by scanning, reprinting, and archiving them for posterity.

Another reason for scanning is the total digital changeover in the printing and publishing world. Over the years it has been worrisome to hand over precious slides or prints to some publication

where damage or loss is an ever-present danger. Today, high-quality scanning allows photographers, graphic artists, and others to transmit creative material in digital form without the risk of loss or damage to the original. Scanning has taken an enormous weight of responsibility off both sides of the photography business.

An image can now be sent around the world just moments after you made that scan or took that digital photograph. Scanning also allows you to copy and protect those precious documents, book pages, or articles you want to share. Even objects like jewelry, leaves, flowers, or just about anything that will lie flat on a scanner is fair game, and can give you a quality that is surprisingly three-dimensional. The drawback is that once in digital form, anyone can own a perfect copy of your original. Protecting your scans from theft and illicit use is an important consideration, especially if you're a working photographer.

Finally, there is special software called OCR (Optical Character Recognition) that will scan pages of text and interpret them into sentences you can edit on your computer's word processor. It's scary how accurate these OCR programs can be. One must respect the copyright of others and understand that there are stringent guidelines as to what is "fair use." Crossing the line of copyright infringement, especially in publishing or on the Internet, can be very expensive. Most people with creative properties are aggressive in protecting their works.

CHOOSING THE RIGHT KIND OF SCANNER

After the initial investment in a digital camera, a computer, software and a printer, many photographers and amateurs next turn to scanning their collections of film and prints. It must be noted that just having a digital camera doesn't automatically give you a superior image. I have made some of my best large-scale digital prints from scans of negatives I shot years ago. Side by side, a great scan of a negative can match or exceed the quality of even high-end digital cameras.

In choosing a scanner, first make a list of the most important uses you have in mind for it. List the most common film or print sizes you plan on scanning. Do you plan to use these scans just for Web or family use or do you need high-resolution scans for commercial or archival use? You can spend from $100 to $20,000

Professional photographers often have both a 35mm scanner and a large-format scanner in their studios.

or more for a scanner, so make use of the Web to research current scanner specifications and reviews and be realistic about needs versus costs. I've sometimes had better results with a $1,200 35mm scanner than with my $15,000 "virtual drum" scanner. But generally speaking, I would encourage you to look at the top-of-the-line scanners from Nikon, Canon, or Epson to begin your search. The following checklist will help you compare models and prices.

SCANNER TERMS AND VALUES

Scanner Resolution

In the world of digital imaging and scanning, resolution has a

big effect on how large a print you can make and still maintain acceptable image quality for the output size you want. Resolution determines how much you can enlarge your image when you go to print. The more ppi per inch (see below) that your film scanner records, the bigger the print you will be able to make. Most 35mm film scanners now support 4,000ppi which is adequate. If you are only going to scan prints on a flatbed scanner, resolution is not quite as important. A resolution of 300ppi is sufficient unless you plan to enlarge the original print. However most models now offer much higher resolution, which, together with their built-in transparency adapter, lets you get good results even from 35mm film originals.

PPI or DPI?

Probably one of the most confusing terms when it comes to scanning and printing is dpi (dots per inch) versus ppi (pixels per inch). Many software and hardware companies use these terms incorrectly, making it even more confusing. Scanner companies use dpi in describing their scanner's resolution when they should really be using ppi.

So here it is in a nutshell: "Dpi should be used when describing printing resolution of images on paper, and ppi should be used to define image resolution of scans and computer images."

It might be easier to remember that digital scans and images consist of a field of pixels, with each pixel having a color value (bit depth). So the size of a scan is defined by the number of pixels in the image. The file size of your scanned image will give you a realistic indication of how much information or pixels your scan contains.

At the same time it might help to remember that dpi is the density, or number of ink dots sprayed by a printer (as in the inkjet model). A 700dpi print has 700 dots of ink sprayed into a one-inch area.

Bit Depth

Bit depth is a numerical value that describes a range of colors a pixel is able to record. It is important to understand how much color information is available to a photograph or image in this digital world. A pixel of a black-and-white image is either one or

Expanding the dynamic range in Photoshop brightens the image by raising the highlight levels. This image scanned in 8-bit shows some tonal loss in the histogram, which might cause an uneven tone in the sky. Scanning in 16-bit would help prevent this problem.

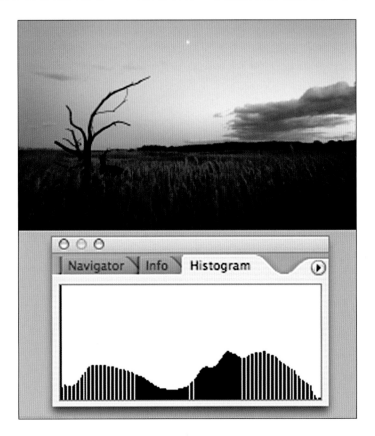

zero, or black and white. That is one-bit color. Eight-bit color can represent up to 256 colors maximum. When you get up to 24-bit color you are applying 256 different values of color for each of the red, green, and blue channels, which in effect give you millions of colors to work with.

Dynamic Range

This term is always used in comparing scanners. Dynamic range is the capability of a scanner to detect and record the brightest to darkest values of light passing through a slide or reflected off a print. A general range is from 0 to 4 or more. Therefore, the scanner with the highest dynamic range has the better ability to interpret the lightest and darkest areas of the photograph. Some scanners will have a dynamic range as high as 4.8.

Histogram

The histogram is a simple graph that cameras and scanner software make available to display the brightness levels in a captured

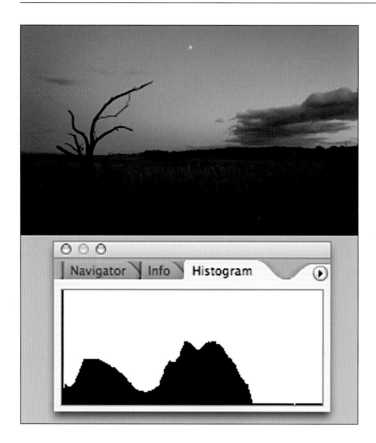

The histogram of the scanned image shows how the scan was not set up properly. The highlights are down in the mid-tone area, creating a rather muddy and lifeless picture.

image, from the darkest to the brightest. These values are displayed across the bottom of the graph from left (darkest) to right (brightest). The vertical axis (top to bottom) shows how much of this value is found at any particular brightness level. Histograms can be adjusted before you scan and also later in Photoshop. It's always better to make the correct adjustments at the source rather then saving it all for later. It's like saying to a singer, "You don't have to sing very loud. We can fix that later in the studio." Sure, some of that is true, but the best approach is to do the best you can at the front end of the process.

The goal of a good scan is to keep most, if not all, of the data value from "clipping" over the dark or light ends of the histogram graph. Anything outside the graph represents data that is forever lost and will not appear in your scan as usable data. In other words, those will be parts of the picture that are either all black or all white. Some scanners can make several passes over the film that can help reveal detail in overly bright or dark areas, but the results will never match that of a nicely exposed photo.

SCANNER TYPES

Film Scanners

These come in various sizes based on negative size. Tabletop scanners for 35mm slides are the most common size used by amateurs and professionals. Film scanners have the light source on one side of the film with the CCD (Charged Coupled Device) array on the other. In most scanners of this type, the CCD moves slowly across the image. This is what gives you the resolution, the density of the CCD, and the distance between the steps the light moves across the negative. If you have uncommon negative sizes, be aware that most scanners do not accept negative sizes other than those they were designed for. (You may have to use a flatbed scanner in such cases.) Check the negative size limits of each scanner carefully.

Consumer film scanners generally outperform flatbed scanners when it comes to scanning negatives. Some flatbed scanners have film adapters for their scanning bed, but if the majority of your work is going to be with negatives or slides, the optics, scanning path, and software of a dedicated film scanner will most likely give you better results.

Scanning 35mm slides and negatives can be a challenge, since many of the older negatives have a warp or curl and do not sit perfectly flat in the holder. The pricey but worthy Imacon scanner has a unique method of holding the negative or transparency in a magnetic frame and then scanning it on a curved track, creating a perfect flexed tension for an even focus across the plane. The Imacon is out of the price range of most amateurs, but it represents the very high end of tabletop film scanning.

Flatbed Scanning

Flatbed scanners are more versatile because some models scan both prints and negatives. In an ideal world you would have a film scanner for your negatives and a flatbed scanner for your flat art or prints. But if space and money are a consideration, a multi-use flatbed scanner is a good choice. Flatbed scanners can also copy documents just like a copy machine.

If you're only scanning prints and documents, flatbed scanners actually provide a wider dynamic range than the actual print can show. A good example is that a negative can have a tonal range of

An optical reader allows
you to scan pages of text.

500:1 whereas a print is around 50:1. Therefore, your final scan will only be as good as the quality of your print but never better than going back to the original negative.

If you plan on purchasing a flatbed scanner but also want to do film scanning, be very certain your unit has the specific holders for your film sizes. Also look for the dynamic range of the scanner to be a least 3.6. (See the definition of dynamic range.)

Added Features

If you have hundreds of family slides that appear to be fading or damaged, you might not have the time to sit for endless hours at the scanner. A number of the higher-end scanners, such as the Nikon Coolscan, can accept what they call a batch scanning attachment. Up to 50 slides can be loaded at a time and if you've edited your images into similar contrast and lighting situations your settings can be applied to the whole batch. During a batch scanning it's best that you keep an eye on the process, since warped slides or other problems can jam the operation.

DO I WANT TO CALIBRATE MY MONITOR?

There are so many variables in photography, and when it comes to digital, that has not changed. The goal is to create good scans that represent the original, and the first step is to calibrate your monitor so the contrast, brightness, and color are set to some standard. It is amazing how inconsistent monitors can be. You

don't want to be adjusting colors on your scanner when the monitor itself is way out of balance. Adobe Photoshop and Photoshop Elements have a calibration wizard that can assist you. Macintosh computers have a nifty display calibration built into the system preferences that will walk you through a calibration.

LCD VS CRT Screens

LCD screens are the flat liquid-crystal display monitors only inches thick, whereas CRT monitors are the older TV-like cathode ray technology that can take up a large portion of your desktop. In either case, you need a monitor that allows adjustments on brightness, contrast, and gamma settings. But don't be quick to throw away that older technology. Most good CRT monitors still have a wider tonal range than cheaper LCD monitors and make for a better imaging screen. In recent models, manufacturers such as LaCie, Sony, and Apple have developed LCD monitors that can match the contrast and color range of CRTs.

On a Windows machine you need to go into the control panel > display > settings and make sure your monitor is set to maximum color depth (24 bit). Also in Windows in the control panel, open Adobe Gamma (if you are using an Adobe image-editing program) which will help you adjust your monitor. When you're done, you can save this adjustment and use that profile as your monitor's default setting.

Here are the simplified steps for Windows:
- Open Control Panel.
- Open Display, then choose Settings tab (Control Panel > Display > Settings).
- Choose highest color depth your monitor and display card will support. (24bit millions of colors)
- Close and go back to Control Panel > Adobe Gamma (If you've installed Photoshop Elements or Photoshop) and step through the wizard.
- Reopen Control Panel > Display > Settings > Advanced Button > Color Management tab.
- Choose or add the profile you created in Adobe Gamma and make that your default.
- Apply the setting.

Calibrating your monitor can help you make better scans.

If you want to take this to the next level, you can purchase a hardware-calibration unit that is simple to use. Since the cost of hardware monitor calibrators has dropped dramatically, there really is nothing to preventing you from taking this next step. A little searching on the Web will bring you a wealth of information as to what's available and where to begin.

MAKING THE PERFECT SCAN

First, let's set the rules. Rule number one is "Garbage in, garbage out." Rule number two is "Garbage in, garbage out." My point is that so many people make a quick-and-dirty scan, never concerning themselves about the scanning settings or trying to correct color cast. The result is that they send e-mails with washed-out or weirdly colored pictures of their child's birthday party.

If you take just a little bit of time to go through the simple steps of scanning by adjusting the colors and setting tonal levels before you scan, you may have a wonderful translation of your slide or print.

The Steps Are:
- Prepare a place for your scanner near your computer so you can work in an organized and clean environment. Connect the scanner through your USB or FireWire port.
- Place your cleaned negative or negative strip into the scanner or flatbed with the supplied holder.
- Start up the software that came with your scanner or use third-party scanning software such as SilverFast, a relatively low-priced scanner software for the novice with versions for the professional.
- Use the Preview button to pre-scan your print or negative and use the crop tool to set the scanning area you actually want to scan.
- Set the final output dimensions, resolution, and bit depth of your scan as high as is practical; you can always resize the images to make them smaller later. It's never good to resize an image above its original scanned size.
- Before scanning, adjust the preview curves in the histogram for good separation of highlights and shadows. Or use the Auto-Adjust for color, contrast, and dust management. This can be very simple and often very effective. Don't be afraid to experiment with the manual controls. You won't break anything.
- Give your scan a file name that has some type of system. Organized folders will help you locate your images later for additional work in Photoshop.
- Adjust and size your image in Photoshop for printing or sharing on the web.
- Turn off your scanner to preserve the life of the lighting elements.

The first step in scanning is to clean off your negative. It seems obvious, but many overlook this and waste time later in Photoshop spotting out all the dust. Use compressed air or a camelhair brush. Be careful to hold the can upright and squeeze off a couple of test blasts to clear any propellant from the tube. Use a light touch on the trigger. Quick, delicate blasts will usually do the trick. If you use a brush, don't handle the bristles since oil from

your hands will eventually make the brush useless. Also, it's a good idea to turn off other programs running on your computer to free up memory.

Follow the scanner's instructions for inserting the negative film into the scanner or flatbed. These negative holders can be a little fragile, so be careful since getting carrier replacements can take time and money. The trick to a good scan is a good focus, so you want the negative to be held as flat as possible in the carrier. This can be a challenge with older negatives that have developed a serious curl. Placing the negative in the carrier can be a delicate process, so be careful not to scratch or place fingerprints on the emulsion. White cotton negative gloves are a nice addition to the digital darkroom and make handling the negatives easier.

For scanning prints, align the print in the correct corner of the scanning glass, face down toward the lighting element. Again, make sure the glass is clean. If scanning film on a flatbed, read your instruction manual to learn how to activate the light that resides in the top lid. This is usually done through the scanning software. When closed, the light in the lid shines through the negative to the array passing underneath. There are other ways flatbed scanners handle negatives, so read your manual thoroughly.

Next, start up your software or, if you're working in Photoshop, go to File > Import > to connect to your scanner. The goal here is to preview the image before you scan. The scanner will make a quick pass of the print or negative after which tonal corrections and cropping should be done on the preview image. I suggest you place the crop marks just outside the image area to prevent cutting off critical areas. After the scan, you can accurately crop the image in Photoshop. Your scanning software will often have presets so you can pick the film type that will help create a natural-colored scan. You must also define the bit level of color you want to scan or set the scan for grayscale (black-and-white photographs) or line art (for printed text or line drawings).

An Auto Adjustments button in the software can also simplify things. But be careful when it comes to auto-sharpening or dust removal. You will lose sharpness if you overuse this feature. A dust-removal program such as Digital ICE is packaged with many scanners. This works during the scanning process to remove surface defects and dust. It can be very effective and

Cleaning negatives before scanning ensures a better file.

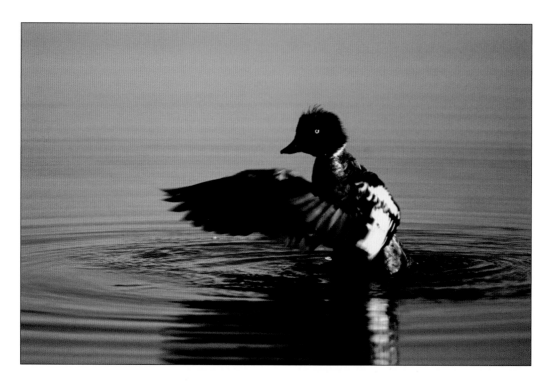

The two close-ups above compare the top image scanned at 300ppi (left) and 72ppi (right).

saves an incredible amount of time. Photoshop also has dust-removal adjustments that can help greatly. In Photoshop it's often smart to select areas such as the sky and remove dust or sharpen selectively. As in all imaging software, making huge changes for the entire image is fast but can adversely affect parts of the photograph where you lose important details. Read Chapter 5 about

image editing software to learn how to selectively tweak parts of your images.

Setting the size of the output is the next step. If you only want to send images through e-mail for viewing on a computer, set the scan at 72ppi, which will give you reasonable pixel dimensions and save you lots of disk space. A good size might be 400 pixels wide at whatever length at 72ppi. If you scan for printing or want an archive of your most important slides, you should scan as high as your scanner can be set without going beyond its optical limits. (See the explanation of dpi and ppi above.)

The advantage of scanning a negative that creates a large file with high bit-depth is that it can only help later when you make contrast and color corrections in Photoshop. These files are also big enough to allow you to make large, wonderful prints. The disadvantages are that it takes more time to scan and save the files (sometimes much more if your computer is on the slow side) and requires much more storage capacity, especially if you are scanning many photos.

If you look at the histogram in Photoshop after making corrections in 8-bit and then compare it to changes made to the same scan in 16-bit or 24-bit, you will see the characteristic white lines of missing tonal information in 8-bit. Some photographers might argue that your printer will never show these variations. Still, I think it's advisable to scan your most important work at the highest bit-level you can. The scan will also be a backup of the original image, and having the highest quality backup is always a good idea.

THIRD-PARTY OPTIONS TO SCANNING

Your local camera store and Web-based services have a number of scanning options for those of you without the resources or desire to take this on yourself. But you always run the risk of loss or damage when you turn over your precious images to someone else to handle. I once lost 20 important images with a highly reputable courier, so think this one through. Accidents do happen. Personally, I love to scan my work to give it that special care that always shows in the end product.

> **TIP:**
> It can be helpful to record the particular steps you have taken with your scanner when you achieve a successful scan. Weeks later when you come back to scan, you'll be amazed how much you've forgotten. Your cheat sheet will shorten the learning curve.

MAKING ART FROM FOUND
OBJECTS AND OLD PHOTOGRAPHS

At first glance, Maggie Taylor's images have a certain uniformity. Most of them are square and the same size at 15 x 15 inches. They have a similar color palette of cerulean blues, pale roses, and muted greens. They are dreamy.

But ask Maggie how she creates them and you discover layers, sometimes 40 to 60 of them created in Photoshop CS, carefully assembled to become the image you see. "This is a very convenient way for me to work," Taylor told *Focus on Imaging* magazine about the layering. "I'm always being interrupted, or I might only have an hour or two hours in a working session, so I can save the image and come back to it another day."

Taylor began her career after earning a B.A. in Philosophy from Yale University in 1983 and an M.F.A. in Photography from the University of Florida in 1987. Her first images were black and white, mostly of suburban landscapes. She moved more closely to her present narrative work when she started a series of still-life images in the studio using a 4x5 view camera and found objects. In 1995 she discovered that she could simply place objects directly onto a scanner rather than go to the expense and mess of film and processing. "My scanner was giving me better quality images than any digital camera that I could afford at the time," says Taylor. The digital equivalent of her 4x5 view camera in those days cost more than $10,000, whereas her Epson flatbed scanner, purchased at a local store, cost $300.

Today her study tool is a pocket-size 4-megapixel digital camera that she keeps with her at all times. "If I see clouds outside my window on the plane, then I can shoot them." Sharp detail is not so important to Taylor because images are layered in her work. For other imagery, she scours flea markets and eBay looking for objects she can scan. Fish, butterfly wings, tintypes, birds, and toys all recur in Taylor's work. For "Woman Who Loves Fish," Taylor took a stunned goldfish out of the bowl in her studio and placed him directly on the scanner, leaving the lid open in a darkened room so the background would fall off to black. Often the antique texture in her work is a scan of cracked corners on old photographic prints.

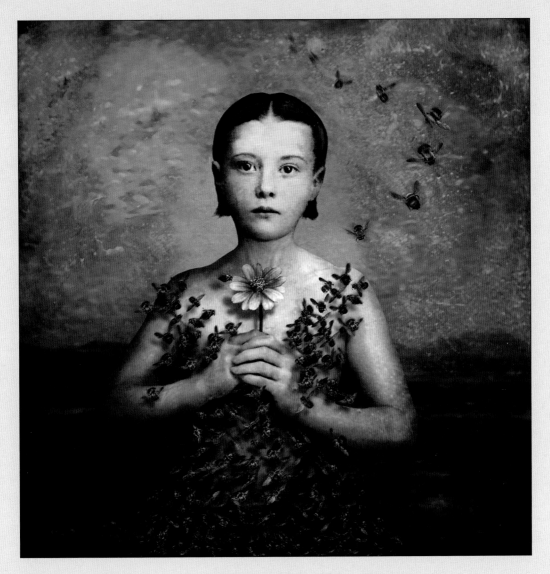

"Girl with a Bee Dress,"

2004

This photograph consists of found objects: dead carpenter bees, a flower, a snapshot from Ireland, texture from an old, cracked photograph, a one-inch tintype of a young girl, and a digital self-portrait of the photographer's body.

Once she is happy with the way an image looks, she prints her work with an inkjet printer onto a slightly textured matte watercolor paper.

"As technology has changed," says Taylor, "so has my work. Now with Photoshop CS3 I can warp the fish to look up and over someone's shoulder." To see more of her work, go to *www.maggietaylor.com.*

Chapter 9
Archiving

9 | *Archiving*

DON'T LOSE THOSE PICTURES!

Welcome to the chapter on archiving, the one you probably suspect is the least interesting section of the book. Although you may not be looking forward to sorting your pictures, your pictures might appreciate being safe and accessible, since being looked at is their reason for existence. That is, after all, why you created them in the first place.

Chances are, you know you should be archiving. And chances are, you aren't. Quick—think about it—is the only home of your beloved digital images your computer's hard drive? If it is, please put this book down, head to your local big-box store and buy a stack of brand-name, writable CDs. Burn your favorite pictures to discs and come back when you're done.

Why is backing up so important that you should put down this fascinating book? Because hard drives fry, crash, and get infected by JPEG-eating viruses. Although they're a great temporary home for the pictures you're working on, they're a terrible place for long-term storage.

At minimum, archiving is about backup. It's about keeping your images safe from harm. But it can be about much more. If you're the family documentarian, it's probably up to you to create those slide shows of weddings, the memory book for a family reunion, or even to quickly fill requests from aunts or cousins for pictures. How wonderful to accomplish those tasks quickly and with pleasure rather than with brewing resentment because you spent three sunny Saturdays in a row rummaging around for the shots.

The process can be fun, too. Sorting through your images, you'll certainly find pictures long forgotten. You may find yourself inspired by what you shot in the past, get ideas for new projects, and even learn things about yourself as a photographer. You may learn, for example, that you have a tendency to underexpose, or that it might not be such a bad idea to start carrying around a tripod. (You already knew that, didn't you?)

Archiving doesn't have to take forever. Skim this chapter, get some ideas, go deeper into the ones you like and, for goodness sake, please start backing up your pictures.

Assess Your Collection

Before you start thinking about how you're going to archive, think about *what* you're going to archive and how you want to use it. How far does your collection go back? If all you've got are digital images, you're in luck; the process is going to be easier. If your images consist of negatives, slides, and prints, however, you've got more to think about and more to do.

Burning your pictures to CD is the first step to ensure their longevity.

Prints will eventually deteriorate, so protect them well.

You could attempt to scan all of your negatives and slides at high resolution and archive them all. But if you did that you'd probably be either nuts or a devoted photographer. The keyword is *editing*. You probably don't need everything. So take some time and go through it. Keep what's good, flattering, or meaningful to you. And put the rest in boxes labeled, "Not-so-good stuff that I couldn't bear to throw away."

Consider Your Archive's Purpose

When you're trying to figure out what kind of archive you want, and how much archiving to do, consider what you'll use it for. What are your needs? If you shoot a lot of high-resolution RAW images that you work with and access often, you may want a sophisticated system that includes a pretty serious database, multiple external hard drives, and a DVD burner. If you only need to access your pictures by date along with a few major categories, some simple inexpensive software and a pile of good CD-Rs will do.

Plan Your Time Wisely

Some people love to categorize; you open their kitchen cabinets and there are jars of pastas, labeled alphabetically from fusilli to linguini, their socks are sorted hierarchically by texture, color, and occasion, and their movie collection is organized by genre and date of release. If you're one of those people, you're going to love this project. The categorizing, naming, and sorting possibilities for your images are endless. If, however, you're one of those people whose idea of organization includes piles and overflowing junk drawers, there is still hope. You'll find that because of built-in information in digital images (called EXIF data), picture files are much easier to organize than objects.

Some archivists love to categorize their work in accessible albums.

The most important question to ask yourself when you begin archiving is: How much time do I realistically want to put into this? Be honest with yourself and start small. You can always do more. Check out the different ideas in this chapter and pick out a few that actually sound like fun. Or, if none sound fun at all, go straight to the next section: The Minimalist Approach. It enumerates the things that you absolutely have to do to make sure that you don't lose the pictures you love.

The Minimalist Approach:
Archiving for People Who Hate Archiving

Hate the sound of all of this? Way too busy taking pictures to think about adding keywords and browsing by location photographed? Then perhaps you fit the profile of the minimalist archiver. So let's consider the least amount of archiving you have to do before the digital police start coming after you. With this method, you may end up spending more time searching for the images you want, but perhaps you'll make it up in the time you spare by not being super thorough in your organization. You'll also be living a little

If you're a minimalist, choose a method and stick with it.

bit dangerously, but at least you won't lose what matters most. Note to non-minimalists: This section contains some basic principles that you'll want to think about no matter how sophisticated your system gets.

Organize Your Files from the Start

PCs and Macs alike have a folder designated just for pictures. Take advantage of the pre-labeling. And every time you copy your images from a memory card to your computer, make new folders within your Pictures folder with names that relate to your shoot, and make them descriptive. These names will be your only clue as to what your folder holds. So instead of writing "Spring Flowers" call the folder "yard_magnolia_springblooms." Abbreviate when necessary, but get in as much information as possible. Don't be poetic; be concise.

To make this process easier on yourself, empty your memory cards early and often. That is, after every set of pictures you take, dump your card. It will be a lot simpler to remember what's there and to put it in a proper folder than when the card contains everything from soccer games to snowy landscapes.

Use the Power of Your OS

You minimalists may be aware of this already: Your computer comes with methods for browsing images that don't require separate software. PC users can navigate folders of images using a filmstrip view that lets you use your arrow keys to flip through big preview versions of your pictures without opening them. Mac users can use OS X's Cover Flow to preview a bunch of images quickly in a similar manner.

Burn the Best to Disc

If you're willing to take your chances by leaving most of your images on your hard drive, you've at least got to back up some. To get yourself to do it, back up the first time you look at your shots. You've already named your folder of images something descriptive, so make another folder on your desktop with the same name. This time append the name with "favorites" or some positive word like that (so your folder would be: yard_magnolia_springblooms_favorites), and, as you edit, drag copies of your favorites to

PC users: Take advantage of the filmstrip view to edit as you organize.

that folder. When you're done, pop in a CD and burn that folder to disc. Label it with the folder name and put it on your shelf.

Hope for the Best

With the minimalist approach, a little bit of faith and hope is important. Although at least you have a system, and at least with a crash you won't lose your best images, you are putting some of your pictures at risk, and you're putting an awful lot of faith in your original editing decisions. But at least it's better than nothing.

ARCHIVING FOR THE POINT-AND-SHOOT PHOTOGRAPHER

If you shoot mostly JPEGs and your old film is pretty well organized, your archiving task isn't too complicated. Still, if you're doing a lot of photographing and you want to be able to find your images fast, you're going to need some help in the form of software.

Choose a Good Program

The first thing to do is find out if you already have a program to

manage your files. If you have a new Mac, you almost certainly do: iPhoto. If you have a PC and you bought Adobe Photoshop Elements 3 or higher, you got a built-in organizer with it. (For more software options, see the sidebar on page 348.) Most of them offer free, downloadable trial versions so you can see which one you like. There are lots of good ones out there, and lots of good organizer/editor combinations that will take care of everything in one integrated program—not a bad idea when you're really trying to concentrate on picture-taking.

Do Most of the Work on Offload

The easiest way to save yourself time and keep yourself organized is to take care of your sorting when you're copying your images to your computer. Set your software to notice when you insert a memory card or connect your camera (most of the time it's under Preferences or Options, but many applications, such as Elements' or Microsoft's organizers, do it automatically). Then make sure you always have the option to rename. Add a descriptive word or phrase to the file name that will help you find the picture later. Each time you import, make a new, logically named folder to

Many photographers download their pictures from the camera directly into folders on their computers.

house your images. That way, if you need to, you can find your images without the help of your software's database.

Rate the First Time You View

After you copy your images to your computer, the first thing you'll probably do is look at them. And since you want to make a good archive and save time, use those first-look moments to do some editing. Pick a program that lets you see a full-screen view of your pictures (most do), and as you flip through your slide show, rate your pictures. Whether it's with stars or a system of 1-5, rate as you go. That way you'll be able to quickly see your favorites later, and print, e-mail, or make slide shows, without having to go through them over and over again.

While your pictures are fresh in your mind, return to the thumbnail view and quickly add a few keywords. Select a bunch of images at once and slap some common keywords on them. Get really detailed if you like—but if you added a couple on import, feel free to be minimal. You'll always be able to sort by date.

Delete the Not-So-Good

Hard drives can fill up fast, and considering that digital encourages us to keep trying until we get it right, we can end up with lots of images that work better as exercises than pictures. Delete them! It's okay not to treat your failures as successes. But don't do it right away. We don't always see clearly when we're close to the shoot. So a month, or two weeks, or whatever period seems right to you after you shoot, sort your images to see the ones to which you gave one or fewer stars, or ratings of one or less. Take a look at your rejects. If you missed a gem, give it a couple of stars. But if you were right the first time and they are truly awful, go ahead and throw them in the trash.

Backup Regularly to CD or DVD

You know those regular reminders that tell you to insert a CD and back up your photos? Don't ignore them; they are your friends. If you learn only one thing from this chapter, it's that you must back up. Terrible things happen. Survey your colleagues and you'll probably hear at least one horror story. Don't learn the hard way. Use the software to let you know when it's time to pop in a CD or DVD and backup. Do this regularly. It's worth it.

ARCHIVING FOR THE D-SLR SHOOTER

If you were to build the ultimate archiving and database system, what would it look like? You'd probably have one computer dedicated to managing the database connected to a series of local external hard drives and massive online storage. You might have everything backed up to CD and all your film work scanned, with reference files kept on your hard drive. Every image would be keyworded by emotion, color scheme, and content. It would all be completely up-to-date. And you'd have, of course, a dedicated staff doing all the work for you. Because, realistically, you can't have an archive like that unless you either hire people to maintain it or quit shooting to maintain it. You can, however, have a good and useful system and reasonable expectations for yourself.

Professional photographers have to be very organized with their large digital files, including extra hard drives and detailed databases.

Pick Your Software

You can't be a serious shooter without using some software to sort your images. Well, you can, but it's inadvisable. For hints on what to pick, check out the sidebar on software options and read carefully the section called "Will my carefully added keywords transfer to another program" on page 355. You'll want to decide if you'll use a system that will use that metadata, which can be read by both PCs and Macs and is embedded in the file, or if you want to commit yourself to a serious and eminently searchable (yet higher-maintenance) database program. In either case, do most of your work when you import your files. Always put them in logically named folders, and rename the files according to their content. Use the program's rating system to rate the first time you check them out so you don't waste your first impressions by not recording them.

Working With RAW Files

If you shoot a lot of RAW files, you know how much space they take up. To ease the burden, shoot in RAW + JPEG, a file-format option that saves your image as separate JPEG and RAW files. (Most D-SLRs give you the option.) Try offloading the JPEGs from your card first. Mark off the junk, then offload only the RAW files that are decent. Make sure you've got them in two places before you erase them from your memory card. If you have space, keep your favorite JPEGs on your hard drive for reference or, if your software can keep thumbnails of backed-up images available for reference, don't bother.

Storage Solutions

No matter what you do, you can't keep all your image files on your computer's hard drive. Depending on how accessible they need to be, different storage

solutions are available. If they can sit on a shelf, unconnected to your machine, CDs are the safest, though lower capacity. High capacity DVDs hold many more pictures but tend to be less stable over time (see page 354).

Old-fashioned print drawers are still a good storage option for photographers.

If you'd like high-resolution copies of all your images to be immediately available at all times, you have a couple of choices. External hard drives are one option. They're right next to you, they're portable, and they're getting cheaper by the day. Connect them to your machine via USB 2.0, FireWire, or, for the fastest connection, FireWire 800. Unfortunately they can "fry." To prevent that from happening, turn off their power when you're not using them and pad them nicely if you'll be toting them around. And of course, make sure the whole drive is backed up to CD, DVD, or elsewhere.

Another option is online, off-site storage with various service providers. Among the benefits: The files don't take up any space in your house, good services will keep backups of your backups so if something happens you'll probably never even know about it, and should anything happen to your on-site stuff, your files will be fine. Unfortunately, off-site storage is much more expensive. If you're the kind of shooter who's already filled up a 150

Alfred Eisenstadt's famous picture from 1944 is stored in a cold, temperature-controlled room.

GB hard drive in a year or two, it could cost you more than $200 a month to store your images online. If you just want to upload the best images, sites like xDrive and ibackup offer varying plans to suit your budget and space needs. Lots of sites that offer prints will let you store unlimited images online. The only catch? You have to pay to get them off in the form of prints.

ADVICE FOR THE PARANOID: ANSWERS TO YOUR WORST-CASE SCENARIO QUESTIONS

Archiving can be scary, but don't panic. You can most likely save your images for all time. Here are some straight answers to some frightening questions.

How Can I Be Absolutely Sure I Won't Lose My Photographs?

Always make sure your images are in two places at once. No matter where you are in your process, you always have two copies. That means: Don't delete your images from your memory card if they've only been copied to your computer's hard drive. And don't delete them from your computer's hard drive until they're in two places. That can be on one disc at home and on one disc at the office, or on one local external hard drive or on one online storage location, etc. If you always obey that principle, barring a major disaster you should be able to rest assured your images are safe and sound.

Will My Files Become Obsolete?

The fear that a file type may become obsolete is not an irrational one, but it is a fear than can be easily conquered with a little rational thought. Let's take, for example, the 45 rpm record. Lots of people used to own lots of them. Now, few people listen to them. But, even many years after the format was the most popular one for big hit singles, you can still buy record players to play them. And you can even buy a connector that lets you record your favorite records onto a computer and turn it into an MP3. Why? Because people still own 45s and people still care.

The same goes for your RAW files and your JPEGs. Many people have these file types and many people care. That means there will always be companies ready to help these people (and

make money from them). What we're getting at is, of course, that the JPEG will not be eliminated before there's an easy way to convert the file into something legible. And by the time that happens, computers will probably be so fast that converting your hundreds of JPEGs to the new format will probably take less than five minutes.

But what, you ask, about your RAW files? If you rely on those digital "negatives," you're serious about keeping them around. We stand pretty firm on our theory that as long as lots of people have those files lying around, software companies will spring up to deal with them. Not to mention that companies swear that they will support their proprietary RAW format as long as they're in business. (However, tell that to all the people who bought Konica Minolta's D-SLR camera, which is now obsolete.)

If you're still worried, Adobe says it has a solution: DNG, or Digital Negative format. Convert your RAW files to DNG and they'll always be convertible with Adobe's RAW converter. That's pretty good news, though Adobe doesn't have access to all of the camera companies' codes, and thus you may not get quite as good a conversion as you might have using software specifically designed for your camera. So what should you do? It may not be a bad idea to occasionally convert your absolute favorites to DNG, but beyond that, a wait-and-see approach is reasonable.

Looking at the Time Life archive server room, you can bet they don't ignore their backup warnings.

Save endless searches for games of hide-and-seek and not for lost pictures.

Will My CDs and DVDs Rot?

The answer is, sadly, most likely, yes. But some discs are better than others, and you can prevent some problems by making good choices ahead of time.

DVDs, while wonderfully roomy, are currently the least reliable. Not only are their formats still in a state of flux, but new, higher-capacity technology is constantly on the horizon. So, although the good news is that new-format DVD-readers will read the old ones for at least a little while, the bad news is that DVDs themselves are more susceptible to destruction anyway. It's never a good idea to bend your disc when you're taking it out of its package, but the high-density DVDs crack easily. Those little cracks let in data-busting humidity that destroys the disc. They're a good temporary solution, but DVDs are not a great option for long-term storage.

CDs, on the other hand, are a much more stable technology. Because they're more resistant to cracking, they're a much better candidate for archiving. CD-Rs are the most stable, but make sure to choose a solid brand (like Imation, Maxell, Verbatim, TDK, or the lesser known but popular-with-the-pros brand Matsui). Then store them upright in a low-humidity place.

The way you label your discs also affects their archivability. Scrawling on them with a ball-point or other hard-tipped pen can actually damage the read-side, and soft-tipped pens with solvent-based inks can make trouble chemically. To be on the safe side,

write only on the clear plastic center and label the sleeve or jewel-case thoroughly.

The exceptions are gold CDs and DVDs. Properly handled, Kodak says their preservation line of CDs and DVDs can last up to 300 and 100 years, respectively. Delkin Devices makes similar claims for their gold disks.

Will My Carefully-Added Keywords Transfer to Another Program?

If you use an archiving software program's built-in databasing or cataloging system, the answer is probably no. That's one sad side effect of many excellent organizers. To make images accessible according to that software's specific rules, you have to use their system. But that means you're locked into that system. Unless, that is, you choose a program like Photo Mechanic or Adobe Bridge (part of Photoshop CS3), which lets you do most of your archiving using files metadata. Metadata includes EXIF data—information that's written into the file about your file when you take a picture. EXIF stores information like the make and model of the camera, the shutter speed, focal length, and ISO. It also includes IPTC data. Originally designed for the press, this is data you can add yourself—your copyright, image description or keyword, title, and more. Metadata is great because it's standard, and readable on both Macs and PCs. That means it doesn't matter if you switch organizers, because the information is in the file.

So what's the downside? Not all files can include metadata. If you want to organize files of types other than JPEG, TIFF, and PSD (Photoshop's format), you'll have to use some other keywording system. You also won't get databases that are as flexibly searchable, because there will be a limited number of ways to describe your files.

So it's up to you: If you're a very serious creator of a database, it may pay to commit to one program. If you're not as serious but are careful about renaming your files on import and keeping them in orderly, descriptively named folders, you may feel free to hop around in different programs regardless of metadata. But if you shoot a lot and don't need to keyword a lot, a program that lets you sort by metadata might be just the thing.

Will My Prints Fade into Oblivion?

If you're using an inkjet printer, the answer is, well, yes, most likely—but not necessarily soon. Some kinds of inkjet prints are more archival than others. According to the Wilhelm Research Institute, if you keep your images behind glass, a Canon inkjet will get you 30 or more years, HP's Photosmart printers 70 or more, and, on Epson's pigmented inkjet printers, up to 200. Still, the real question is: How long do you need them to last? If you're making a print for yourself, you can always pop out another one, and chances are by the time your print fades technology will be good enough that your next print will last even longer. On the other hand, if you're making a print to sell at a gallery or to give to a friend, consider one of the more archival printer and paper combinations. You can check out Wilhelm's statistics yourself at *www.wilhelm-research.com.*

DIGITIZING PRINTS, SLIDES, AND NEGATIVES

Let's say you want to digitize your whole collection, including all those old slides and prints. The first thing to decide is whether you'll be doing it yourself or outsourcing the job. If you've got a lot of free time, or if your workstation is set up near your TV, try it at your own risk.

You can buy a Nikon film scanner and get, for about an extra $450, an attachment that feeds slides through in bulk. And if you never cut your negatives (or still shoot film and are planning to keep them in roll form) you can get a similar attachment that force-feeds the scanner negatives. Of course, unless you really want to invest a lot of time, you'll have to be content with the scanner's auto settings. On the other hand, if you're just scanning so you can have some searchable, low-resolution previews of your film work, and will make high-quality scans of the ones you need later, this can be a good solution.

If you don't have the time, patience, or inclination to make the scans yourself, consider hiring someone else. A scanning service scans anything, from slide to negative to VHS video. If you had, say, 500 prints you wanted scanned at 300dpi and 1,000 slides you wanted scanned at 2000dpi (so they'd be big enough to print), they'd get it done for about $700. That's less

than the cost of a scanner and loader, and you don't have to do much work.

A quick Internet search for "bulk scanning services" will give you options. Before you settle on a service, send in some samples to different places. Then check the scans to make sure they're clean and relatively color-accurate before sending them the whole shoebox—or shoeboxes, as the case may be. Keep in mind though that there's a possibilty of your work being lost or damaged by either the services or the mail/delivery service. For this reason I always request the scans and the images be delivered seperately and on seperate days, just in case.

This scanner has a bulk-loader attachment.

NEVER THROW PICTURES OUT

Photographer Annie Griffiths Belt loves to edit her work. Each time she is asked to teach a workshop or speak at a seminar, she dives back into her archive to piece together a presentation with a collection of old and new photos that help her tell her story. In 2005 she redesigned her website, which gave her another chance to edit her work.

What she has discovered through the years of reorganization are six clearly definable chapters in her work: her years in the Middle East; a book on conservation; stories in the Pacific; aid work in more than 30 countries; life in Africa; and the United States, where she now resides. For each story she has photographed, she has kept the whole take. Each story gets a file drawer. In the front of the file drawer she keeps the "selects;" in back of these are the "seconds." As time passes, some of the pictures deemed a second choice in the past rise up as selects. This can happen for a variety of reasons: A good picture didn't fit the original layout, or the focus of a story was different. By keeping the originals, Belt allows the photographs to mature in their aesthetic value. Her archive now speaks of a rich and layered life because of her meticulous collecting.

Belt's editing is not for commercial use only. She edits her work for her family and for herself as much as she does for her lectures. "There is the archive that I should believe in," she says. In the years she has been a mother during her 30-year career, Belt has included her children as much as possible. She took them with her on trips, preferring to stay in apartments and houses with kitchens where they could live a more normal life during her assignments.

In 2005 Belt switched to digital cameras as well, a change she says she felt she had to make. Now, with the help of a technology assistant, she concentrates one day a week on slides she needs to digitize to add to the growing body of digital work she is now creating. In doing so, she is starting to find ways to bring the six different chapters of her life and work onto one hard drive. Last year she used that collection to create a book entitled *A Camera, Two Kids, and a Camel*, a photographic memoir about life on the road as a National Geographic photographer and mother of two children.

To learn more about her work, please log on to *www.annie*

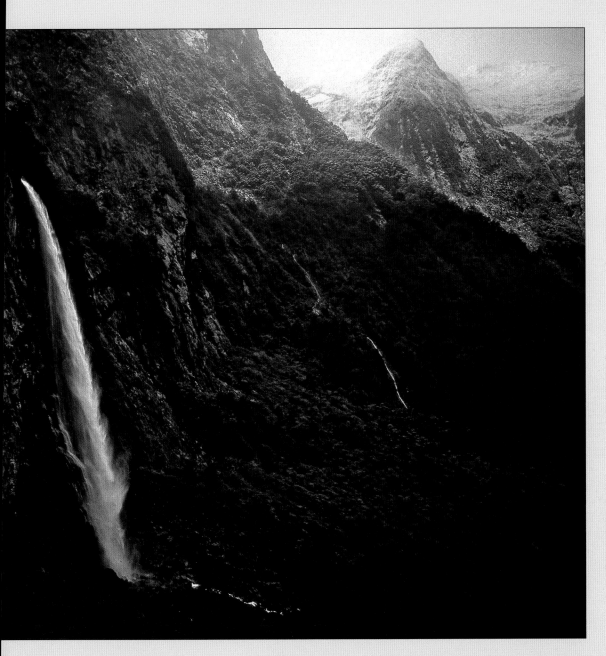

During her travels, Annie Griffiths Belt made this dramatic image of a mountain waterfall in Fiordland National Park, New Zealand.

griffithsbelt.com. There you can find selects from her work for *Life, Smithsonian, National Geographic, American Photo,* and *Stern.* Belt has also published a book with writer Barbara Kingsolver entitled *Last Stand: America's Virgin Land.* She has exhibited in New York, Moscow, and Tokyo, and she is a frequent collaborator with the organization Habitat for Humanity.

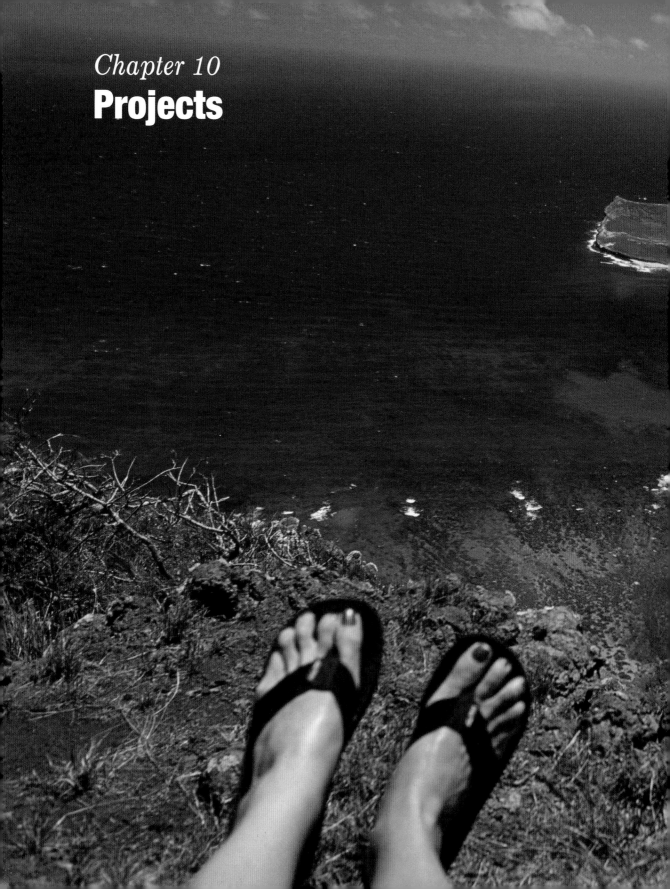

Chapter 10
Projects

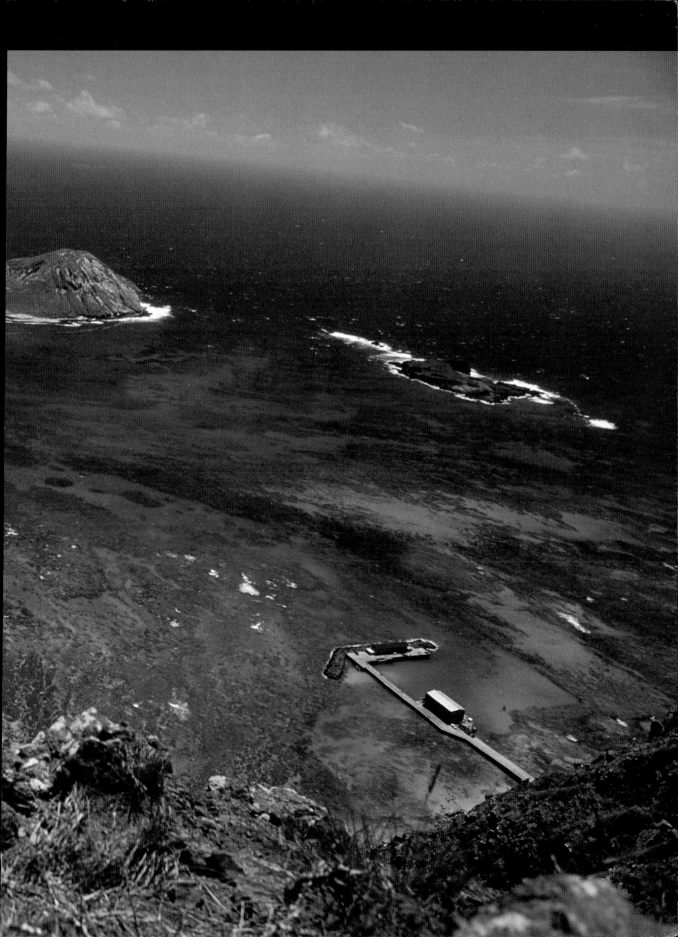

10 Projects

CREATE YOUR OWN COMICS

Coming up with a unique means of displaying your photos can be painful. Turning your photos into comic books is anything but. Software programs make comic-book creation so easy you and your dog can do it, according to the Comic Life intro on Plasq's website. You may not like the idea of your dog drooling on your computer, but that comment is not far off the mark. In fact, Comicbook Creator's website literally talks you through the process of laying out your comic, adding text balloons, using clip art, and applying different techniques to adjust the look of your book. About the only thing these programs don't do is take the photos. In the end, you'll have a personalized comic you can e-mail to friends, frame, or even have bound into a coffee-table book.

1. Choose your photos—either some you've taken already that you want to turn into comics, or a story you've shot specifically for comic-book purposes. Once you've decided on an edit for your story, you are ready to begin. Download photos from your camera to your computer. If they're prints, scan them into your computer. For Comicbook Creator, put the images you'll use into a specific folder you can access from the program (their website tutorial can talk you through this process). With Comic Life, your images will be accessible from your iPhoto library once you've downloaded them to your computer.

2. With Comicbook Creator, you can enter a title and author for your work now. (You'll add the title in a later step with Comic Life.) For both programs, you'll need to choose a template. Templates vary in the number of panels and page layout. If you like a template that doesn't have as many panels as you need, it's easy to add extras.

3. Put images into panels in the order you choose. This is also the time to adjust photos to fit, or to flip the direction of photos. It's a fun chance to play with your photos and with clip art, resizing and flipping, until you get exactly what you want.

WHAT YOU'LL NEED

- *Photos/images (one or many, depending on your project)*
- *Comic-making software, such as Comicbook Creator for PC (www.planetwidegames.com) or Comic Life for Mac (www.plasq.com)*
- *Photo printer*
- *Good photo paper*

4. Speech balloons and captions are essential to comics. You choose their placement, size, and shape, as well as the text you use. Fiddle until the captions match your comic's tone.

5. At this point, Comic Life offers some special effects you can apply to your photos (such as shading them with dots or giving them a hand-drawn look) to further enhance the comic-book look.

6. Finally, save your finished product so you can print it yourself onto good-quality paper or cardstock. You can also e-mail it, post it on your website, or upload it to one of the many photo websites that will print and bind it into a book for you. Just a few to try are: *www.iPhoto.com, www.kodak-gallery.com, www.blurb.com, www.lulu.com, www.shutterfly.com,* and *www.photoworks.com.*

Ten-year-old Max Cetta turned an ordinary home-work assignment into the Sunday comics.

Few people can resist a lavishly frosted cake. The allure may be even greater when the cake features a personal photo as well. A photo cake can feature the birthday boy or girl, a bride-to-be, or even an entire sports team. If you can photograph it, you can put it on a cake—or cupcakes or cookies. You will need food coloring-filled inkjet cartridges, paper made of rice, potato, or cornstarch on which to print, and a dedicated inkjet printer that will be used only for your baking efforts.

Otherwise, you can find local bakers and even many supermarket chains that will do the work for you. You need only e-mail them or bring them a photo in a format they can use (these may differ, so it's best to ask first). If your baker has a scanner, you can even bring a print of the photograph.

Several online resources for photo desserts include; *www.goodfortunes.com* (for decorated photo cookies); and *www.sugarcraft.com*. (They'll print the photo for you; you make the cake, cupcakes, or cookies yourself).

1. Choose the image you'll be using, and use your image-editing program to fix it. Eliminate red eyes, adjust contrast and brightness, and make the photo as clear as you can. Crop any unwanted background from the photo. Simple photographs tend to make better-looking cakes.

2. Most websites that sell supplies for photo cakes also offer software (often free) that will walk you through the process of creating your edible photo. After deciding which size you'll be printing (rectangular for a sheet cake, three-inch circles for cupcakes, or eight-inch circle for a round cake), use the template to adjust the size and shape of your photo. Once the photo fits your template, you're ready to print.

3. Insert the food coloring-filled inkjet cartridges into your dedicated baking printer and carefully load the edible paper. Once both are properly loaded, print a copy of your dessert photo.

4. When your cake is frosted, carefully peel the backing from your photo and place the photo exactly as you want it on the

WHAT YOU'LL NEED

- *Images, downloaded or scanned onto your computer*
- *Printer (most of the available food-coloring inkjet cartridges fit only Canon printers and only certain types of those; www.kopykake.com now has cartridges that fit Epson printers)*
- *Food-coloring ink cartridges (www.tastyfotoart.com; www.kopycake.com; www.sugarcraft.com); make sure you have plenty of these so you don't run out mid-project*
- *Edible printer sheets, sized to match your project (the above websites also offer these)*
- *Templates to resize your photos to fit cupcakes or cookies (check the above websites for downloadable templates)*

cake. Most edible sheets work best on moist, buttercream-type frostings. If you're using a royal icing for cookies, you need to place the photos on the cookie before the icing hardens.

A photo cake features a wedding photograph for a couple's anniversary.

5. One final reminder: If you are using candles, try to decide where to put them on the cake before you select the photograph. You'll want to avoid poking the birthday girl in the eye. The same is true for piped icing, sugary decorations, or glitter. Make a drawing of the cake as you imagine it before you select the elements.

FAMILY PHOTO CALENDAR

A family calendar is a great way to show off the photos that accumulate each year. With the help of a consumer-level imaging program, most of which have a calendar-making feature, it's also easy to put together and makes a fun gift, especially for those featured on its pages. And getting through the long, cold winter seems somehow less painful when the calendar shows pictures of you at the beach in August. But as one veteran calendar maker notes, never leave home without your camera. Every family outing or event is an opportunity, especially if you have a lot of people you want to include.

1. Organize the photos you want to use. Make sure they're the largest file size possible. You'll get better picture quality if you shrink a photo to fit than if you have to enlarge it. (Set your camera on high-resolution JPEG format when you're shooting.) Use your editing program to eliminate red eyes, fine tune, and crop. Add captions or play with colors if you're so inclined; create montages if you're planning on more than one picture per calendar page. Decide how you want to group them—by event or maybe by birthdays, anniversaries, or other special days each month.

2. Create the calendar, using the program of your choice. Most will give you national holidays, daylight saving time reminders, and choices of Christian or Jewish holidays. (Among the online sources for holiday calendars are *www.holidaysmart.com*, and *www.timeanddate.com/calendar.*) You can use your software to add family birthdays and other momentous occasions, as well as to choose fonts, colors, and any optional graphics.

3. Once all the dates and pictures are in place, you're ready to print. Print the photos first, then print the calendar pages on the backs of the photos. Your calendar software should include clear instructions on how to get the photos and dates to line up properly when the calendar is hung (you want to make sure the photos you picked for December are actually above the December dates). Print each month's photo on the back of the previous month's calendar page, i.e., February's photo goes on the back of January's calendar. Pay close attention to your

WHAT YOU'LL NEED

- *Photos or images, either digital or scanned into your computer or onto a disc*
- *Photo-editing software, such as Apple's iPhoto for Mac, Adobe Photoshop or Google's Picasa*
- *Calendar software such as Calendar Wizard (Alchemy Mindworks) or Calendar Builder (RKS Software) for PC; The Print Shop for Mac Broderbund). Check first to see if you already have software on your computer that contains a calendar program. Many word processing programs offer such templates.*
- *Good quality, double-sided matte paper*
- *Photo printer*

printer's loading instructions so you don't wind up with photos or calendars that are upside down or don't match up.

4. Finally, either bind the calendar yourself or have your local copy center do it. If you don't want it spiral bound, you can use a hole punch and decorative ribbons or rings to keep your calendar together.

If you're neither eager nor equipped to take on the printing yourself, a number of Internet photo sites will do the job for you if you upload your photos to the site. Try *www.shutterfly.com*; *www. photoworks.com*; *www.snapfish.com*; *www.walmart.com;* or *www. createphotocalendars.com;* or *www.photomax.com.*

POP-ART PRINTS

Pop art for the masses is not quite what Andy Warhol was selling with his iconic, silkscreen portraits of Marilyn Monroe and Jacqueline Onassis. But now virtually anyone can make (or order) similar portraits on a computer. It's not an original, but wouldn't you prefer to display pop-art pictures of your own family and friends rather than Marilyn Monroe? Using image-editing software, such as Adobe Photoshop, you can "paint" your photos any colors you like—a far easier and less messy proposition than Warhol's silkscreening process. The final products can be printed at home and framed to keep or give as gifts. If you really want your art to pop, consider enlarging it and having it printed on canvas and stretched for hanging.

1. Choose your image wisely. Head shots work best for this kind of project, so either find one you really like or take a new one. Decide what tone you want your photo to have—serious and sophisticated or playful and fun? Once your photo is downloaded or scanned into your computer, you need to convert it to black and white. Open the image you'll be using in your photo-editing software and convert it to black and white with as much contrast as possible.

2. Use a masking function to separate the subject of your photo from its background, or simply erase the background, then paste it into a new file so you have no distracting background. Now you can work in layers just on the subject to fill in the colors you want to use.

3. Select the background layer and use a paint tool to fill in the color you want. Make sure to fill in all of the white spaces.

4. Select the subject and again use your paint tool and one or more colors of your choice to fill in any white space on the subject. Save your work often.

5. If you want a print with two or more versions of the image, make a copy of it first. Begin the coloring process again, using different colors for each copy.

WHAT YOU'LL NEED

- *Digital image (at least 200 dpi, or a print scanned in at 200-300 dpi)*
- *Image-editing software*
- *Inkjet or laser printer*
- *Good quality photo paper*

6. Copy and paste each image into a new document, making the new document the final size you want to print. Adjust the images to get the orientation and layout you want.

7. Now you can print or send out the image for large-size printing. Websites such as *www.imagestoart.com; www.power-graphics.com;* and *www.discountphotogifts.com* will print the photos on canvas for you to create artwork that looks like a lithograph. Ask the manufacturer about other possibilities for background materials as well.

The Price family mined personal photographs to make large colored digital prints that hang in their family room.

CREATE A PANORAMIC PHOTO

There are a number of digital cameras with an option to take a series of photos that can be stitched into a single panoramic shot in the camera. You can watch it happen in your viewfinder. But you don't need a special camera if you're partial to wide-angle or panoramic. With the various image-stitching software programs available today, you can make your own panoramic photos—either to print or to view in a 360-degree "virtual reality" image.

1. Once you've decided on the image you want to capture, you'll need to take enough photos of it to stitch together into a complete panorama. This can be done with a handheld camera, but a tripod will ensure that your photos are uniform and line up properly. Take your first picture, turn your camera slightly to the right or left, and take your next picture keeping a bit of the previous frame in your shot. Each photo needs a certain amount of overlap with the images on either side of it so the end result will look seamless. Continue shooting this way until you've captured the whole scene that you want included in your finished photo.

2. When you're finished shooting, download the images from your camera to your computer and import them to your photo-editing or photo-stitching program. Make copies of the photos you'll be working on and put them in a new file. You may want to make changes or start over, and you don't want to risk any permanent changes to your original photo.

3. If you plan to weave the images together yourself using something like Photoshop or iPhoto, your next step is to line up your images in the order you want them and begin the process of overlapping each one until you have the correct size and shape you want. Your program may have a photomerge or similar command that can help here. Using the selection tool, you'll want to outline the portions of overlap that you want to remove and then merge the remaining edges together.

4. When the panorama looks the way you want it to, save a copy and begin the cleanup process. You can crop it to fix

WHAT YOU'LL NEED

- *Digital camera*
- *Tripod (optional, but a good idea)*
- *Photo-editing software, such as Apple's iPhoto, or Google's Picasa, or photo-stitching software, such as Panavue (www. pana-vue.com); Pixtra (www.pixtra.com); PanoPrinter (www. immervision.com); or Panoweaver (www. panoweaver.com) for Windows or Mac. Some digital cameras come with free photo-stitching software, so check if you have one already in your software bundle.*
- *Photo printer*
- *Good quality photo paper*

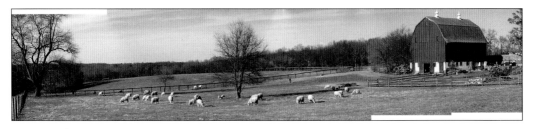

uneven edges or to eliminate items you don't want to include in the photo.

5. If you're using a photo-stitching program, all you have to do is import your pictures and let the program take over. You will have the chance to adjust seams where the photos overlap. You may also want to tweak the picture's contrast and brightness. At this point you can create a 360-degree virtual-reality image—the kind of virtual tour you might find when researching travel guides, vacation homes, or real-estate listings on the Web.

6. Now, you're ready to print. Or you might prefer to order panoramic prints from a photo lab either locally or online. A few websites to try include *www.photothru.com*; *www.digiprint-store.com*; *www.pixeloutpost.com;* and *www.perfectposters.com.*

Many home printers have the capability to output to long sheets of paper, e.g., 8 1/2 inch x 44-inches long. If your printer doesn't have this capability, you can still make a homemade panorama print. Check your image-stitching software for printing guidelines to help you divide your panorama into pieces that can be printed individually. Then you'll have to carefully glue the finished prints together if you want to frame them as one piece. If the idea of gluing your work together and risking unsightly seams makes you queasy, you can frame each print individually and hang them side by side.

Robert Caputo used simple stitching software to make a panorama of the country-side in Pennsylvania.

MANY-FACES-OF-YOU POSTER

A poster featuring multiple portraits of the same person looks great framed. The multiple-frame format would also work well with a single theme, such as a trip, a summer, or a school year. We made this poster using Adobe Photoshop CS3, a professional-level image-editing program. Check your image-editing software for similar features.

1. Decide the number of photos you want to have in your poster—9 for a three-by-three layout or 25 for five-by-five. Choose your best photos, with as many expressions and moods as possible. Make sure the subject is the same size in each photo, the background should be neutral, and the lighting should be as well. If you're shooting specifically for the project, use a telephoto lens to get the best portrait size, and shoot all photos with the same format, either horizontal or vertical.

2. Download the photos and edit, making sure they match in color and exposure. Copy the pictures to a new folder, numbering them in the order you'd like them to appear on the poster, from left to right.

3. In your editing program (from now on we refer specifically to Photoshop CS3), select Contact Sheet II from the File>Automate menu. Select the appropriate number of columns and rows. Deselect "Use Filename as Caption" and "Flatten All Layers." Select a resolution of 300dpi, choose the final size of your poster, and click OK.

4. If you want to add text, make sure there is enough space. Go to Canvas Size in the Image menu and decide on a border size. The Anchor menu allows you to add space where you want it. If you do add a border, you'll need to resize the file before printing: Select the Image Size option from the Image menu and then reenter your poster dimensions. Leave the resolution set at 300dpi.

5. Add text by selecting the background layer, then using the Type tool in the Photoshop toolbar.

WHAT YOU'LL NEED

- *Digital camera*
- *Image-editing software*
- *Good-quality photo paper and printer*

6. When you're satisfied, save it as a Photoshop file to preserve the various layers in case you want to make any adjustments. Then save it as a JPEG file to reduce its size if you're going to send it to an online photo service. If you take it to a local printer you can preserve its detail and quality better by saving it as a TIFF file, a format that most any photo printing service can print.

7. If you are lucky enough to have a large-format printer or can borrow one, you're now ready to print. If you'd rather have someone else do it, try *www.perfectposters.com* and *www.digiprintstore.com*. Local printing companies such FedEx Office (formerly Kinko's) usually offer the service too.

PHOTO ALBUMS

Overstuffed shoeboxes have never been a great means of storing your favorite photos, and they hardly warrant coffee-table display. But with digital photos and a computer, anyone can be a master of the bound, printed photo album. Both Mac and PC users can find a host of photo websites that make it remarkably simple to organize your photos into an album that the service prints and binds for you. This is also a great way to preserve old family photos that may not withstand the rigors of life in a box or even a traditional album. And just think of all the shoeboxes you'll be able to recycle.

1. Choose the images you'll be using for this project and put them in the order you'd like them to appear in your book (Moving photos around once they're in the book is certainly an option, but it seems easier to work with these if the photos are already in a sequence you like.) Use your image-editing software to adjust colors, fix red eyes, and otherwise enhance the photos.

2. Decide which photo book offer is the one for you. Apple's iPhoto and Google's Picasa have programs that make it very easy to create and order photo books. Many online resources are also available. These include *www.mypublisher.com*; *www. snap-fish.com*; *www.shutterfly.com*; *www.kodakgallery.com*; and *www.photomax.com*. You can peruse their websites to compare prices, color choices, and delivery times before making your final decision.

3. You'll have many cover options depending on which service you choose. Your book can be small or large, hardcover or softcover, black or another color. Some sites even offer leather covers. It's all a matter of taste and what you think the project warrants. Maybe you want a hardcover as a special gift, with a softcover version to save or share. Make this daunting decision, and it's on to photo placement.

4. You can choose the number of pages you'll have in your book as well as how many pictures per page. Each page can be different. You may want to display a particular photo on a single

WHAT YOU'LL NEED

- *Images downloaded from your camera to your computer*
- *Scanner, if you're using prints*

page, but put two or more photos on the facing page. It's a simple matter of pointing your cursor and clicking on the desired layout for each page.

Online photo album services have lots of styles from which to choose.

5. Next, you'll import your photos into the program and begin placing them on the appropriate pages. Spend some time deciding which pictures look best next to each other or how you want to tell a story in your book.

6. Most of these services also allow you to put in text, either on the cover or on the pages. Put some thought into that, too. Remember that these are printed, bound books rather than photo albums with removable pages. You can't undo a goofy caption once it's printed.

7. Now that you've done the heavy lifting, decide how many copies of the book you want and hit the order key. Sit back, relax, and wait for your tome to arrive in the mail.

PHOTO GREETING CARDS

Turning your favorite photos into greeting cards gives you the chance to send an announcement, invitation, or holiday message that is uniquely your own. Your photos, imagination, and editing skills combine to produce stationery that no one can match. One couple turned their birth announcement into an homage to the 1964 album, "Meet the Beatles." We'll tell you how they did it, but you can play around with the various filters, colors and other enhancements in your image-editing software to create a card that reflects your personality and taste and befits the occasion. Try adding texture or converting the image to sepia tones to make it look more antique; insert your subjects into old movie posters or famous photographs. There is no end to the fun you can have with your digital photos.

1. The photos for the Beatles-like card were shot in black and white and sidelit. Each person was photographed individually. If your photos are not black and white, convert them using your software and adjust the contrast and lighting until you get what you want.

2. The layout for the faux album-cover announcement was prepared with Quark software; but if your software offers a greeting-card option, use it to construct your card. Choose fonts, colors, and sizes, and decide placement of your photo and text.

3. Open the photos in the photo-editing software. Reduce the shoulders in mom's photograph to baby size and save it as a new photo. Use the outlining tool to copy the baby's head onto the reduced image of mom's shoulders. This saves you from having to pose baby in a black turtleneck.

4. Flatten the layers and convert to duo-tone. Use your filter selection to add a grainy appearance that matches the original album cover.

5. Put the image into your greeting-card layout and print—or have someone else print it for you. Many photo shops will do the printing for you, as will online resources like *www.wink flash.com.*

WHAT YOU'LL NEED

- *Good quality image*
- *Photo-editing software, such as Photoshop*
- *Printer*
- *Printable card stock in your choice of size, color, and finish*

MEET THE BABY!
The First Release by Ghezzi & Greenman is Out Now!

WARNER BROS
BOGART
BERGMAN
HENREID

Casablanca

CLAUDE RAINS
SIDNEY GREENSTREET
mise en scène de MICHAEL CURTIZ

Here we see our talented birthday girl and playboy husband as they appear in the off-Rea Road Theater Production of the classic Casablanca. Joan, voted "Most Talented" in her recent(?) high school graduating class, has brought joy to the hearts of her fellow neighbor Keswickians. Have a great celebration this Monday, August 1, 2005!

A birth announcement inspired by the Beatles and a birthday invitation inspired by a film are just some of the creative ways to use family photographs to make greeting cards.

PHOTO TRANSFERS

Photo-transfer paper makes putting your own digital photos onto fabric a simple matter of printing and ironing. And with a little tweaking of your photos, the possibilities are endless. With either opaque or translucent papers, the finished look will change. If you use translucent paper, the garment will show through the photo and lend its color to the image. If you don't want it to show through, use opaque paper.

1. Use your software to sharpen contrasts and eliminate red eyes. This is also an opportunity to change the way the image will appear when transferred by adding sepia tone or other filters and effects to age or define your photo. Experiment with changes or add text.

2. Resize the photo to fit the garment you've chosen. Measure exactly the space where you plan to place the transfer and resize the picture to fit.

3. If your photo has text or if you want it to appear on your shirt exactly as it appears on-screen, you'll need to use the Flip or Mirror command before you print.

4. Print a test sheet on plain paper to make sure the flip worked and that your transfer is the right size. This is also a good opportunity to see how the picture will look on your garment and decide on any changes.

5. Print on transfer paper. Trim any excess.

6. Read the paper manufacturer's instructions before ironing. Use the iron's hottest setting and do not use steam. Iron out the wrinkles in your garment before applying the transfer. Use your manufacturer's instructions to determine how long to iron the transfer. Time yourself carefully to avoid mistakes. Press carefully but firmly, keeping the iron moving over the transfer at all times to prevent scorching. Try not to catch the edges of the transfer paper with the tip or back of the iron. When the time is up, place your garment on a cool, flat surface.

WHAT YOU'LL NEED

- *Digital image*
- *Photo-editing software*
- *Iron-on transfer paper (available from HP, Canon, and Epson, among others)*
- *Clean, solid-color garment, preferably cotton or mostly cotton*
- *Iron*
- *Hard surface for ironing (an ironing board won't work—use a kitchen counter or heat-safe table instead)*
- *Pillow case for covering the table during ironing*

Most papers must cool completely before you can remove the backing paper. When you're ready to peel away the backing, do it slowly and carefully and avoid pulling on the image.

If you'd rather do this project online and have someone else do the printing and ironing, most online photo developers also offer image transfers on such things as T-shirts, aprons, and tote bags. Many of them let you add text or otherwise personalize your garment. A few to try are *www.shutterfly.com; www.kodakgallery.com;* and *www.snapfish.com.*

Dog leashes, diaper bags, aprons, and T-shirts are just some of the items you can customize yourself.

11 *More on Photography*

MAGAZINES AND ONLINE JOURNALS

Ag
As well as showcasing fine photography, this magazine features valuable insights into the craft of photography. Issues such as archival permanence, printing, and self-publishing are covered in depth.
www.picture-box.com

American Photo
This monthly magazine has features on photography trends, profiles of influential photographers, and how-to advice from working professionals.
www.americanphotomag.com

The Art List
This monthly online newsletter lists grants, upcoming art contests, competitions, and juried shows across the United States.
www.theartlist.com

Black + White
This monthly magazine showcases the best in contemporary photography, fashion, design, and popular culture.
www.bandwmag.com

Blind Spot
Published three times a year, this magazine is the international source book of photography-based fine art for artists, collectors, creative directors, designers, curators, and art aficionados. The organization also publishes books and represents a select group of fine-art photographers.
www.blindspot.com

Camera Arts
As well as providing how-to advice from the professionals, this magazine regularly reports on the annual trade shows and photo festivals in the photography community.
www.cameraarts.com

Communication Arts
This high-quality monthly magazine ispublished for the photography and design communities. In-depth profiles and trend analysis make it a presence on the shelf. The annual contest winners are an excellent resource to find new talent and assess innovative ideas.
www.commarts.com

Daylight Magazine
A publication of the Daylight Community Arts Foundation, Inc., dedicated to documentary photojournalism.
www.daylightmagazine.org

The Digital Journalist
Former Time photographer and University of Texas professor Dirck Halstead created this online monthly magazine for photojournalists about photojournalism.
www.digitaljournalist.org

Digital Photo Pro
This monthly magazine is for the working digital photographer. Articles include in-depth profiles, portfolios, and equipment reviews.
www.digitalphotopro.com

Documentography
A U.K.-based collective of six photographers focus on reportage, including social and political issues.
www.documentography.com

Dpreview.com
This website is dedicated to up-to-the-minute equipment reviews for the digital community.
www.dpreview.com

EOS Magazine
EOS magazine is for owners of Canon EOS cameras, showcasing techniques and resources.
www.eos-magazine.com

EuropePress.com
This online service for photographers includes technology information, exhibition information, portfolio help, and sales information.
www.europepress.com

European Photography Magazine
This international art magazine includes contemporary photography and new media. It is a vital forum for images and ideas.
www.equivalence.com

Exit
Published in Madrid, this quarterly bilingual magazine is devoted to contemporary photography.
www.exitmedia.net

foto8

Started in 1998 by photographer Jon Levy, this highly-acclaimed magazine and website have published stories by independent photographers from around the world.

www.foto8.com

Leica Fotografie International

This magazine features practical and technical aspects of 35mm photography as pertains to the Leica systems. Information addresses developments in digital technology as well as film.

www.lfi-online.de

LensWork

This is a bi-monthly magazine dedicated to the art of photography and the creative process.

www.lenswork.com

Mother Jones

The editors of this magazine routinely publish and promote innovative photography and photo essays.

www.motherjones.com

Musarium

This website features interactive photo essays on subjects from childbirth to cigar bars to the Watergate decade.

www.musarium.com

National Geographic

This monthly magazine is filled with photographic stories from around the world. The website is updated daily with Photo of the Day, photo galleries, and how-to advice from some of the world's busiest and best photographers. Web contests are a good place to interact and compete with other enthusiasts.

www.nationalgeographic.com

News Photographer

Published by the National Press Photographers Association (NPPA), this magazine focuses on photojournalism and television reporting.

www.nppa.org

Next Level

Published every six months, this publication features work pegged to a central theme by new and established writers and photographers.

www.nextleveluk.com

Nikon World

Nikon World features the photography, equipment, and techniques of photographers who use Nikon products.

www.nikonworld.com

Outdoor Photographer

This photography magazine is for nature, travel, and landscape enthusiasts. It includes equipment reviews, profiles, and portfolios. A great resource for amateur landscape photographers.

www.outdoorphotographer.com

Pavilion

This magazine is an art and culture magazine which by its name alludes to the relative contemporary structure of contemporary art. It features wide-ranging, multi-disiplinary content in each issue, by means of the varied formats of columns, essays, interviews, and artistic projects.

www.pavilionmagazine.org

Photo Archive News

Photo Archive News is an independent online magazine covering news and topics of interest from photographic libraries, agencies, and collections.

www.photoarchivenews.com

Photo District News

PDN is the primary business-to-business trade publication for the photo industry. PDN Online updates information on a weekly basis.

www.pdnonline.com

Photographer's Forum

This annual magazine is filled with photographs from the winners of the Photographer's Forum Spring Contest.

www.serbin.com

Photography in New York International

This publication is a bi-monthly guide to the national and international exhibitions, private dealers, auctions, and events in New York City. A must for serious collectors and students of photography alike.

www.photography-guide.com

PhotoMedia Magazine

This magazine targets serious photographers and artists who use photo-based materials. Each issue includes educational and inspirational articles dedicated to a theme.

www.photomediagroup.com

Photovision Magazine

A useful archive of past articles for this now-defunct magazine still exists on the Web.

www.photovisionmagazine.com

Picture

This bi-monthly, NYC-based photography magazine includes calendar and event information, photographer profiles, and magazine and advertising reviews.

www.picturemagazine.com

Picture-Projects

Picture-Projects, a NYC-based studio founded in 1995, uses new media technologies, audio, and documentary photography to examine complex social issues.

www.picture-projects.com

PLUK Magazine

In each issue of PLUK— an acronym for Photography in London, the United Kingdom, and Europe—there are reviews of exhibitions, interviews, previews of shows and events, books reviews, extensive listings and informative articles on the industry.

www.plukmagazine.com

Popular Photography

With the widest circulation on the newsstands today, this monthly magazine features how-to articles, interviews with photographers, and trends. It also covers equipment and software updates.

www.popphoto.com

Reportage

Formerly an award-winning magazine of the 1990s, this website continues to archive and update some of the international photojournalism community's finest stories. Well-respected among professional photographers and editors alike.

www.reportage.org

ReVue

Created by ten independent photographers, this online magazine features portfolios, articles about black-and-white or color photography, and interviews. It is published in both French and English.

www.revue.com

Shots Magazine

Shots Magazine is a quarterly, reader-supported journal of photography that solicits work based on pre-established themes.

www.shotsmag.com

Shutterbug

This magazine and website provide detailed technique information, camera reviews, and online galleries.

www.shutterbug.net

Time

This weekly newsmagazine has consistently published photo essays and innovative photography from some of the best photojournalists.

www.time.com

View Camera

This bimonthly magazine dedicated to large-format photography includes essays, tips on darkroom techniques, and an annual competition.

www.viewcamera.com

Zoom

A treasure trove of photography, gallery, and exhibition information worldwide, and industry news, this magazine/website is an invaluable resource.

www.zoom-net.com

ZoneZero

Photojournalist Pedro Meyer's website encourages camaraderie and gallery space for photographers.

www.zonezero.com

PHOTO BOOK PUBLISHERS

Assouline

Assouline published highly designed art and photography books that reinvent the category of gift books in fun, innovative ways. One set of books worth noting is a comprehensive history of photography in four bound tomes.

www.assouline.com

Bulfinch Press

Bullfinch has published Ansel Adams, JohnSzarkowski, Sally Mann, and other accomplished photographers.

www.hachettebookgroupusa.com

Chris Boot Ltd.

Chris Boot publishes books by photographers such as Larry Towell, Luc Delahaye, Martin Parr, and other contemporary photographers around the world.

www.chrisboot.com

Distributed Art Publishers, Inc.

This is a distributor and sometime publisher of fine art books sold in museums and special-interest bookstores. Topics include photography, art, architecture, fashion, design, and art criticism.

www.artbook.com

Dewi Lewis

This British publishing house has published the works of

Simon Norfolk, Thomas Hoepker, and Stephen Dupont, to name a few.

www.dewilewispublishing.com

de.MO

Created by the design team of Giorgio Baravalle and his wife, Elizabeth, de.Mo has published 13 award-winning books during its first few years.

www.de-mo.org

Lumiere Press

A private press owned by Michael Torosian, Lumiere's books are composed in lead, hand-printed, and hand-bound. A history of his business is on his website.

www.lumierepress.com

Nazraeli Press

A publisher of fine art books, this team is strong in landscape (Robert Adams, Michael Kenna, Jerry Uelsmann), Japanese photography, and contemporary monographs.

www.nazraeli.com

Phaidon

For over 75 years this publisher has focused on art, fashion, film, photography, design, architecture, and pop culture in its books. Its most popular book is *The Art Book*, which includes more than 500 examples of art.

www.phaidon.com

Powerhouse Books

A frequent publisher of ground-breaking photography books that can be both innovative and substantial.

www.powerhousebooks.com

Rizzoli/Universe

Rizzoli publishes architecture and design books, monographs, country books, and witty photographic essays pegged to the times.

www.rizzoliusa.com

Steidl

A printer from the start, Gerhard Steidl has built a publishing house that controls all aspects of publishing from the design to the typography to the reproduction and printing.

www.steidl.de

Taschen

Taschen is publisher of the old (Edward Weston, Man Ray, Edward Curtis), the new (Pierre et Gilles, Wolfgang Tillmans), and the avant-garde (Helmut Newton, Terry Richardson).

www.taschen.com

Thames and Hudson

This company is a leading publisher of books about art, architecture, design, and photography.

www.thameshudson.com

Trolley Books

Trolley has established itself as an innovative and exciting imprint recognized for its diverse and often daring range of projects.

www.trolleynet.com

Twin Palms

For over 20 years this publisher has designed beautiful books for publication including first works by Duane Michals, Robert Mapplethorpe, Debbie Fleming Caffery, and Joel-Peter Witkin.

www.twinpalms.com

Umbrage Editions

This publishing house is dedicated to creating photography books along with travelling exhibitions, websites, plays, and films.

www.umbragebooks.com

EVENTS CALENDAR

January

FotoFusion

Created by some of the legendary photo editors and photographers of *Time* and *Life* magazines, this annual gathering features classes, exhibitions, and lectures given by some of today's most active photographers. It is usually hosted by the the Palm Beach Photographic Centre in Del Ray Beach, FL, during the second week in January.

www.fotofusion.org

PHOTO L.A.

More than 70 galleries and private dealers display work, from 19th-century photography to modern digital prints. The seminars also features guest lecturers from the art world and artist presentations of recent portfolios.

www.photola.com

March/April

AIPAD: The Photography Show

An organization dedicated to the exhibition, buying, and selling of photography, AIPAD sponsors an annual exhibition in New York City for its members and international dealers to showcase fine-art and archival photography. A great way to see historical work.

www.aipad.com

Works on Paper
International exhibitors must be accepted through an application and portfolio review to participate in this annual exhibition.
www.sanfordsmith.com

The Armory Show
Located on Piers 90 and 92 in New York City, this large exhibition offers international art and photography for sale.
www.thearmoryshow.com

FotoFest
The city of Houston sponsors a month of photography and photo-related art with exhibitions, portfolio reviews, workshops, and events.
www.fotofest.org

FotoFreo (Australia)
This annual festival in the city of Fremantle exhibits contemporary photographers from both the journalism and art worlds during its week of exhibitions and lectures.
www.fotofreo.com

Society for Photographic Education National Conference
Industry exhibitors and photographers mingle among the academics. Classes and exhibitions are offered during the four days.
www.spenational.org

May

The Toronto Photography Festival
CONTACT is an annual festival of photography featuring exhibitions and events from around the world.
www.contactphoto.com

June/July

Art 38 Basel
Located in a small town in Switzerland, the festival has been called the "Olympics of the art world" by The New York Times. It is an annual gathering of galleries from around the world.
www.artbasel.com

PhotoEspana
The International Festival of photography and the Visual Arts turns Madrid into the capital of photography for a month and a half each summer. Some of contemporary photography's best-known names such as James

Nachtwey, Henri Cartier-Bresson, and William Klein have attended each summer.
www.phedigital.com

July

Rencontres Internationales de la photographie D'Arles
This annual photographic festival in France appeals to contemporary art enthusiasts as well as photojournalists. Includes exhibitions, seminars, and a contest.
www.rencontres-arles.com

Photo Ventura
The seaside town of Ventura, California, hosts dozens of photography-themed events. Exhibitions showcase fine-art photography and multimedia projects.
www.buenaventuragallery.org

August/September

Encuentros Abiertos Festival de la Luz
Located in Buenos Aires, this month-long festival that includes exhibitions, projections, and lectures of modern international photography.
www.encuentrosabiertos.com.ar

Visa pour L'image
Created by a former *Paris Match* photo editor, this annual festival in Perpignan, France, is a true magnet for editors and photographers who are active in photojournalism. Special emphasis is on stories previously unpublished in the exhibitions and projections.
www.visapourlimage.com

September/October

Le Mois de la Photo a Montreal
Curated by an invited guest from the art world, this biennale brings together artists, curators, and other specialists of the image to study the transformations of the image in our contemporary culture.
www.moisdelaphoto.com

Fotoseptiembre USA
This annual exhibition in San Antonio and other cities in Texas promotes art and commerce in photography. New artists are encouraged.
www.safotofestival.com

Noorderlicht Photofestival
This annual photofestival alternates between the two

Dutch cities of Groningen and Leeuwarden. All past winners and exhibitions since 1997 are available on the website for research purposes.
www.noorderlicht.com

October

The Hereford Photography Festival
Founded in 1989, this annual gathering promotes Hereford as a photography center known for its year-round program of events and classes. Contemporary photographers attend as guest speakers.
www.photofest.org

PhotoPlus Expo
Atn this annual convention in New York City, equipment manufacturers, camera dealers, agents, and photographers mingle to gather all the latest technology information. Seminars with invited panelists discuss the latest issues.
www.photoplusexpo.com

Rhubarb Festival
Editors and curators meet with photographers whose portfolios have been selected during this annual meeting in Birmingham, England. Special guest lectures are also available.
www.rhubarb-rhubarb.org

October/November

Fotonoviembre
This annual exhibition is held on Tenerife, one of the Canary Islands off the coast of Spain.
www.fotonoviembre.com

Mesiac Fotografie
This annual photofestival with portfolio reviews for amateur and professional photographers is held in Bratislava, Slovakia.
www.sedf.sk

Month of Photography in Krakow
This annual exhibition features portfolio retrospectives, a guest of honor, and exhibitions selected by a panel of judges and curators.
www.photomonth.com

Paris Photo
Paris Photo hosts some hundred galleries and publishers from around the globe at the prestigious Carrousel du Louvre. The fair offers a clear perspective on trends and the market to art lovers and collectors.
www.parisphoto.fr

December

Art Basel/ Miami Beach
The sister of Art38 Basel, this annual event attracts more than 150 galleries from around the world to showcase new artwork and emerging artists in the fields of art, photography, architecture, and design. Photography in recent years has become a more important component of the gallery offerings.
www.artbaselmiamibeach.com

WORKSHOPS

Atlanta Photojournalism Seminar
This non-profit organization was created in 1973 to promote higher standards in photojournalism. Working photographers from around the country gather during one weekend to share their insights as well as judge a contest of independent entries.
www.photojournalism.org

D-65 Workshop
Created by Boston photographer Seth Resnick, this workshop concentrates on digital workflow, digital equipment, and business strategies. Private consulting and portfolio reviews are also available.
www.d-65.com

Eddie Adams Workshop
Named after the late Associated Press photographer Eddie Adams, this gathering is an intense four days in upstate New York at the Adams farm where top editors and photographers in the industry instruct 100 students who have been carefully chosen during a rigorous portfolio review.
www.eddieadamsworkshop.com

FoTofusion
A series created by the Palm Beach Photographic Centre, these two-day, practical, hands-on courses are available year-round throughout the country. An intense week of classes, lectures, and exhibitions is available during January at the main center in Florida.
www.workshop.org

Fotovision
This San Francisco-based, non-profit organization was created by documentary photographers. Past weekend workshops have included classes taught by Eugene Richards and Antonin Kratochvil.
www.fotovision.org

Joop Swart Masterclass
Twelve photographers are selected each year to spend

one week in Amsterdam with seven of the world's top photographers and editors. Classes, seminars and on-site portfolio review and instruction are provided during the week, ending with a story review.
www.worldpressphoto.nl

Maine Photographic Workshops
This center offers 250 one-week workshops during the year, ranging from film photography to digital workflow strategies. Travel workshops also provide students with hands-on training abroad with industry professionals.
www.theworkshops.com

NPPA Flying Short Course
This is the traveling version of NPPA's series of workshops for professional photojournalists.
www.nppa.org

NPPA Northern Short Course in Photojournalism
This annual weekend of workshops and seminars, given by professional newspaper photographers for photographers, usually takes place in Cherry Hill, N.J.
www.northernshortcourse.com

Platypus Workshop
Created by the founders of the Digital Journalist, this seminar teaches the basics of video storytelling to people who are comfortable working with still photography.
www.digitaljournalist.org

Poynter Institute for Media Studies
This non-profit organization offers classes year-round in St. Petersburg, FL for photographers and photo editors and graphic designers who want to improve their skills.
www.poynter.org

Santa Fe Workshops
This year-round center offers courses from storytelling to digital workflow to bookmaking. Several National Geographic photographers and editors give lectures here as well as sponsor travel photography seminars.
www.sfworkshop.com

Sports Shooter Workshop
A community of sports photographers sponsors this annual workshop attended by over 400 professionals. Its interactive website also provides nightly tips, stories, and industry chatter. A good resource for amateurs and professionals alike.
www.sportsshooter.com

Stan Kalish Picture Editing Workshop
The workshop is aimed at developing the integrated journalist with a strong emphasis on the visual presentation.
www.kalishworkshop.org

Truth With a Camera Workshop
Created by the founders of the Missouri Workshop and heavily supported by members of the Virginia Pilot newspaper, this hands-on workshop is full of practical guidance and storytelling.
www.truthwithacamera.org

Visual Edge Workshop
Visual Edge workshops explore the latest improvements in multimedia photographic reporting and technology and grapple with issues related to reporting, ethical decision-making, leadership, diversity, workflow, and quality control.
www.visualedge.org

Visual Studies Workshop
Affiliated with the State University of New York at Brockport, these workshops offer one-day classes, weekend classes, and classes for credit in the fields of photography, film, video, bookmaking/artists' books, and electronic imaging.
www.vsw.org

GRANTS, AWARDS, AND CONTESTS
(APPLICATION DEADLINES IN PARENTHESES WHERE KNOWN)

Aaron Siskind Foundation Individual Photographer's Fellowship (October)
Every year this foundation offers five fellowship grants of $5,000 each to photographers who are pursuing individual projects in contemporary photography. The winners are chosen by a selected panel of judges in December.
www.aaronsiskind.org

Alexia Foundation for World Peace Photography Competition (January)
This competition was established in memory of Alexia Tsairis, an honor photojournalism student at the S.I. Newhouse School of Public Communications at Syracuse University, and victim of the terrorist bombing of Pan Am Flight 103. Check the website for details about the application and requirements.
www.alexiafoundation.org

Alicia Patterson Foundation (October)
One-year grants are awarded to working photojournalists/journalists to pursue independent projects of significant interest and to write articles based on their investigations

for the APF Reporter, a quarterly magazine published by the
Foundation. A great resource for working professionals
and documentarians.
www.aliciapatterson.org

Archibald Bush Foundation Artist
Fellows Program (October)
The Bush Artist Fellowships provide artists with signifi-
cant financial support to enable them to finish indepen-
dent work. Fellows may decide to take time for solitary
work, engage in collaborative community projects,
embark on travel or research, or pursue any other activ-
ity that contributes to their lives as artists. Note narrow
geographic restrictions.
www.bushfoundation.org

The Art Directors Club (January)
The ADC is a non-profit organization for communications
professionals. The annual awards competition honors the
best work of the year in print and broadcast advertising,
interactive media, graphic design, publication design,
packaging, photography and illustration.
www.adcglobal.org

Association 3P (October)
The Association 3P, founded by Yann Arthus-Bertrand,
who created the popular Earth from Above books, grants
money to applicants after a portfolio review by a panel
of established photographers.
http://3p.iotanet.net

Atlanta Photojournalism Seminar
Digital Contest (November)
The non-profit Atlanta Photojournalism Seminar, founded
in 1973 by a group of photojournalists, promotes standards
of photojournalism through an annual conference and a
photography contest judged by working photographers.
www.photojournalism.org

China International Press Photo Contest
Created by editors of the Xinhua News Agency and sev-
eral Chines newspapers, this contest began in 2004 and
has already attracted an experienced panel of judges.
www.chipp.cn

Dart Award for Excellence in Reporting on
Victims of Violence
This award of $10,000 is for outstanding newspaper
coverage of victims and their experiences. Stories can be
international or local, but must address the impact of vio-
lence on a community or an individual.
www.dartcenter.org

Deutsche Borse Photography Prize
Formerly the Citigroup Photography Prize,
this prize is organized by the Photographers' Gallery in
London. The prize aims to reward a living photographer,
of any nationality, who has made the most significant
contribution to photography in Europe.
www.photonet.org.uk

Dorothea Lange-Paul Taylor
Documentary Prize (January)
A $10,000 award is given annually by the Center for
Documentary Studies to the entry that best represents the
continuance of the legacy of FSA photographer Dorothea
Lange and her colleague, Paul Taylor.
www-cds.aas.duke.edu

FiftyCrows Fund for
Documentary Photography
For 13 years, the Photo Fund competition has been one
of the premier documentary photography programs in the
world. Its goal is to enable emerging and mid-career pho-
tographers to create in-depth essays that can be catalysts
for positive action and social change.
www.fiftycrows.org

Getty Grant for Editorial Photography
(Round One: November; Round Two: June)
Getty Images will enable five photographers each year to
bring projects of personal and journalistic importance to
reality, and to the marketplace, through a new program,
Getty Images Grants for Editorial Photography. Five grants of
$20,000 each will be awarded to five photojournalists annu-
ally. Grant recipients will be selected by a panel of indepen-
dent judges in two separate rounds of judging each year.
contributors.gettyimages.com

The Golden Light Awards
This is an international competition for emerging photog-
raphers and professionals who have embarked on a per-
sonal project or have amassed a personal body of work.
Entry is open to photographers everywhere.
www.theworkshops.com

Gordon Parks Photography Competition
Each year the Gordon Parks Center for Culture & Diversity
at Fort Scott Community College awards prizes of $1,000,
$500 and $250 to photographers whose images reflect
important themes in the work of Gordon Parks.
www.nppa.org

Hasselblad Foundation - the Victor Fellowship
The aim of the fellowship is to encourage continuing

professional and artistic development at an institution of higher education outside the Nordic countries. The foundation is recognized for its high standards.

www.hasselbladfoundation.org

Howard Chapnick Grant (July)

This $5,000 grant for the advancement of photojournalism is to be used for activities such as education, research, a long-term sabbatical project, or internship. Special consideration is given to projects that promote social change.

www.smithfund.org

John Simon Guggenheim
Memorial Foundation (October 1)

The Foundation offers fellowships to further the development of scholars and artists by assisting them in research in any of the arts, under the freest possible conditions.

www.gf.org

New York Foundation for the Arts
Artists Fellowships (Early October)

These awards are $7,000 cash awards made to individual artists living and working in the state of New York.

www.nyfa.org

NPPA and Nikon Documentary
Sabbatical Grant (December)

The NPPA/Nikon Documentary Sabbatical Grant enables a working photojournalist to take a three-month leave of absence to pursue a documentary project illuminating "The Changing Face of America". The award is $15,000.

www.nppa.org

Oscar Barnack Prize (January 31)

The international jury gives the award to the photographer whose sure powers of observation most vividly express man's relationship to his environment. Entries must include a series of 12 pictures.

www.leicacamera.com

OSI Documentary Photography Distribution Grant

The Documentary Photography Project of the Open Society Institute offers a grant to encourage new ways of presenting documentary photography to the public. The grant enables photographers who have already completed a significant project on issues of social justice to present the work to the public in innovative and appropriate ways, ensuring that the work gains critical exposure and has the greatest chance to stimulate constructive social change.

www.soros.org

OSI - Moving Walls Exhibition

Moving Walls is a traveling photographic exhibition series sponsored by the Open Society Institute. The series represents the transitional condition of open societies and the promotion and maintenance of democratic values. Nations often erect obstacles and barriers such as political oppression, economic instability, and racism, yet even as these walls are built, there are people committed to tearing them down. Moving Walls is an artistic interpretation of this struggle.

www.soros.org

Overseas Press Club Awards (Late January)

Categories are specific to both writing and photography for journalists working overseas. The Robert Capa Award is one of the most prestigious awards a photographer can receive.

www.opcofamerica.org

PDN Photo Annual (February)

Photo District News sponsors an annual contest. The work of the winners is shown on their website and in a monthly magazine.

www.pdnonline.com

Pew Fellowship in the Arts - PFA (December)

The grants provide financial support directly to the artists so they may pursue their projects independently. Highly competitive.

www.pewarts.org

Pictures of the Year International (January)

Sponsored by the University of Missouri School of Journalism, the Pictures of the Year contest is a massive effort to sift through thousands of entries from newspapers and magazines and independent photographers to find three winners in each category. Winners receive recognition in the global photo industry.

www.poyi.org

Sante Fe Center for Photography

The Project Competition honors committed photographers working on long-term documentary projects and fine-art series. Often a place where magazine and book editors look for new talent.

www.sfcp.org

University of Arizona Center for Creative
Photography - Ansel Adams Fellowships in
Photography (October)

Through a generous endowment provided by the Polaroid Corporation, the CCP at the University of Arizona offers

annual research fellowships for people who want to spend time in the archives and the photograph collection of the Center for Creative Photography.

www.creativephotography.org

University of Minnesota McKnight Photography Fellowship Program (April)

This program is one of 11 artist fellowship programs funded by the McKnight Foundation of Minneapolis. The program annually awards four $25,000 fellowships to Minnesota photographers.

www.mcknightphoto.org

W. Eugene Smith Memorial Fund (July)

The W. Eugene Smith Grant in Humanistic Photography is presented annually to a photographer whose past work and proposed project, as judged by a panel of experts, follows the tradition of W. Eugene Smith's compassionate dedication exhibited during his 45-year career as a photographic essayist. The award is substantial.

www.smithfund.org

White House News Photographers' Association (October)

A $5,000 project grant is available for a WHNPA member to work on an in-depth independent story.

www.whnpa.org

World Press Photo Awards (January)

Invited editors from around the world sift through thousands of entries in many different pre-determined categories to find three top winners. The winning photographs become part of a traveling exhibition and a bound book which are made available to professional editors around the world. The winners receive a plane ticket to Amsterdam for the awards ceremony.

www.worldpressphoto.nl

Worldstudio Foundation Scholarships (April)

Worldstudio Foundation scholarships allow young people from minority and economically-disadvantaged backgrounds to realize their artistic dreams.

www.worldstudio.org

PROFESSIONAL ORGANIZATIONS

Advertising Photographers of America

This professional organization is dedicated to promoting the interests of advertising photographers.

www.apanational.com

Americanphotojournalist.com

This website and forum were created by photojournalists for photojournalists. News, classifieds, and portfolios keep the information up-to-date.

www.americanphotojournalist.com

American Society of Media Photographers - ASMP

This trade association for professional photographers offers insurance as well as business and legal information.

www.asmp.org

American Society of Picture Professionals

This trade association is for photographers, photo researchers, photo editors, stock agents, librarians, etc.

www.aspp.com

Aperture Foundation

A premiere not-for-profit arts institution, this foundation publishes a quarterly magazine, regularly exhibits new work, publishes books, sells photographs from its archive online, and provides a forum for photographers—all in an effort to advance fine photography.

www.aperture.org

Artists Rights Society

Founded in 1986, ARS represents the intellectual property rights interests of over 30,000 visual artists (painters, sculptors, photographers, architects and others) and estates of visual artists from around the world.

www.arsny.com

British Association of Picture Libraries and Agencies

BAPLA is the UK trade association for picture libraries and the largest organization of its kind in the world.

www.bapla.org.uk

Brooks NPPA

The Brooks NPPA Student Chapter is dedicated to the advancement of photojournalism and its role in society.

www.brooksnppa.org

Camera Club of New York

Since the 1880s, The Camera Club of New York has been a place of introduction for amateur and professional photographers alike. Edward Steichen lectured about aerial photography here, Paul Strand learned about right-angle viewfinders here, and Alfred Stieglitz was a part of the community. Lectures, darkrooms, and a studio are still available today for individual or annual fees.

www.cameraclubny.org

Center for Photographic Art
Established in 1988 to encourage an increased awareness and understanding of photography as a fine art form, this gallery in Carmel, CA, publishes books and exhibits work. It is a non-profit public benefit corporation.
www.photography.org

Center for Photography at Woodstock,NY
A good source of information about modern contemporary photography, the center provides lectures and seminars, residencies, and exhibitions in an effort to promote phohotgraphy. Members of the staff also publish a quarterly magazine.
www.cpw.org

CEPA
This arts center in Buffalo, NY, produces internationally acclaimed exhibitions, community education programs, and workshops. The center also sponsors artist-advocacy programs and open-access creation facilities. The Biennial Art Auction is a major fundraiser for CEPA and an opportunity for individuals and organizations to collect contemporary photographic artwork.
www.cepagallery.com

Digital Imaging Websites Association
DIWA is an international network of independent websites focusing on digital imaging, a Consumer Reports type website for people to research equipment before you buy or invest in it.
www.diwa-awards.com

Editorial Freelancers Association
The EFA is a national, nonprofit, professional organization of self-employed workers in the publishing and communications industries.
www.the-efa.org

En Foco (Bronx, NY)
This non-profit organization created by Latino photographers publishes the Nueva Luz photographic journal, administers the New Works Photography Awards, and offers a Print Collectors Program as well as other membership benefits.
www.enfoco.org

FiftyCrows (IDPF)
FiftyCrows Foundation, created by Andy Patrick, gives the necessary space and time to documentary photographers to show their work in the broader effort to affect social change with their images. An annual competition called the the International Fund for Documentary Photography rewards grant money to the winner. Highly competitive.
www.fiftycrows.org

Graphic Artists Guild - GAG
The Graphic Artists Guild is a national union of illustrators, designers, web creators, production artists, surface designers, and other creative professionals.
www.gag.org

International Center of Photography
Interpreting the power and evolution of photography, the International Center of Photo-graphy is a museum and school dedicated to the understanding and appreciation of photography. Students can enroll in individual classes or a masters program. Regular exhibitions and a growing archive make this organization an important presence in the photography community-at-large. The museum and school are located in New York City.
www.icp.org

International Documentary Association
This association represents supporters and creators of documentary film: producers, writers, directors, musicians, researchers, journalists and others.
www.documentary.org

Journalism and Women Symposium - JAWS
JAWS supports the personal growth and professional advancement of professional women in journalism.
www.jaws.org

Kids with Cameras
Part of the effort first created with Zana Briski's Oscar-winning documentary *Born into Brothels*, members of this non-profit organization teach photography to marginalized children in communities around the world. The website also sells their prints.
www.kids-with-cameras.org

Light Factory Photographic Arts Center
Started as a photographer's cooperative in Charlotte, NC, this group has become a place for classes and exhibitions.
www.lightfactory.org

Light Work
Since 1973, Light Work has provided direct support to artists working in the mediums of photography and digital imaging through exhibitions, lectures, classes, artist residencies, publications, and other related projects.
www.lightwork.org

National Press Photographers Association

This trade association for news photographers offers insurance as well as discount purchases, networking, etc. The annual contest is a good marketing tool.

www.nppa.org

Nature and Travel Photographers Network

This international cooperative network of amateur and professional photographers is dedicated to nature photography.

www.naturephotographers.net

North American Nature Photography Association

NANPA is another community dedicated to the field of nature photography.

www.nanpa.org

Overseas Press Club of America

This international association is for journalists working in the United States and abroad.

www.opcofamerica.org

Photo Marketing Association International

This association is dedicated to groups involved in the processing, servicing, or marketing of photographic goods. It sponsors an annual convention.

www.pmai.org

Picture Agency Council of America

PACA is the trade association for stock photo agencies in North America.

www.pacaoffice.org

Picture Research Association

This is an association and networking group for picture researchers based in the U.K.

www.picture-research.org.uk

Professional Photographers of America

This online community has monthly contests, resource links, and forums.

www.ppa.com

Society of Photographers and Artists Representatives

Created in 1965, SPAR monitors and promotes the necessary details of proper representation of artwork by photographers and illustrators alike.

www.spar.org

Society for Photographic Education

Through its programs, services, and publications, the society seeks to promote a broader understanding of the medium in all its forms, and to foster the development of its practice, teaching, scholarship, and criticism.

www.spenational.org

Stock Artists Alliance

Created in 2001, this membership organization monitors the issues affecting photographers who license their own images. It also provides a searchable website database for photographers who wish to sell through SAA. A good alternative to more commercial ventures.

www.stockartistsalliance.org

The Photographic Resource Center (PRC) at Boston University

This independent non-profit organization serves as a vital forum in the New England area for the exploration and interpretation of new work, ideas, and methods in photography and related media. Classes are available.

www.bu.edu/prc

The Association of Photographers

This U.K.-based organization promotes the interests of editorial, fashion and advertising photographers.

www.the-aop.org

Visual Studies Workshop

Based in Rochester, NY, the workshop offers a Masters in Fine Arts in conjunction with a local university. It houses a collection of photography and art books, offers one-month artist residencies, and research on the premises.

www.vsw.org

White House News Photographers Association

Created by photographers, this group sponsors the annual WHNPA contest, which features work being created by its professional membership, most of whom are based in Washington D.C. and nearby areas.

www.whnpa.org

Women in Photography International

Founded in 1981, this group is a non-profit, outreach organization that promotes the visibility of women photographers and their work.

www.womeninphotography.org

World Press Photo

Based in Amsterdam, this organization aims to support photographers around the world with educational programs, an annual contest, exhibitions, and books.

www.worldpressphoto.nl

ADVOCACY GROUPS

Reporters Sans Frontieres
The association defends journalists and other media contributors who have been imprisoned or persecuted for doing their work. It speaks out against the abusive treatment and torture that is still common practice in many countries.
www.rsf.org

Committee to Protect Journalists
This group promotes press freedom by defending the rights of journalists to report the news without fear of reprisal. The organization is very active during news stories that involve the endangerment of working journalists.
www.cpj.org

Dart Center for Journalism and Trauma
This group is dedicated to educating photographers and journalists about the impact of violence on persons and societies they may cover.
www.dartcenter.org

International Federation of Journalists
The world's largest organization of journalists, the IFJ promotes international action to defend press freedom and social justice through independent trade unions of journalists.
www.ifj.org

Crimes of War Project
The Crimes of War Project is a collaboration of journalists, lawyers, and scholars to raise public awareness about the laws of war.
www.crimesofwar.org

Editorial Photographers
This group of photographers educate themselves and others about the business issues affecting the industry.
www.editorialphotographers.com

International Journalists' Network
IJNET is an online service for journalists, media managers, media assistance professionals, journalism trainers and educators about the media.
www.ijnet.org

Witness.org
Witness is an organization that provides local activists with video cameras to document human rights abuses.
www.witness.org

SCHOOLS

Brooks Institute of Photography
801 Alston Road
Santa Barbara, CA 93108
1-888-304-FILM
www.brooks.edu

International Center of Photography
1133 Avenue of Americas
New York, NY 10036
212-857-0000
www.icp.org

Ohio University
School of Art
Photography
Siegfred Hall 527
Athens, OH 45701
gradstu@www.ohiou.edu

Pratt Institute
200 Willoughby Ave.
Brooklyn, NY 11205
212-647-7775
www.pratt.edu

Rochester Institute of Technology
School of Photographic Arts & Sciences
One Lomb Memorial Drive
Rochester, New York 14623
(585) 475-6631
www.photography.rit.edu

San Francisco Art Institute
800 Chestnut Street
San Francisco, CA 94133
415-775-7120
www.sfai.edu

School of the Art Institute of Chicago
37 S. Wabash Ave.
Chicago, IL 60603-3103
(312) 899-5219 Fax: (312) 899-1840
www.artic.edu

School of Visual Arts
Photography
Office of Graduate Admissions, 209 East 23rd Street
New York, NY 10010-3994 U.S.A.
gradadmissions@sva.edu

Syracuse University

Syracuse University
Syracuse, NY 13244
315- 443-2461

www.syr.edu

Temple University

Tyler School of Art
and Photography
7725 Penrose Avenue
Elkins Park, PA 19027 USA
Phone: 1-215-782-2828

tyler@temple.edu

University of New Mexico

College of Fine Arts
Department of Art and Art History
Graduate Program in Photography
UNM MSC04 2560
Albuquerque, NM 87131 USA

art255@unm.edu

University of Texas at Austin

1 University STA
Austin, TX 78712-0900
512 471-3434

www.utexas.edu

ONLINE ARCHIVES AND COMMUNITIES

AOL Pictures
pictures.aol.com

dotPhoto
www.dotphoto.com

Flickr
www.flickr.com

Fotki
www.fotki.com

Image Event
www.imageevent.com

ipernity
www.ipernity.com

Jalbum
jalbum.net

JPG Magazine
www.jpgmag.com

Kodak Gallery
www.kodakgallery.com

KoffeePhoto
www.koffeephoto.com

locr
www.locr.com

Nikon my Picturetown
www.mypicturetown.com

Panoramio
www.panoramio.com

PBase
www.pbase.com

Phanfare
www.phanfare.com

Photobucket
www.photobucket.com

Photocheap
www.photocheap.biz

Photomax
www.photomax.com

Photo.net
photo.net

PhotoShelter
psc.photoshelter.com

Photoworks
www.photoworks.com

Picasa 3
picasa.google.com

Picturetrail
www.picturetrail.com

Piczo
www.piczo.com

pikeo
www.pikeo.com

Pixagogo
www.pixagogo.com

Plazes
www.plazes.com

Printroom
www.printroom.com

Sacko
www.sacko.com

Shutterfly
www.shutterfly.com

SmugMug
www.smugmug.com

Snapfish
www.snapfish.com

Swiss Picture Bank
www.swisspicturebank.com

TripTracker
triptracker.net

Webshots
www.webshots.com

Winkflash
www.winkflash.com

Woophy
www.woophy.com

Worldisround
www.worldisround.com

ZoomIn
www.zoom.in

Zooomr
www.zooomr.com

Index

Photo Credits

Key:

NGSIC: National Geographic Society Image Collection, PS: Product Shot (courtesy the manufacturer, unless otherwise noted)

COVER: (Upper left) Joel Sartore/NGS; (Upper right) Jodi Cobb/NGS; (Lower Left) Jim Webb/NGS; (Lower right) Jason Edwards/NGS; spine, Gary Calton; Back cover, Michael Nichols/NGS

FRONT MATTER: 2-3, Jim Richardson; 4, Carsten Peter; 6, Michael Melford; 8, Angelo Cavalli/zefa/CORBIS; 9, Mark Thiessen, NGS; 10, PS; 11, Steve St. John/NGSIC.

CHAPTER 1, POINT & SHOOT: 12-13, Alaska Stock Images/Michael DeYoung; 15, Jasper James/Getty Images; 17, Aaron Graubert/Getty Images; 18, John Burcham/NGSIC; 20 (both), Mark Thiessen, NGS; 21, Bill Hatcher/NGSIC; 22-23, Michael Nichols/ NGSIC; 24, Joel Sartore/NGSIC; 25 (both), Mark Thiessen, NGS; 26, Library of Congress (#-DIG-matpc-14896); 27, PS; 30 (upper), Mark Thiessen, NGS; 30 (lower), PS; 31, Bronwen Latimer, NGS; 33, Fran Brennan; 34-35, Chris Anderson/Magnum Photos; 36-37, Paolo Pellegrin/Magnum Photos; 38-39, Alex Majoli/Magnum Photos; 40-41, Chris Anderson/Magnum Photos; 42-43, Alex Majoli/ Magnum Photos.

CHAPTER 2, BASIC RULES: 44-45, Jodi Cobb, NGS; 46-49 (all), PS; 50, Image Acquisition/Getty Images; 51, Carsten Peter/NGSIC; 52, Joel Sartore; 53, Joel Sartore/NGSIC; 54-55, Winfield Parks, NGSIC; 57, Charlie Archambault; 60-61, Justin Guariglia/NGSIC; 63 (all), Mark Thiessen, NGS; 64, Slim Films; 65, Bruce Dale; 67, David Alan Harvey/Magnum Photos; 68-69, Joel Sartore/NGSIC; 70 (both), Bruce Dale; 72-73, Kenneth Garrett; 74, Stephen Alvarez/NGSIC; 76, Justin Guariglia/NGSIC; 77, Richard Olsenius/NGSIC; 78, Chris Anderson/Magnum Photos; 79, Bob Martin; 80-81, Sarah Leen; 82, PS: 83, Bob Sacha; 84, Sean Murphy/Getty Images; 85, Dustin Hardin/Getty Images; 86, Chris Johns, NGS; 87, Michael Yamashita; 88-89, Sandra-Lee Phipps; 90, Fredrik Broden; 92, Mattias Klum/ NGSIC; 93, Bob Martin; 94, Jim Naughten/Getty Images; 96-97, William Albert Allard, NGS; 98 (upper), Mark Thiessen, NGS; 98 (lower), Slim Films; 99, Grace Bruty; 100 (upper), Mark Thiessen, NGS; 100 (lower) & 101, Michael Nichols/NGSIC; 102, VCL/Spencer Rowell/ Getty Images; 104-105, Sisse Brimberg/NGSIC; 106, James P. Blair; 107, William Albert Allard, NGS;108-117 (all), Jodi Cobb, NGS.

CHAPTER 3, ADVANCED TECHNIQUES: 118-119, George Steinmetz; 121, Bill Hatcher/NGSIC; 122, Stephen Alvarez/NGSIC; 123, Randy Olson; 124, Raul Touzon/NGSIC; 125, Bobby Model; 127, Bob Martin; 128 & 129, Gordon Wiltsie; 131, Robert Clark; 132, Randy Olson/NGSIC; 134-135, Chris Johns/NGSIC; 137 (both), Timothy Greenfield-Sanders/Olympus Fashion Week/CORBIS Outline; 138-139, Tim Laman; 140, Rebecca Hale, NGS; 142-143, Raymond Gehman/NGSIC; 144-145, Michael Nichols, NGS; 147, Martin Parr/Magnum Photos; 149, Josef Isayo; 151, Vincent Laforet; 152, Josef Isayo; 154, Michael Nichols, NGS; 155, Chris Johns, NGS; 156-157, Jim Richardson; 158-159, Tim Laman/NGSIC; 161, Robert Clark; 162, David Arky; 163, Holly Lindem; 165, Jonathan Blair/NGSIC; 166, Todd Gipstein/NGSIC; 169, Joel Sartore; 170-177, Michael Nichols/NGSIC.

CHAPTER 4, A CAMERA PHONE TRAVELOGUE: 178-179, Justin Guariglia/NGS/Getty Images; 180-209, Robert Clark.

CHAPTER 5, THE DIGITAL DARKROOM: 210-211, Frank Herholdt/Getty Images; 213, Michael Pole/CORBIS; 215, James L. Stanfield/NGSIC; 216-249 (all), John Healey; 250 & 251, Julie Blackmon.

CHAPTER 6, MAKING BETTER PRINTS: 252-253, Andrew H. Walker/Getty Images; 255, George Eastman House; 256-259 (upper), PS; 259 (lower) Richard Olsenius; 260, Library of Congress (#LC-DIG-cph-3f05982), 263-266 (all), Richard Olsenius; 268-269 (both), Randy Olson.

CHAPTER 7, FILM PHOTOGRAPHY: 270-271, Kevin Horan; 273, Museum of the History of Science; 274, Gernsheim Collection, Harry Ransom Humanities Research Center, The University of Texas at Austin; 275, Adam Fuss, courtesy Fraenkel Gallery, San Francisco; 276, Library of Congress (#LC-USZC4-1807); 277, Hill & Adamson Collection, Glasgow University Library, Department of Special Collections; 278, Library of Congress (#LC-DIG-cwpb-02880); 279, Museum of the History of Science; 280-281 & 283, George

Eastman House; 284, Victoria & Albert Museum; 286, George Eastman House; 288-289 (both), Wes Pope; 291, Autochrome Lumière 13x18cm, Lumière Family Collection, courtesy of Alain Scheibli; 292-293, C.J. Gunther; 293, David Burnett/Contact Press Images; 294, Prokudin Color Collection, Library of Congress (#LC-DIG-ppmsc-04413); 297, Dorothea Lange, Library of Congress (#LC-USF34-009058-C); 298, Cornell Capa Photos by Robert Capa © 2001/Magnum Photos; 299, Elliott Erwitt/Magnum Photos; 301, Russell Kaye; 302, University of Missouri School of Journalism; 304-305, Reza/ NGSIC; 306, Joe McNally/Getty Images; 307, Time Life Pictures/Getty Images; 308, Coneyl Jay/CORBIS; 309, James Keyser/Time Life Pictures/Getty Images; 310-317, William Albert Allard, NGS.

CHAPTER 8, SCANNING: 318-319, Penny De Los Santos; 321, Eddie Ephraums; 322, M. Neugebauer/zefa/CORBIS; 324-334 (all), Richard Olsenius; 337, Maggie Taylor.

CHAPTER 9, ARCHIVING: 338-339, David Zaitz/Getty Images; 341, Neo Vision/Getty Images; 342, Carl Glover/Getty Images; 343, Henry King/Getty Images; 344, Christopher Stevenson/zefa/CORBIS; 346, Debbie Grossman; 347, Rebecca Hale, NGS: 349, Raymond Gehman; 351, Richard Olsenius; 352, Alfred Eisenstaedt/Time Life Pictures/Getty Images; 353, Time Life Pictures/Getty Images; 354, Tomasz Tomaszewski; 357, Richard Olsenius; 358-359, Annie Griffiths Belt.

CHAPTER 10, PROJECTS: 360-361, Jodi Cobb/NGS; 363, Rebecca Hale, NGS: 365 & 367, PS; 369 (all), Fran Brennan; 371 (all), Robert Caputo; 373, Bob Martin; 375, PS; 377 (upper) courtesy of Gail Ghezzi, (lower) courtesy of Stuart Segal; 379, PS.

Bob Martin is a London-based award-winning professional photographer with more than 20 years experience in sports photography and documentary photojournalism. His images have been published in *Sports Illustrated, Time, Stern, Paris Match* and *The Sunday Times*.

Robert Clark is an award-winning photographer with 12 *National Geographic* cover stories to his credit. Sixty of his images have been selected for book covers and he has recently published one of the first books using images from a camera phone entitled *The Camera Phone Book.*

John Healey has worked for several years in professional photography as an assistant and photographer for magazine and commercial clients. He has a masters in journalism from the University of Texas at Austin.

Richard Olsenius is an award-winning photographer, filmmaker, and former photo editor at *National Geographic* magazine. His work spans 35 years and has appeared in numerous books and magazine stories for the National Geographic Society.

Robert Stevens is a former picture editor with *Time* magazine. He is a collector of photography books, a consultant for Sotheby's, and a teacher at the International Center of Photography and the School of Visual Arts in New York City.

Born in the home of Kodak (Rochester, N.Y.), **Debbie Grossman** has been devoted to photography most of her life. Formerly the photo editor of *Nerve.com*, she's currently an editor at *Popular Photography* magazine, where she reviews software and writes the monthly Photoshop column, Digital Toolbox. A photographer in her spare time, she shows her work with artist group collective #nine.

Fran Brennan is a former writer and reporter for the *Miami Herald* and *People* magazine. Her articles have also appeared in the *Washington Post*.

ULTIMATE FIELD GUIDE TO PHOTO GRAPHY

Contributing Authors

Bob Martin, Robert Clark, John Healey, Richard Olsenius, Robert Stevens, Debbie Grossman, and Fran Brennan

Published by the National Geographic Society

John M. Fahey, Jr., President and
 Chief Executive Officer
Gilbert M. Grosvenor, Chairman of the Board
Tim T. Kelly, President, Global Media Group
John Q. Griffin, President, Publishing
Nina D. Hoffman, Executive Vice President;
 President, Books Publishing Group

Prepared by the Book Division

Kevin Mulroy, Senior Vice President and Publisher
Leah Bendavid-Val, Director of Photography
 Publishing and Illustrations
Marianne R. Koszorus, Director of Design

Barbara Brownell Grogan, Executive Editor
Elizabeth Newhouse, Director of Travel Publishing
Carl Mehler, Director of Maps

Staff for This Book

Bronwen Latimer, Project Editor, Illustrations Editor
Rebecca Lescaze, Text Editor
Cameron Zotter, Designer
Al Morrow, Design Assistant
Russell Hart, Consultant
Lewis Bassford, Production Project Manager
Meredith C. Wilcox, Illustrations Specialist

Jennifer A. Thornton, Managing Editor
Gary Colbert, Production Director

Manufacturing and Quality Management

Christopher A. Liedel, Chief Financial Officer
Phillip L. Schlosser, Vice President
Chris Brown, Technical Director
Nicole Elliott, Manager
Monika Lynde, Manager
Rachel Faulise, Manager

Founded in 1888, the National Geographic Society is one of the largest nonprofit scientific and educational organizations in the world. It reaches more than 285 million people worldwide each month through its official journal, NATIONAL GEOGRAPHIC, and its four other magazines; the National Geographic Channel; television documentaries; radio programs; films; books; videos and DVDs; maps; and interactive media. National Geographic has funded more than 8,000 scientific research projects and supports an education program combating geographic illiteracy.

For more information, please call
1-800-NGS LINE (647-5463)
or write to the following address:

National Geographic Society
1145 17th Street N.W.
Washington, D.C. 20036-4688 U.S.A.

Visit us online at www.nationalgeographic.com

For information about special discounts
for bulk purchases, please contact
National Geographic Books Special Sales:
ngspecsales@ngs.org

For rights or permissions inquiries, please contact
National Geographic Books Subsidiary Rights:
ngbookrights@ngs.org

ISBN-10: 978-1-4262-0431-9

31901050182486